ART
IN THE AGE OF
QUEEN
VICTORIA

ART
IN THE AGE OF
QUEEN VICTORIA

A WEALTH OF DEPICTIONS

EDITED BY MARK BILLS

WITH ESSAYS BY

MARK BILLS • MARY COWLING

MATTHEW CRASKE • PAMELA GERRISH NUNN

BENEDICT READ • ALISON SMITH

RUSSELL-COTES ART GALLERY AND MUSEUM, BOURNEMOUTH

IN ASSOCIATION WITH

LUND HUMPHRIES

First published in 2001 by
Russell-Cotes Art Gallery and Museum
Bournemouth Borough Council
East Cliff
Bournemouth
BH1 3AA

in association with

Lund Humphries
Gower House
Croft Road
Aldershot
Hampshire GU11 3HR
and
131 Main Street
Burlington
VT 05401
USA

Lund Humphries is part of Ashgate Publishing

British Library Cataloguing-in-Publication Data
A catalogue record for this book is available from the British Library

Hardback ISBN 0 85331 829 8 (Lund Humphries)
Paperback ISBN 0 905173 65 1 (Russell-Cotes Art Gallery and Museum)

Library of Congress Control Number: 2001092317

Art in the Age of Queen Victoria: A Wealth of Depictions
Copyright © 2001 Russell-Cotes Art Gallery

Unless otherwise stated, all images are reproduced courtesy
of the Russell-Cotes Art Gallery and Museum

Designed by Harry Green

Printed in Belgium by Snoeck-Ducaju & Zoon, Ghent

COVER IMAGE Louise Rayner, *Cambridge Street Scene* (Cat.48)

CONTENTS

Contributors 6

Acknowledgements 7

Abbreviations 7

INTRODUCTION
The Russell-Cotes Art Gallery and Museum 8
Mark Bills

CHAPTER ONE
Art in the Age of Queen Victoria 12
Mary Cowling

CHAPTER TWO
Display and Exhibition in the Victorian Era 42
Mark Bills

CHAPTER THREE
Private Pleasures? *Paintings of the nude in the Russell-Cotes Collection* 53
Alison Smith

CHAPTER FOUR
We are not a Muse: *Women artists and the Russell-Cotes Collection* 68
Pamela Gerrish Nunn

CHAPTER FIVE
Landseer, Animals and the Russell-Cotes Collection 88
Matthew Craske

CHAPTER SIX
Art and Taste in Black and White: *Prints in the Victorian period* 104
Mark Bills

CHAPTER SEVEN
Victorian Sculpture at the Russell-Cotes Art Gallery and Museum 116
Benedict Read

Afterword 130

Notes 131

Index 135

CONTRIBUTORS

MARK BILLS
Mark Bills is a curator at the
Russell-Cotes Art Gallery and Museum,
Bournemouth. He is author of *Edwin
Long* (1998), which includes a catalogue
of known works by the eminent history
painter, and editor of *A Victorian Salon:
Paintings from the Russell-Cotes Art
Gallery and Museum* (1999). He has
curated exhibitions of Victorian art at
the Russell-Cotes including *Evelyn De
Morgan* (1996–7) and *A Victorian Salon*
(1999–2000). He was previously a
curator for English Heritage.

MARY COWLING
Dr Mary Cowling is a lecturer in
History of Victorian Art and Design
at the Victorian Centre, Royal Holloway
College, University of London and
Curator of the Royal Holloway
Collection. She previously taught at the
Roehampton Institute and Homerton
College, University of Cambridge.
Her publications include *The Artist as
Anthropologist: the Representation of Type
and Character in Victorian Art*
(1989); *Victorian Figurative Painting:
Domestic Genre and the Contemporary
Social Scene* (2000); and *Victorian*

Figurative Painting: The Pre-Raphaelites
(2001). The third volume in this series,
The History Painters, is due to appear in
2002. Dr Cowling is now working
on a book about the Pre-Raphaelite
landscape in its moral, philosophical
and scientific context.

MATTHEW CRASKE
Dr Matthew Craske is currently
Leverhulme Fellow in the History
of Portraiture at the National Portrait
Gallery. He is based at the Humanities
Research Centre at Oxford Brookes
University. Although a specialist in
the history of British sculpture of the
eighteenth century, he has published on
a broad range of art and design topics.

PAMELA GERRISH NUNN
Pamela Gerrish Nunn has specialised
in the history of women artists
for over twenty years. She is author of
*Canvassing: Recollections by Six Victorian
Women Artists* (1986), *Victorian Women
Artists* (1987), *Problem Pictures* (1995)
and, with Jan Marsh, two volumes
on Pre-Raphaelite women artists.
She lectures at the University of
Canterbury, New Zealand.

BENEDICT READ
Benedict Read is a senior lecturer
in the School of Fine Art at Leeds
University. Since 1974 he has published
extensively on all aspects of British Art
from 1840 to the present day. Among
his publications are *Victorian Sculpture*
(1982), and *Millais* (1983);
he also coedited and contributed to
Pre-Raphaelite Sculpture (1991).
He was chair of the Public Monuments
and Sculpture Association from 1993
to 2001.

ALISON SMITH
Alison Smith is a senior curator in the
exhibitions department, Tate Britain,
London. She is author of *The Victorian
Nude: Sexuality, Morality and Art* (1996)
and curator of *Exposed: The Victorian
Nude* (Tate Britain, Winter 2001).

ACKNOWLEDGEMENTS

This book would not have been possible without the knowledge and enthusiasm of its contributors. In its preparation the help and advice of the following people is particularly noted: Shaun Garner, Jacqueline Sarafopoulos, Phillip Ward-Jackson and all the staff of the Russell-Cotes Art Gallery and Museum. The Heritage Lottery Fund project to refurbish the Russell-Cotes Art Gallery and Museum and conserve and redisplay the entire collection provided a valuable incentive for the creation of this book. The photography of James Howe, taken with care and professionalism at extremely short notice, is greatly appreciated. Thanks also go to Francis Marshall for the authorship of the sculpture captions and to the Conway Library of the Courtauld Institute of Art for granting permission to reproduce the images on pages 118 and 119.

ABBREVIATIONS AFTER ARTISTS' NAMES

ARA	Associate of the Royal Academy of Arts
ARWS	Associate of the Royal Watercolour Society
HRCA	Honorary Member of the Royal Cumbrian Academy, Manchester
HRPE	Honorary Member of the Royal Society of Painters and Etchers (later RE)
PRA	President of the Royal Academy of Arts
PRBA	President of the Royal Society of British Artists
RA	Member of the Royal Academy
RBA	Member of the Royal Society of British Artists
RCA	Royal College of Art
RE	Royal Society of Painter-Etchers and Engravers
RI	Member of the Royal Institute of Painters in Oil-Colours
RWS	Royal Watercolour Society

THE RUSSELL-COTES ART GALLERY AND MUSEUM
'the most complete representative collection of British Art'

MARK BILLS

Queen Victoria ascended the throne in 1837 and died in 1901. One hundred years later we stand at the beginning of a new century with fresh attitudes to the past and the future. The intervening time has witnessed an immense change in attitude to the Victorian period and to the art that characterised it. At the turn of the twentieth century, self-assured critics hailed the success of Victorian art. Just a decade later, it was decried by a new generation that set the tone for the greater part of the next hundred years. It was only in the last third of the twentieth century that this important period of creativity was reassessed. Setting aside past prejudices, historians began to look afresh at the art within the context of the period. Indeed, many of the scholars who first explored neglected areas of Victorian art are represented in this volume.

Similarly, collectors and collections that had been dismissed as tasteless and parochial cultural hangovers of the previous century have been rediscovered. The Russell-Cotes Art Gallery and Museum, which can still be visited today on Bournemouth's East Cliff, is one such important example. Founded by Sir Merton Russell-Cotes (1835–1921) and Lady Annie Russell-Cotes (1835–1920) at the turn

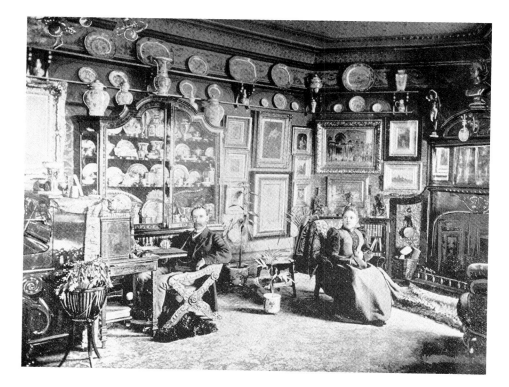

Fig.1 'One of Our Sitting Rooms'. Merton and Annie Russell-Cotes at the Royal Bath Hotel, Bournemouth, *c*.1880.

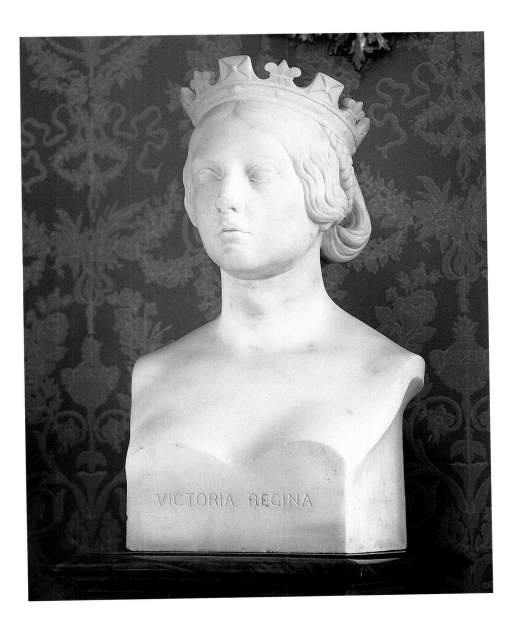

Cat.1 John Gibson (1791–1866)
Queen Victoria, c.1848–50
Marble, height: 57 cm (22½ in)
Inscribed lower right side: *I. Gibson Roma*
and *Victoria Regina* (lower front)

John Gibson began his career when he was apprenticed to a firm of cabinet-makers in Liverpool at the age of fourteen. A year later he met the sculptor F.A. Legé (1779–1837), who was then working for Messrs Franceys, the Liverpool statuaries. Legé had made a head of *Bacchus* which Gibson proceeded to copy, and he also carved a small marble head of *Mercury*. His work was so impressive that Franceys offered to pay his employer to cancel his contract and, after considerable difficulty, it was arranged that Gibson should become their apprentice. In 1816 Gibson had work accepted by the Royal Academy and in the following year went to London, which resulted in a number of commissions. On 20 October 1817 he arrived in Rome where he was received by Antonio Canova (1757–1822), who gave him instruction in his own studio and at the Academy of St Luke; he was also instructed by Bertel Thorvaldsen (c.1770–1844) who was living in Rome at the time. Gibson was now on the road to success and was urged by his friends to return to London, where they felt he would make more money. This he steadfastly refused to do, declaring 'I thank God for every morning that opens my eyes in Rome.'

It was not until 1844 that he at last revisited England and received a royal commission for a statue of the Queen, which Albert, the Prince Consort, wished to be 'like a Greek statue'. This particular bust was probably executed as a result of this commission.

In 1850 Gibson returned to England again in order to model another statue of the Queen, this time for the Houses of Parliament, and took five years to complete the work. It was during this period that he began the celebrated statue known as *The Tinted Venus*. Gibson's Neoclassical style is exemplified in that work which he described as 'the most carefully laboured work I ever executed … I tinted the flesh like warm ivory scarcely red, the eyes blue, the hair blonde, and the net which contains the hair golden.' The sculptor returned to Rome in 1847 where he died in 1866.

of the century (Fig.1), within its late Victorian confines it houses an important collection that in its breadth is reflective of the diversity of art created in Britain between 1837 and 1901. 'Mr Lance Hannen (the principal of the firm of Christie, Manson and Woods)', Sir Merton wrote, 'told me that it was the most complete representative collection of British Art that they had had through their hands.'[1]

The building of East Cliff Hall was begun in 1898 to provide a new home for the Russell-Coteses and to accommodate their collection. A three-gallery extension built between 1916 and 1919 allowed further expansion and large-scale acquisitions of art including Edwin Long's enormous *Anno Domini* (1883). The building was given to the people of Bournemouth in 1908, complete with its contents, becoming fully open to the public in 1922 after the deaths of its founders. Successive curators made subsequent additions to the art collection, although the Russell-Cotes family collected the majority of the works. Their son, Herbert, later added to the collection with works such as Evelyn De Morgan's *Aurora Triumphans* (1886). In many ways the Russell-Cotes has been sealed in time and stands as one of the very last important Victorian buildings to be constructed.

It is the intention of this book to examine some themes most pertinent to Victorian art through the Russell-Cotes collection, in a series of short essays by leading scholars in the field. They serve to give a context to the collection and introduce the complexity of opinion and approach that persisting generalisations choose to ignore. It is not a comprehensive exploration of the subject but it is important in bringing many aspects together in one volume. Introductory books on Victorian art, on the whole, have sought to cover the extensive ground of the period through general surveys of key movements and forms of art: Neoclassicism, Pre-Raphaelitism, genre painting, social realism and aestheticism. This book intends to deal rather with the subject-matter, forms and practices crucial to our understanding of art in the period.

It opens with an introductory essay by Dr Mary Cowling, which outlines the broad scope of Victorian art, from history painting to depictions of scenes of modern life, through its representations within the Russell-Cotes collections. My essay on the exhibition and display of art in the Victorian era outlines the options available to artists and collectors. The hotly debated subject of the naked female form is discussed in Alison Smith's essay with reference to the paintings of nudes for private and public viewing collected by Sir Merton Russell-Cotes. The position of women in the Victorian art world and their extensive presence in the Russell-Cotes collection is explored by Pamela Gerrish Nunn. Matthew Craske introduces the Victorians' complex attitudes towards nature in his essay on the depiction of animals in art. The pivotal role of the printed image and the importance of distributing art to a wide audience is considered in my essay on images in black and white. Benedict Read highlights important Victorian sculpture in the Russell-Cotes collection, an area that is so often unjustly neglected.

This book also seeks to bring to light new examples from amongst the wealth of depictions produced in this era; many images are illustrated here for the first time. By exploring one specific collection in detail, the art can also be discussed with reference to a characteristic figure, the quintessential Victorian collector. Many such collections were formed, although most were dispersed or watered down with other collections and newer acquisitions. The Russell-Cotes collection in this respect has remained remarkably pure.

NOTES
1. Sir Merton Russell-Cotes, *Home and Abroad* (2 volumes), privately published, Bournemouth, 1921, p.688.

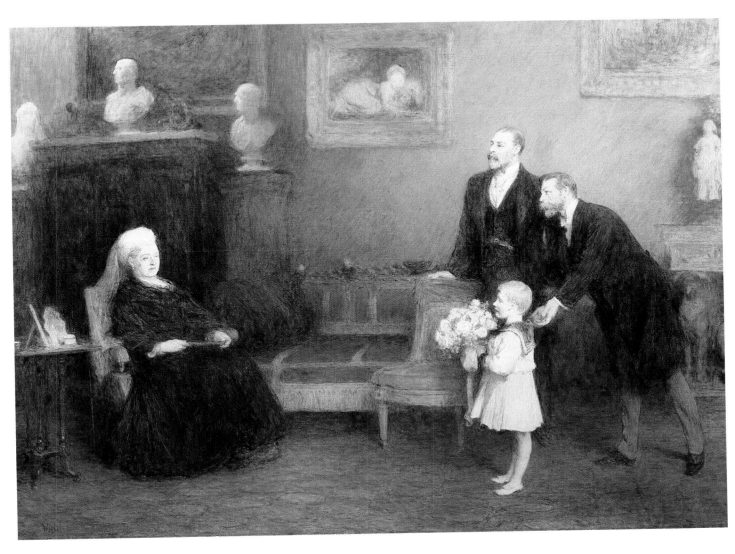

Cat.2 Sir William Quiller Orchardson RA (1832–1910)
The Four Generations, (Queen Victoria, Edward VII, George V and Edward VIII) 1899
Oil on canvas, 76.2 x 104.2 cm (30 x 41 in)
Signed and dated lower left: *W.Q.O.*

William Quiller Orchardson was one of the leading British genre painters in the Victorian period. Born in Edinburgh in 1832 his success as an artist began when he moved to London thirty years later, initially painting historical scenes, often after Shakespeare and Sir Walter Scott. It was for his genre scenes of upper-class life and its dramas, however, that his reputation was most widely established. His style was not typical of the period, opting for a limited palette of yellows, ochres and browns. 'The general effect,' wrote the French critic Ernest Chesneau, 'is splendid in colouring, and as harmonious as the wrong side of an old tapestry.'[1]

This painting, which uses Orchardson's distinctive hues, was commissioned by the Royal Agricultural Society of England under the direction of Sir Walter Gilbey. The original canvas produced for the Society measures 156 by 108 inches and was hung in its council chamber at 16 Bedford Square, London. The secretary of the Society wrote to Richard Quick, curator of the Russell-Cotes Art Gallery and Museum in 1925 explaining the existence of this version. 'Later on the Artist sought permission, and obtained it, to reproduce the picture, as it was thought that many Members of the Council of this Society might care to have a copy of it.'[2] This version is one of those smaller copies made by Orchardson. The secretary also noted that, 'When Sir W.Q. Orchardson was commissioned to paint this picture, it was thought that it might be nice to add the portrait of the little Prince Edward of York, now H.R.H. the Prince of Wales, thus typifying Four Generations of the Royal Family, three of whom have been Presidents of this Society.'[3] As a depiction of Queen Victoria and her heirs it was the archetypal image for a collection of Victorian art.

1. Ernest Chesneau, *The English School of Painting*, London, 1887 (third edition), p.282.
2. Secretary of the Royal Agricultural Society of England, letter to Richard Quick, 14 January 1925, Russell-Cotes Art Gallery and Museum archive.
3. *Ibid.*

ART IN THE AGE
of QUEEN VICTORIA

MARY COWLING

'The object of art is not to gratify the taste of tinkers and cobblers', but to create 'works which humanize those who contemplate them' and at the same time 'glorify the land of their production'.[1] Voiced with that uncompromising frankness which is the delight of Victorian art criticism, such statements clearly reveal the value that the Victorians attached to art in its highest form, and their fervent belief in the importance of its role in both public and personal life.

The art in question, history painting, or 'high art' as it was commonly known, occupied the summit of a recognised hierarchy of subjects. The category embraced not only history in the specific meaning of the word but all subjects of universal significance – scriptural, mythological and literary – the expression of which required an appropriately lofty style. It was the final challenge for all artists worthy of the name and many rose to meet it successfully. This was not, however, the opinion of posterity, and for much of the twentieth century the attempts of Victorian artists to fulfil art's most exalted function were regarded as falling laughably short of the ideal.

This is not to suggest that the reputations of those who embraced lesser genres or who evolved new modes of expression survived better, however sincere their intentions. In 1927 Clive Bell confidently dismissed Pre-Raphaelitism as an episode of 'utter insignificance in the history of European culture';[2] and on its centenary exhibition in 1948, Wyndham Lewis could find no more apt analogy for its brightly coloured and – to him – trivial subjects than 'a bonnet-shop', the products of 'a rebellious, picturesque, but shallow interlude in Victorian philistinism.'[3]

The Victorian age was the greatest period in British history: the age in which was consolidated all that the country had achieved politically, economically and socially over the previous three centuries. But despite this, no other era has attracted such fierce criticism, not least for its art and design. By the eighteenth century, the British had already earned a reputation for practicality and pragmatism, even in their intellectual life; and in the Victorian age itself, the preoccupation with materialistic progress and wealth creation confirmed this perception. It was a leading Victorian spokesman, Matthew Arnold (1822–88), poet and man of letters, who popularised the notion of the *nouveaux riches* as 'philistines' – a label which has stuck;[4] but, ironically, it was the same class – the new industrialists and commercial men – who fuelled an unparalleled boom in art, eager to display their affluence by establishing collections in imitation of the aristocracy, the main patrons in previous centuries. Their taste, however, was for contemporary art. Sir Merton Russell-Cotes was a representative figure in that he 'was always in favour of the modern British School of Art, and never appreciated the work of the Old Masters'.[5] It was a choice much derided in the succeeding century. The growing ascendancy of modernist values

Cat.3 Solomon Alexander Hart RA (1806–81)
*The Submission of the Emperor Barbarossa to Pope Alexander the Third, c.*1867
Oil on canvas, 221 x 177.8 cm (87 x 70 in)

The painting was exhibited at the Royal Academy with the following description in the catalogue:

> ... On Sunday the 24th July, 1177, the Pope repaired from the place of St. Mark and solemnly absolved the Emperor and his partisans from the excommunication pronounced against him. The Doges, the patriarch, his bishops, clergy and the people of Venice, with their crosses and their standards, marched in solemn procession to the church of St. Mark, where, in the vestibule of the Basilica, Frederick, laying aside his imperial dignity, and having prostrated himself at the feet of the Pope and having received his benediction, the Pope led him by the right hand into the church, etc.

The background of the picture represents the actual scene in which the ceremony took place.

Solomon Hart was born in Plymouth in 1806, the son of a Jewish goldsmith. On 15 August 1823 he became a student of the Royal Academy and so began an important association that lasted his entire career. He was elected an Associate of the Royal Academy in 1835 and a full Academician in 1840. He became Professor of Painting at the Academy in 1854 until 1863, and remained there as Librarian until his death in 1881. His important role within the Academy is a reflection of the regard that his art commanded; as primarily a history painter, his work was deemed of the highest status. He also painted official portraits and views of Italian churches. His reputation and works have not been so well known in the twentieth century, often due to their enormous scale. This painting was exhibited at the 1867 Royal Academy summer exhibition, where it was less than flatteringly commented upon by the *Art Journal*:

> S. A. HART, R.A., exhibits a historic picture which it is impossible to pass by, whether for its size, its colour, or its subject ... Mr. Hart has certainly not done the things by halves ... Surely the poor Emperor, judging from the picture before us, will never get on his legs again, unless some of the attendants drag him up by the tails, of which they already have a firm hold. Specially to be observed is the tragic turn of Barbarossa's eye, which seems to have been made, like a certain gun, to fire round the corner. As to Art merits, the colour is indeed gay, but we scarcely think good: the execution has care, but certainly not delicacy. Regarded as a piece of decoration, the picture is not bad; the mosaics of St. Mark's make an ornate background.[1]

1. *Art Journal*, 1867, p.139.

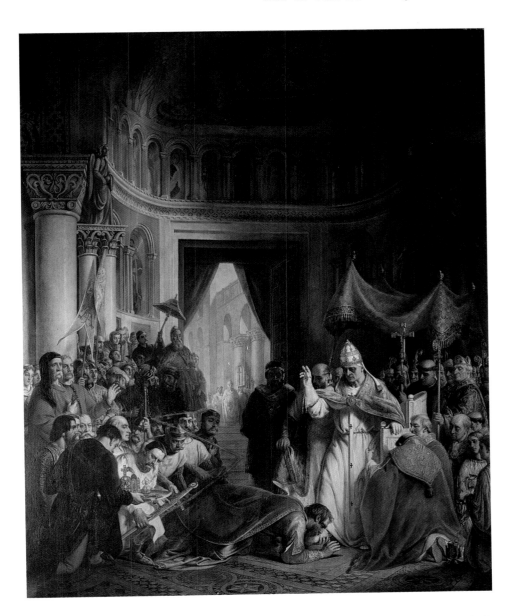

ensured that for the first sixty years and more, opinions of Victorian art were at their lowest, and the bulk of the work which made up the collections of patrons such as Lord Leverhulme, Sir Henry Tate and Sir Merton Russell-Cotes were perceived merely as evidence of the age's philistinism rather than as antidotes to it.

In the early years of the young Queen's reign, the Victorians themselves were by no means complacent about the state of contemporary art. World leader in all else, Britain had doubts on only this score. In the words of the *Art-Union*, founded in 1839 only two years after Victoria's accession: 'EMINENCE in the FINE ARTS is now the one thing wanting to crown the cumulus of England's glory.'[6] Artists blamed the absence of state patronage for the failure to establish a thriving school of history painting, as opposed to more enlightened countries like France and Germany where this was the norm. But the situation was to change dramatically. In 1834 the old Palace of Westminster was destroyed by fire and an elaborate scheme of decoration in the form of mural painting and sculpture was planned for the new building. The series of competitions that followed some ten years later cruelly

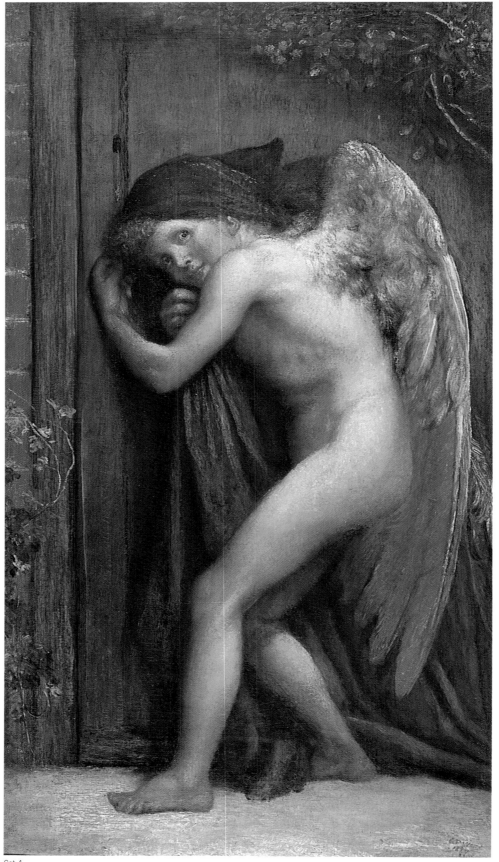

Cat.4

Cat.4 George Frederick Watts OM RA HRCA (1817–1904)
***The Habit Does not Make the Monk*, 1888–9**
Oil on canvas, 111.8 x 62.3 cm (44 x 24½ in)
Signed and dated lower right: *G.F. Watts, 1889*

Watts is a very important figure within Victorian art although his reputation suffered somewhat in the twentieth century. He wrote that he painted ideas and not things: in his own lifetime his symbolic and allegorical works were often viewed with suspicion and his reputation was only really established during the 1880s after he had been painting for a number of years.

This painting of Cupid thinly disguised as a monk is an allegorical depiction of how deceitful appearance can be, how love can be concealed and the troublesome effects that it can have. It was painted, according to the artist's wife and biographer, Mary Watts, in her handwritten catalogue, 'during the winter and spring of 1888–9 at Brighton where Mr. Watts had found a suitable studio at 31 Sussex Square'.[1] Later in her biography she emphasised its allegorical nature: 'It was in Brighton that he completed the little Cupid under the Monk's cowl, and named it "The Habit does not make the Monk." I remember a pretty young girl in that studio asking Signor vaguely as she gazed at the picture, "At whose door is he knocking?" and his quick retort, "Oh, at yours, perhaps."'[2]

It was first exhibited at the Royal Academy exhibition of 1889 and made a marked impact upon Anna Lea Merritt's *Love Locked Out*, which shows a similarly symbolic figure outside a door. The critical reaction was varied, Blackburn's *Academy Notes* calling it one of the gems of the exhibition,[3] while the *Observer* critic wrote that 'Mr. Watts ... is far from doing himself justice in "Cupid" as a monk knocking at a lady's door.'[4] The art critic M.H. Spielmann outlined the subject of the painting in his descriptive review for his *Magazine of Art*: 'A chubby laughing, rosy Love, ill-concealed in the monk's habit which he gathers around him with childish awkwardness, taps gently at a door, and as he waits his face assumes a mischievous expression that forebodes ill to the lady within should she chance to respond to his roguish summons.'[5]

1. M.S. Watts, handwritten catalogue, p.69. The Watts Gallery, Guildford.
2. M.S. Watts, *George Frederic Watts, The Annals of an Artist's Life* (3 volumes), London, 1912, vol.2, p.141.
3. Henry Blackburn (ed.), *Academy Notes*, 1889, p.xii.
4. *Observer*, 5 May 1889.
5. M.H. Spielmann, *Magazine of Art*, 1889, p.230.

exposed the inadequate training from which most British artists suffered at this time. In 1843 the *Art-Union* admitted the high merit of much of the work on show, but deplored the inclusion of mediocre examples.[7] The 'unmitigated trash' and '*rubbish*' displayed in 1844 was, in the opinion of one critic, a national disgrace, 'the worst Exhibition of cartoons and frescos that was ever got together ... in the history of the world.'[8]

In the event, the frescoes painted for the new Palace of Westminster by such artists as William Dyce (1806–64) and Daniel Maclise (1806–70) remain as a lasting credit to Victorian idealism at its highest, and the project set a valuable precedent. For the rest of the century and beyond, painting and sculpture were to remain important adjuncts to the many civic architectural projects which followed. But outside such schemes there was little outlet for history painting and it was to remain peripheral to Britain's major artistic achievements, at least until the rise of a new classical school in the 1860s. In the intervening period, the majority of painters opted for more marketable work or, as in the case of John Ruskin's protégés, the Pre-Raphaelites, for new and alternative means of exploring serious moral issues.

The story of aspiring history painters of the older generation is often one of tragic failure. The rejection of his designs for the Westminster competition contributed to the dramatic suicide of Benjamin Robert Haydon (1768–1846). Others whose undeviating principles cost them dearly in material terms were William Hilton (1786–1839) and John Cross (1819–61), both of whom, like Haydon, were upheld as victims of British philistinism. As one critic admitted, regretfully, in reviewing the latter's work, 'artists, to be successful ... must paint to please the public'.[9]

Solomon Hart (1806–81) was more fortunate. Appointed an Associate of the Royal Academy in 1835, Royal Academician in 1840 and Professor of Painting in 1854, Hart could afford to persist with large historical canvases, making the most of his privileges as an Academician to hang his pictures advantageously at the summer exhibitions, a practice which, in the case of *The Submission of the Emperor Barbarossa to Pope Alexander the Third* (1867; Cat.3) incurred the wrath of the *Illustrated London News*. The response of the *Art Journal* was also unflattering, but Hart's picture earned more favourable mentions elsewhere. The *Athenaeum* thought its position well deserved, admiring its composition, colour and the authenticity with which Hart had recreated the Venice of 1177.[10]

Hart was passionately stirred by the events he painted. In a lecture of 1856 he advised the Royal Academy's students that 'it is only by fancying ourselves parties to, or witnesses of the scene, and feeling the emotions we desire to express ... that we can obtain any right to expect others to be affected by our productions.'[11] But whatever his intentions, historical works of this kind are difficult to appreciate today. They lack the aesthetic appeal which distinguishes the work of the younger generation of classical revivalists like Frederic Leighton (1830–96) and Lawrence Alma-Tadema (1836–1912); and the vivacity and robustness of William Etty (1787–1849), whose reputation has survived much better than Hart's, perhaps because he effectively dispensed with history altogether. Although nominally mythological, Etty's subjects are usually pretexts for painting female nudes which owe more to Rubens and the Venetians than the Greeks. Ironically, it is Etty's very failure to classicise his exuberant responses that has redeemed his work in the eyes of a later generation.

In the work of Etty's followers, Edward William Frost (1810–77) and Frederick

R. Pickersgill (1820–1900), the classical tradition declined into what William Michael Rossetti roundly called 'mere foppery and premature senility'.[12] Frost's *The Sea-Cave* (*c.*1851) is an attractive example of the nymph and fairy subjects, inspired by the poetry of Edmund Spenser and John Milton, which both artists favoured. Frost's early successes included medals won at the Academy Schools and at the Westminster competition of 1843, as well as the patronage of Queen Victoria. In 1849 the *Art Journal* singled him out as 'one of the most distinguished of our rising school of painters'.[13] But 1849 was also the year in which the Pre-Raphaelites began their revolutionary assault on the academic conventions of the day, conventions which Frost's work epitomised: subjects remote from reality – and a technique which included the kind of slick flesh painting which William Holman Hunt (1827–1910) and Dante Gabriel Rossetti (1828–82) rudely likened to 'melted wax' and 'scented soap'.[14] In 1862 W.M. Rossetti asserted that Frost's style had now reached a stage of 'deserved disrepute', and five years later the *Illustrated London News* critic admitted that it was impossible to find anything new to say about 'Mr Frost's nymphs and fairies'.[15]

By this date, Pre-Raphaelite realism was not the only threat, for a new classical school was in the ascendant. Visits made in the late 1850s and early 1860s had convinced the French critic, Hippolyte Taine, that 'Great and noble classical painting' had 'never taken root' in England;[16] but change was imminent. Critics were soon rejoicing that 'Levelling democracy in art … [had] done its worst' and that 'academic dignity and decorum … cultivated taste and poetic thought' were re-emerging at the Royal Academy.[17]

All the artists associated with this movement either trained or studied on the Continent in a conscious effort to escape both the insularity of the Royal Academy and the inadequacy of its technical training. In London itself in the early 1860s, younger artists like Leighton, Albert Moore (1841–93), J.A.M. Whistler (1834–1903) and Edward Burne-Jones (1833–98) began to take advantage of the magnificent collections of Greek sculptures at the British Museum, the 'Elgin Marbles' in particular. Records show that in the following decade the number of students drawing there rose from 2981 in 1870 to 15,626 in 1879, making galleries previously neglected almost impassable.[18]

A booming economy played its part in the classical revival. In the 1860s increasing affluence created a healthy art market and a radical revision of both style and content was to transform ancient history painting into a new and attractive genre that would appeal to rich potentates. Where Haydon and Hilton had struggled to make a living, artists of a later generation were to make comfortable fortunes. Critics monitored this development with interest. In 1867, one of them commented on the gulf between the old academic school – which 'has latterly fallen into discredit amongst us' – and the new, placing Hart, Pickersgill and Frost among the former; and two years later, another approved the fact that artists as diverse as Leighton, Moore, George Frederick Watts (1817–1904) and Simeon Solomon (1840–1905) were finding new and ingenious ways of making 'the cold severity of the antique acceptable to modern tastes'.[19]

Watts, the oldest member of this group, was always generous in encouraging his younger colleagues but his work remained quite distinct from theirs. Watts embraced the highest moral and aesthetic ideals, in emulation of the artists of ancient Greece and the Renaissance, and in 1849 was described by Ruskin as 'the

Cat.5 Anonymous, after Albert Joseph Moore ARWS (1841–93)
***Blossoms*, 1881 (Tate Britain Collection)**
Oil on canvas, 146.7 x 46.4 cm (57¾ x 18¼ in)

Albert Moore was a leading figure of the Aesthetic movement and a great favourite of Sir Merton and Lady Annie Russell-Cotes. They owned at various times several works by the artist, although the only original oil now in the collection is *Midsummer* (1887). 'My profound admiration for my late dear friend's pictures,' Russell-Cotes wrote, 'was only exceeded by that for himself.' Indeed he devotes twelve pages of his autobiography to Moore and calls him, as he was apt to do with artists and people of distinction, a 'great friend'.[1]

It is no surprise to find that a copy of *Blossoms* (1881) was commissioned by Sir Merton so it could be hung in East Cliff Hall. The collector wrote:

Albert Moore's principal works in the possession of the most important art collectors in the world number upwards of one hundred and fifty, exclusive of innumerable sketches and studies, which of course were not of public importance. He was a wonderful portrayer of beautiful women. His models were mostly Yorkshire girls, two or three in particular, all of the same type, tall, well formed, with charming oval faces, beautiful hair and blue eyes – perfect types of English womanhood.[2]

1. Sir Merton Russell-Cotes, *Home and Abroad* (2 volumes), privately published, Bournemouth, 1921, pp.711–20.
2. Ibid., pp.719–20.

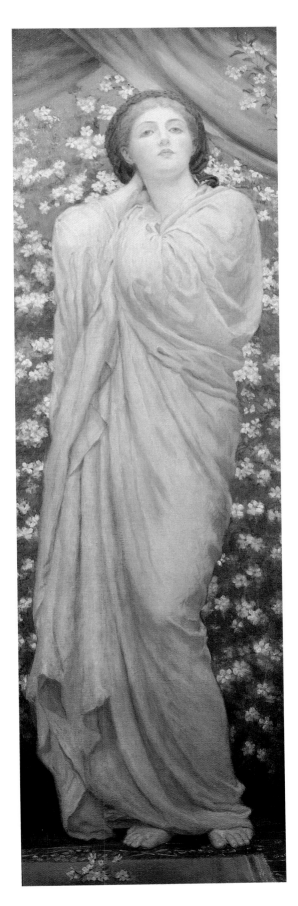

only real painter of history or thought we have in England'.[20] His private circumstances were fortunate. Freed from the pressures of the market through the support of friends and patrons, he was able to maintain his artistic integrity intact, and to concentrate, in his own words, on the creation of symbolic works that were 'frankly didactic … The object … to suggest … modern thought in things ethical and spiritual.'[21]

It proved, however, no easy task to evolve new forms of expression appropriate to the nineteenth century, and Watts's grand ideas are not always successfully realised. *The Habit Does not Make the Monk* (1889; Cat.4) – intended as a warning about the dangers of love – which shows Cupid peeping archly out at the viewer from under his hood, is a case in point. It is nothing like so subtle in conception as another painting inspired by it, Henrietta Rae's *Love Locked Out* (1890, Tate Britain), a copy of which is in the collection. But whatever his occasional failings, Watts stands alone: a great original, and a touching and admirable figure in his unshakeable sincerity and idealism.

Equally high-minded and generous was Frederic Leighton, President of the Royal Academy, whose impressive public career was to be rewarded with a knighthood, a baronetcy and, in the year of his death, elevation to the peerage. Leighton shared with Watts a fierce dedication to the cause of high art and through a long series of ambitious mythological subjects, exhibited almost annually, he established himself as its leading representative in Britain.

Leighton's *Captive Andromeda* (1891) provides an informative contrast with a version of the same subject produced in 1875–6 by Arthur Hill (*fl.*1858–93), a minor contributor to the classical revival school about whom little is known. Although the picture was favourably received initially, the superficiality of Hill's interpretation of the subject seems patent now. His curvaceous model strikes a winsome studio pose, all drama and convincing emotion sacrificed in favour of the grace and beauty of her figure; while Leighton's small sketch, with its harsh brushwork and dark leaden colours, shares all the monumental and heroic qualities of the large version – his major exhibit at the Royal Academy Summer Exhibition of 1891 (Walker Art Gallery, Liverpool).

The majority of classical revivalists, in varying degrees, opted for an aesthetic rather than a dramatic interpretation of the ancient world. There was a natural affinity between classicism and aestheticism, both of which originated in a reaction against the realism of the 1850s and its narrative tendencies in favour of 'poetic imagery and mood … sensuousness of form and colour and the idea of beauty for its own sake'.[22] The affinity is eminently clear in the case of Albert Moore and in many of Leighton's later works, some of which appeared to one critic to be 'decorations only … beautiful adjuncts to the furniture of a room'[23] rather than subjects in the traditional sense. It is, however, Moore's work which comes closest to fulfilling the dictum of the leading aesthetic philosopher Walter Pater that 'In its primary aspect, a great picture has no more definite message for us than an accidental play of sunlight and shadow … on the wall or floor: is itself, in truth, a space of such fallen light, caught as the colours are in an Eastern carpet, but refined upon, and dealt with more subtly and exquisitely than by nature itself.'[24]

Reclusive, unworldly, working in a studio infested with spiders and cats,[25] Moore devoted himself to what W.M. Rossetti called his 'Hellenic Aestheticisms'. The titles of his paintings – as in *Blossoms* (1881; Cat.5), a copy of the Tate version – almost always allude to some accessory detail, in order to make clear that abstract beauty is

his real aim. In *Midsummer* (1887), an image of the most sophisticated artificiality, there is no sign of nature. The lack of movement further emphasises the purely decorative intention of the artist while the silver throne, mother-of-pearl cabinet, carved wooden panels, Japanese vases, fans and tiles are further evidence of his taste for surface enrichment. It exemplifies his unchanging principle: the seeking of formal and colour harmonies of the greatest purity and serenity, undisturbed by any hint of narrative.

Even the detailed recreations of the ancient world by Alma-Tadema and Edward Poynter (1836–1919) became increasingly aesthetic in emphasis. There is a marked progression from their solidly historical subjects of the 1860s – such as Poynter's *Israel in Egypt* (1868, Guildhall Art Gallery) and Alma-Tadema's *Phidias and the Parthenon* (1868, Birmingham City Art Gallery) – to the sensuous delights of their later years. To a lesser extent, the career of Edwin Long (1829–91) also mirrors this development. *The Moorish Proselytes of Archbishop Ximenes, Granada* (Cat.6) was one of the last of the Spanish subjects which had occupied Long since 1857, and was exhibited at the Royal Academy in 1873. In the same year he began his first classical genre picture, and a tour of Egypt and Syria in 1874–5 confirmed his move towards reconstructions of ancient historical and biblical subjects. Merton Russell-Cotes numbered sixteen works by Long in his collection, of which *The Chosen Five* (1885; Cat.27) – showing the ancient Greek artist, Zeuxis, in process of creating his ideal Helen of Troy from the combined features of five models – is one of the most attractive. Long shared with other painters of the Holy Land, such as David Roberts (1796–1864), Holman Hunt (1827–1910) and Thomas Seddon (1821–56), a strong religious faith and from 1883 his business association with Fairless and Beeforth, who owned two Bond Street galleries, was to enable him to devote much of his time to biblical subjects. The fact that *Anno Domini* (1883; Cat.23) was successfully exhibited for thirteen years in Bond Street, is a sign of the continuing demand for such subjects and for affordable prints made from them.[26]

Although still largely neglected by historians, numerous artists worked in this vein, including Thomas Matthews Rooke (1842–1942) who was employed for many years as studio assistant to Burne-Jones and recorded some illuminating conversations with him.[27] Rooke produced a number of biblical subjects in series form, three of which are now in Tate Britain. In *King Ahab's Coveting* (1879) – far removed in scale from Long's ambitious work – the magnificent architectural frame combines with the images to create an object that is beautiful and decorative in itself. Rooke's brushwork is of a delicacy worthy of water-colour and meticulous attention is paid to accessory details of costume, furniture and architecture. The subject is one of destructive passion and evil intent which ends with the gory deaths of both Ahab and Jezebel (the latter thrown to the dogs); but it is handled tastefully and with no hint of sensationalism.

The same cannot be said for the *Jezebel* (1896; Cat.33) of John Byam Shaw (1872–1919) although it is equally successful in its own way. Gaudily dressed, Jezebel sits on a gilded throne, gazing with undisguised admiration into a silver mirror shaped like a cobra, her flagrant sensuality enhanced by exotic accessories such as the overblown lilies, sinister black cat and peacock. Whatever its debt to the Pre-Raphaelites – and Shaw was one of a younger generation much influenced by them – there is nothing remaining of the moral idealism one associates with the movement. Shaw's treatment of the subject is highly realistic, especially in his depic-

Cat.6 Edwin Longsden Long RA (1829–91)
The Moorish Proselytes of Archbishop Ximenes, Granada, 1500, 1873
Oil on canvas, 188 x 274.3 cm (74 x 108 in)
Signed and dated lower left, on a chair: *Edwin Long, 1873*

Edwin Long, another of Sir Merton Russell-Cotes's favourite artists, painted this work in 1873. It marks a period of Spanish history painting that preceded his grand depictions of the ancient world, for which he is most renowned. This scene depicts the aftermath of the Spanish capture of Granada in 1500 when the Muslim inhabitants were forced to convert to Christianity or leave. Archbishop Ximenes appears at the left-hand side of the picture and the group undergoing conversion to the right. The artist used William Prescott's history of Ferdinand and Isabella as the main historical source of the picture: 'The greater part made their peace by embracing Christianity; many others sold their estates and migrated to Barbary, and the remainder of the population, whether from fear of punishment or contagion of example, abjured their ancient superstition, and consented to receive baptism.'[1]

1. William H. Prescott, *History of the Reign of Ferdinand and Isabella the Catholic*, London, 1857.

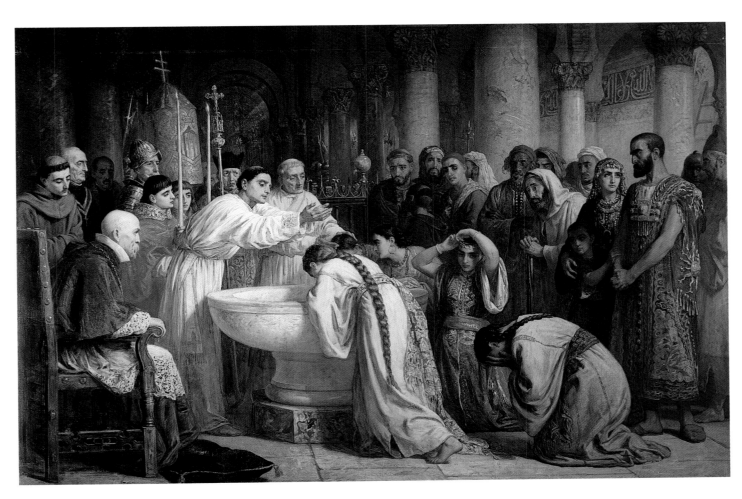

tion of Jezebel's corrupt features which are those of a contemporary woman. In her original nude form (the clothes were added later) the sensuality of Shaw's image would have been even more blatant.

There is an unashamed element of theatricality about Shaw's *Jezebel*, a feature also evident in Edward Matthew Hale's *Psyche at the Throne of Venus* (1883; Cat.32). Hale (1852–1924) was among a number of classicists who made no pretence to the earnest historicism of Poynter, the high-minded idealism of Leighton, or the refined aestheticism of Moore. Undeniably commercial and glamorous in its appeal, *Psyche* embodies a proto-Hollywood vision of the mythological world. In 1873–5 Hale trained in Paris under Alexandre Cabanel (1823–89) and Charles Carolus-Duran (1837–1919), and his technical proficiency is much in evidence. In its polished finish the painting recalls Alma-Tadema, but the voluptuousness of Venus's near-naked legs, the shapely, tensed muscles of which are clearly outlined, and the assertive, triumphant expression of her facial features distinguish it from Tadema's prim re-creations of the ancient world.

These last two examples depend considerably on accessory details in the creation of attractive vignettes of ancient history and myth. An opposite but equally typical development of the period involves dispensing with detail and elaborate composition in favour of the reduction of a significant episode to a single figure, usually female. Leighton's *Electra* (1868–9), *Clytemnestra* (1874) and *The Last Watch of Hero* (1887) – in which overt heroics give way to an emphasis on individual psychology –

exemplify the type, which is also illustrated to great effect in *Judith* (1895; Cat.7) by Charles Landelle (1812–1908). Landelle trained under the great French academicians Paul Delaroche (1797–1856) and Ary Scheffer (1795–1858), and the benefits are patent in this striking portrayal of the biblical heroine as a beautiful but threatening figure, the epitome of physical strength and moral resolution. It is one of numerous examples produced at this time depicting powerful biblical and mythical female figures, and in general conception recalls both *Clytemnestra* (1882, Guildhall) by John Collier (1850–1934) and *Circe Invidiosa* (1892, Art Gallery of South Australia) by John William Waterhouse (1849–1917).

Quite distinct from these resonant figures are those which, despite their historical or exotic settings, have no narrative reference but function rather as decorative motifs. Unpretentious as they are, they form a significant body of work and are usually of a high technical standard. *Grecian Girl* (n.d.) by Edward Radford (1831–1920), despite its accessories, is typical in its detachment from any sense of historical reality. Much of the work of John William Godward (1861–1922) and Charles Perugini (1839–1918), who was a protégé of Leighton, is of this kind. Godward's portrayal of an *Italian Girl* (1902) might just as easily be labelled Roman or Grecian, for it is largely a vehicle for illustrating the artist's phenomenal technique in the representation of marble, hair and soft flesh, staple elements of the hermetic, sensuous world which was his unique creation.

Oriental types figure largely in this category, one of their attractions for Europeans being that the culture appeared to have remained virtually unchanged since ancient times so that, in a sense, the modern and ancient worlds were conflated. Numerous examples by Edwin Long include *Alethe* (1888), with its decorative Egyptian accessories, and *Then to her Listening Ear …* (1881), which is in the more sensuous odalisque tradition. Arthur Hill's *Egyptian Water-Carrier*, showing a young Arab girl draped in a transparent black veil, is an example of how artists might exploit the timelessness of exotic cultures for erotic purposes. It makes an interesting contrast with Henriette Browne's *Moorish Girl* (1875), an objective study of a contemporary ethnic type in authentic – and concealing – costume.

The number of extensive excavations of ancient sites, beginning with Pompei and Herculaneum in the eighteenth century, had steadily escalated in the nineteenth century to encompass Egypt, Assyria and Asia Minor. In London, the mounting collections of antiquities in the British Museum awakened widespread interest in ancient life and culture and the extension of facilities for travel also brought the ancient world closer. Thomas Cook began to organise tours to Egypt and the Holy Land in 1869, for the land of the Bible maintained its fascination over the Victorians despite the mounting threats to orthodox belief. As one critic observed, 'In every mind there are vivid and deep associations with the Holy Land. History and sacredness are in its every rood … and the artist would deserve well … who should present us with sure information upon its historical scenes and its actual condition.'[28]

One artist who recognised the potential of such scenes was Frederick Goodall (1822–1904). From his first visit in 1858–9 Goodall was enchanted with Egypt, 'so full of Biblical and historical associations', as he enthuses in his *Reminiscences*.[29] *The Subsidence of the Nile Flood* (Cat.54)– a copy of his much praised 1873 Royal Academy exhibit – is an archetypal example of Goodall's work, with its pyramids bathed in silvery sunlight, tall, gracefully tufted date palms, herds of native sheep and cattle, and the white stone houses and walls and graceful costume of the Arab

Cat.7 Charles Landelle (1812–1908)
Judith, 1895
Oil on canvas, 142.3 x 101.6 cm (56 x 40 in)
Signed and dated: *Ch. Landelle*

'Then she came to the pillar of the bed, which was at Holofernes' head … And approached to his bed, and took hold of the hair of his head, and said, Strengthen me, O Lord God of Israel, this day. And she smote him twice upon his neck with all her might, and she took away his head from him.'[1] Judith was a rich Israelite woman who saved the town of Bethulia from Nebuchadnezzar's army by beheading the Babylonian general Holofernes while he slept. She was often chosen to be depicted because of her strength and beauty. Here she is shown with the sword in her right hand and the canopy of the bed in her left, looking defiantly out of the painting and about to decapitate the general. The *Art Journal* noted that:

> 'Judith' by Charles Landelle, is one of the most striking pictures in the collection of the Mayor of Bournemouth. Academically correct in drawing, it is painted with great force; and had it been a little freer in brush treatment it might have been a picture of the supreme class. As it is, the classic training of the painter has prevented him letting himself go, with the result that the picture leaves one a little cold notwithstanding its powerful colouring.[2]

Charles Landelle was born in Laval, France, in 1812 and studied under Paul Delaroche and Ary Scheffer. He was one of the few nineteenth-century European artists collected by Russell-Cotes, and painted sacred subjects in an academic manner, carrying out many decorative schemes in Parisian churches such as Saint-Sulpice and Saint-Nicholas-des-Champs and some work at the Louvre. He travelled extensively in the Middle East where he researched his biblical works as well as painting the people and scenes he encountered. His painting of *An Armenian Woman* can be found in the Wallace Collection, London. He was made a Chevalier de la Légion d'honneur.

1. Books of the Apocrypha, Judith, Chapter XIII, verses 6–8.
2. *Art Journal*, 1895, p.281.

world. Goodall's interpretations of Egypt fill a niche between the evocative work of the great pioneer, David Roberts, and that of Holman Hunt and Thomas Seddon, who brought an unflinching Pre-Raphaelite eye to the often harsh desert scene. Goodall's formula, picturesque but convincing, strikes a happy compromise between romance and authenticity and was understandably successful.

It was a feature of the nineteenth century that a large proportion of painters of ancient history and mythology should abandon traditional heroics in favour of more accessible formulae; and in pictures depicting more recent historical periods, the identification with ordinary human experience could be even more closely approximated. Through crystallising the great events of the past into anecdote, historical genre painting enjoyed the same kind of appeal that had turned the novels of Walter Scott and his many imitators into best-sellers, and found its parallel in the work of professional historians who admitted to a new and growing interest in 'the human side of history'.[30]

The proliferation and popularity of historical, literary and contemporary genre painting at this time is understandable, for the new, burgeoning market had its own requirements that were not fulfilled by more traditional forms of painting. The 1832 Reform Bill had acknowledged the *nouveaux riches* who had profited from industry and commerce as a rising power in the land, socially and politically. Keen to indulge in luxury items like art, they were independent enough to have confidence in their own tastes and affluent enough to indulge them.[31] They preferred modern art to the old masters and subjects that were approachable and comprehensible rather than intellectually challenging or provocative.

The founding of 'The Clique' by William Powell Frith (1819–1909), Augustus Egg (1816–63), Henry O'Neil (1817–80), John Phillip (1817–67) and Richard Dadd (1817–87), in 1837 – the year of Queen Victoria's accession – in favour of subjects more suited to contemporary taste was an important development, the first collective statement asserting the irrelevance of the values of the Royal Academy to the real state of art and the market.[32] The Clique artists made their reputations in the 1840s, initially as painters of historical and literary genre, and in the following decade earned lasting fame with their scenes of contemporary life.

Readily adapting to the demands of a changing market, historical genre maintained its popularity to the end of the century. Some artists, such as E.M. Ward (1816–79) and his wife, Henrietta (1832–1924) devoted themselves almost exclusively to it; while Alfred Elmore (1815–81), J.C. Horsley (1817–1903), Ford Madox Brown (1821–93), John Everett Millais (1829–96), John Pettie (1839–93), W.Q. Orchardson (1832–1910) and Marcus Stone (1840–1921) were among the many painters who regularly worked in this vein. The very titles of their paintings clearly distinguish the nature and function of historical genre from its more lofty counterparts: for example, Egg's *Queen Elizabeth Discovers that she is No Longer Young* (1848), Frith's *Coming of Age in the Olden Time* (1849), E.M. Ward's *Parting of Marie Antoinette and Her Son* (1856) and *Toothache in the Middle-Ages* (1856) by Henry Stacy Marks (1829–98).

The Awakening: Studying Galileo (Cat.8) by Reginald Arnold (*fl*.1881–96) exactly illustrates the intimate and sentimental approach of historical genre in its portrayal of a young priest whose mind is thrown into turmoil by Galileo's *Dialogue*, written in support of the Copernican thesis that the Earth moves round the Sun. Despite the differences in subject and style, Herbert A. Bone's *How the Danes came up the*

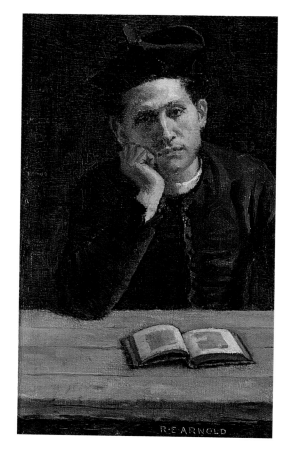

Cat.8 Reginald Edward Arnold RBA (*fl*.1881–96)
The Awakening: Studying Galileo
Oil on canvas, 16 x 9.5 cm (6¼ x 3¾ in)
Signed lower left: *R.E. Arnold*

Reginald Arnold was a genre painter who also produced decorative work. The themes of his paintings were often theatrical or operatic and his scenes of history were also infused with a sense of lavish costume and drama. In the early 1880s he painted Spanish scenes, from observation as well as using operatic sources. The artist lived most of his life in London but moved later to Byfleet in Surrey. This painting by Arnold represents a young priest undergoing the revelation of reading Galileo, whose teachings rocked the Church on their publication. Condemned as heretical, the *Dialogue* led to the author's imprisonment by the Inquisition in 1633.

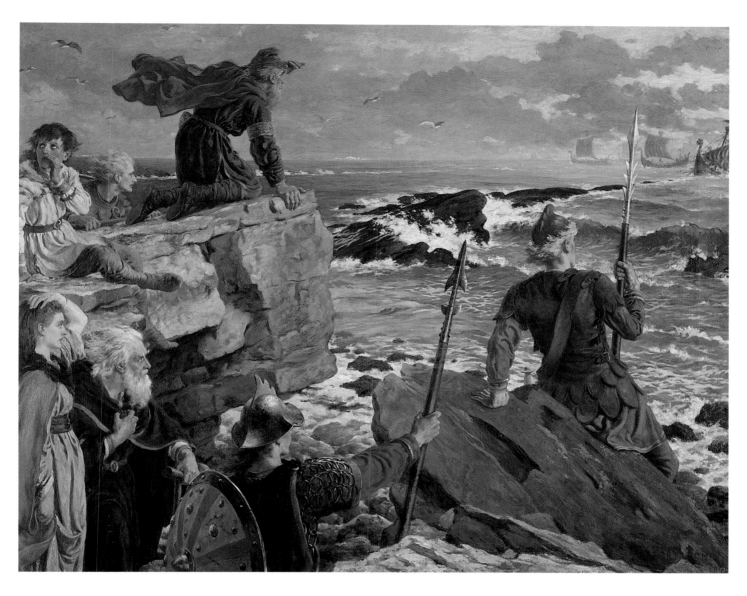

Cat.9 Herbert A. Bone (1853–1931)
***How the Danes Came up the Channel a Thousand
Years Ago. Off Peveril Ridge, Swanage, AD 877, 1890***
Oil on canvas, 101.6 x 127 cm (40 x 50 in)
Signed and dated lower right: *Herbert Bone pxt. 1890*

Herbert Bone was born at Camberwell in 1853
and educated at Dulwich College. His art master
at Dulwich, John Charles Lewis Sparkes (*fl.*1850s,
d.1907), an artist and director of the Lambeth
Pottery, later taught Bone at the Lambeth Art
School. Bone was successful in reaching the Royal
Academy Schools and trained under John Everett
Millais and Frederic Leighton. On winning the
Royal Academy's Armitage prize, he was
recommended by Millais to design scenes from the
life of King Arthur for tapestries for the Duke of
Albany (Albert and Queen Victoria's youngest son).

He had studied for a short time at the Academie
des Beaux-Arts at Antwerp where he became very
familiar with tapestry techniques. The Russell-
Cotes Art Gallery and Museum has two examples of
his tapestry designs in its collection as well as a
pencil portrait study for King Arthur. He was also a
prolific illustrator, a member of the Art Workers'
Guild and the Arts and Crafts Exhibition Society.

His interest in the Dark Ages was typical of the
Arts and Crafts movement and demonstrates the
clear influence of William Morris. *How the Danes
Came up the Channel a Thousand Years Ago* is
based upon an account given in the *Anglo-Saxon
Chronicles* of a naval battle of 877 between Alfred
the Great and the Danish fleet of King Guthrum.[1]
According to the twelfth-century chronicle, the
fleet of 120 ships sank off 'Swanich'. The painting
is an imaginative Victorian reconstruction of the

event: its interpretation of many aspects of the
early account is uncertain and the costumes and
weaponry are an elaborate fiction, although it was
important to the artist that they have some basis in
fact. In a letter to Richard Quick, Bone's daughter
Margaret pointed out that the painting
'(depicting the threatened invasion at Swanage
failed by the wrecking of the Danish fleet off
Peveril Ledge), [was] being painted while living
near Professor York Powell who was making a great
study of Early English history.'[2]

1. Dennis Smale, 'The Battle for Swanage', *Dorset Life*,
no.240, March 1999, p.27.
2. Margaret Bone, letter to Richard Quick, 1931.
Russell-Cotes Art Gallery and Museum archive.

Channel a Thousand Years Ago (1890; Cat.9) operates in much the same way. Although the subject was suggested by the *Anglo-Saxon Chronicle*, Bone (1853–1931) was less concerned with learned detail than with creating a lively evocation of the arrival of the Vikings as experienced by a handful of native Saxons living on the Dorset coast in AD 677. The figures are imaginary, ordinary people of their time: young and old, male and female, people with whom the viewer would find it easy to empathise. Artists like Bone showed how history could be revivified and made attractive and inviting to a wide audience.

Both of these paintings take a true historical event as their focus and bring it to life with the aid of imagined but plausible characters. In other cases, both figures and events are imaginary, and the past is used mainly as a source of picturesque types and accessories. Henry Stacy Marks's medieval and eighteenth-century scenes are of this kind: humorous evocations of an Old England inhabited by jolly jesters, modest maidens, and quaintly comic antiquarians and ornithologists absorbed in their erudite studies.

Marks belonged to a successful group of genre painters known as the St John's Wood Clique, which also included George Dunlop Leslie (1835–1921), P.H. Calderon (1833–98) and W.J.F. Yeames (1835–1918), author of one of the most renowned of all historical genre pictures, *'And When Did You Last See Your Father?'* (1878, Walker Art Gallery, Liverpool). That the beggars in *Hark, hark! the dogs do bark ...* (1865; Cat.10) constitute no real threat to respectable society is evident to the young mother who brings her babies outside to see the shabby tribe as they pass through the village. Their behaviour is orderly and one of them even politely doffs his cap to the viewer. While conceding that they looked happier than was credible in a situation such as theirs, the *Athenaeum* commended the painting for providing 'all the character and funny points' that Marks's admirers had come to expect of him.[33]

Marks's associate George Dunlop Leslie opted for feminine beauty as the focus for his own historical scenes. His father, Charles Robert, who with David Wilkie (1785–1841) and William Mulready (1786–1863) was one of the founding fathers of Victorian genre, had early recognised that his son's ability to 'paint a pretty face' would guarantee him a living.[34] That refined taste which enabled him to render 'the sweet naivetee and innocence of pure maidenhood with rare delicacy'[35] is abundantly clear in his *Portrait of a Girl* (n.d.). Attractively composed and firmly drawn, it is typical in its restrained but carefully discriminated colour scheme of subdued yellow and dark greyish blues, set off by the mellow red-brick wall.

Leslie's eighteenth-century settings provided an escape from the prosaic ugliness of the present; but although fanciful, his work was not regarded as trivial. Wilfrid Meynell defined its specific function as supplying what was perhaps the most pressing need of the age, 'the need for sweetness and cheerfulness of heart', and felt that 'The painter ... who, towards the end of a melancholy century, gives us ... images of free and serene happiness, has understood his art and his time.'[36]

Period elegance was exploited by many leading genre painters as disparate as W.Q. Orchardson and Walter Dendy Sadler (1854–1923), and was widely propagated through illustrators like H.M. (1875–1960) and Charles Brock (1870–1938), Randolph Caldecott (1846–86) and Hugh Thompson (1860–1920). Leaders of what was appropriately called the 'Georgian' or 'Cranford School' (the latter name deriving from Mrs Gaskell's evocative sketches of genteel eighteenth-century village life), they epitomised the continuing nostalgia for an imaginary notion of Old

England. The air of modesty and old-fashioned reticence which attaches to such scenes is very much a part of their charm, and renders acceptable subjects like *The Beggar* (1886; Cat.11) by Henry Glindoni (1852–1913). The beggar seems to be a respectable man who has fallen on hard times but this does not recommend him to the elderly gentleman whose evident indignation (shared by the beribboned pug-dog) contrasts with the more sympathetic expression on the face of the daughter.

It was the same kind of appeal that drew artists to Spain and Italy in search of picturesque settings. Still unscarred by the Industrial Revolution, countries like these retained their ancient architecture and traditional way of life. J.F. Lewis (1805–76), John Bagnold Burgess (1830–99) and Edwin Long visited Spain over many years, and Venice provided the venue for a number of successful genre painters including Henry Woods and Luke Fildes (1843–1927). Two scenes by Dome Skuteczky (1850–1921) and Burgess illustrate the scope provided by Venetian and Spanish character and costume. *The New Model* (1883) shows an awkward peasant girl brought to the studio for the first time by her elderly gondolier father, much to the amusement of the artist's more sophisticated female companions; while Burgess contrasts the situations of two young girls, recipients, respectively, of *Good and Bad News* (1876). In true genre fashion, both pictures invite the viewer to empathise with what is happening through various details and clues as to the characters and their feelings.

In the opinion of those who continued to uphold the aims of high art, historical genre was vulgar and trivial enough; but of all the developments of the period, the one that perhaps aroused the greatest contention was the painting of contemporary life which, for some critics, epitomised a general decline in artistic standards, but one which would always find a ready market, especially among the new middle-class patrons who bought for pleasure rather than for any more serious purpose. In the words of one critic: 'Scenes of quiet felicity are more agreeable to the mass of mankind than high-wrought tragedies or stately histories ... in our modern society, the intellect is under stress and strain ... and thus persons in the severe conflict of life turn to literature and art for repose and relaxation.'[37]

Inevitably, there was some danger where buyer's tastes were so often uneducated. W.M. Thackeray had never ceased to argue on behalf of modern subjects and modern feeling, as opposed to 'wolf-sucking Romuluses; Hectors and Andromaches in a complication of parting embraces, and so forth'.[38] But he was aware of the blatant commercialism already rampant in 1844, comparing the exploitation of patrons by artists and 'dextrous speculators who know their market' to the way in which 'savages are supplied with glass beads' and 'children ... accommodated with toys and trash'.[39] The same point was regularly reiterated in the decades that followed. In 1862 the journalist and playwright Tom Taylor complained that new buyers and dealers were colluding to force gifted young painters to produce trivial but saleable subjects, and that these were rapidly becoming 'the staple of English art'.[40]

There was, however, a recognised distinction between the sincere treatment of everyday subjects and mere pandering to the market. In responding to contemporary life, many painters exercised considerable thought and ingenuity, with the result that some of the greatest and most ambitious of all Victorian paintings fall into this category.

Seventeenth-century Dutch painters provided the ultimate models, a fact directly acknowledged by Laura Alma-Tadema (1852–1909) in *Always Welcome* (1887), a

modest domestic scene in which she pays tribute to the period, its costumes and furnishings. British genre had become firmly established in the eighteenth century, embracing both the raffish urban subjects of William Hogarth (1697–1764) and the more traditional rural scenes of George Morland (1763–1804) and W.R. Bigg (1755–1828), whose *The Sailor Boy's Return from a Prosperous Voyage* (RA 1792; Cat.12) is the earliest genre picture in the Russell-Cotes collection. The rural genre tradition had been thoroughly updated by David Wilkie, some of whose work (such as *Distraining for Rent*, 1815) qualifies as social commentary – a tendency which found more direct expression in the work of Richard Redgrave (1804–88) and G.F. Watts during the 'hungry forties'. But in the 1850s, realism in both form and content was to advance significantly. The Pre-Raphaelites played an important part in this development. Although always critical of them, W.P. Frith and other members of the Clique were considerably influenced by the hard-edged style, vivid colour and minute detail evident in their exhibits from 1849 onwards. In the first Pre-Raphaelite modern-life subject, Holman Hunt's *Hireling Shepherd* (1852), realism and earnest moralising reached unprecedented levels and, while not aspiring to the same degree of high seriousness, many artists began to follow the Pre-Raphaelites in developing that 'wonderfully keen eye, the born journalist-novelist eye for details of human behaviour',[41] which has ensured the historical value of genre painting for future generations.

Some commentators were aware of the intrinsic value of contemporary genre. Frith predicted that 'pictures of contemporary life and manners have a better chance of immortality than ninety-nine out of every hundred of the ideal and so-called poetical pictures produced in this generation.'[42] W.M. Rossetti and Frederick Wedmore were amongst the critics who agreed that re-creations of the past would never equal in interest the record of the Victorian present that genre painters were in the process of constructing.[43]

Despite his faith in its long-term value, Frith was aware that he took a calculated risk in painting *Ramsgate Sands* (1854; Cat.17). Its realism was too much for one artist who described it as 'a piece of vulgar Cockney business unworthy of being represented even in an illustrated paper'; and there were others who made similar comments.[44] But at the Royal Academy, public enthusiasm voted it the picture of the year. Its purchase by Queen Victoria set the seal on Frith's success and encouraged him to embark on the much larger and more heterogeneous crowds of *Derby Day* (1858) and the *Railway Station* (1862). As documents of Victorian social life Frith's panoramas remain the most important and comprehensive of the period.

Another important copy which Russell-Cotes purchased was Edwin Landseer's *Flood in the Highlands* (1864), the original of which is now in the Aberdeen Art Gallery (c.1845–60; see Cat.51). Landseer (1802–73) was best known for his animal painting – a category represented in the Russell-Cotes collection by Briton Riviere (1840–1920; Cat.57), Arthur Elsley (1861–1952) and other leading practitioners. In this example, Landseer brings animals and people together in a scene inspired by the disastrous Moray floods of 1829; his choice exemplifies the kind of challenging subjects which artists were increasingly prepared to tackle.

Despite the diversification of genre and the increasing readiness of artists to confront serious issues, traditional subjects retained their popularity; subjects which centred on personal and domestic rather than social relations and less on the difference between social classes than on the universal feelings and experiences which

Cat.10 Henry Stacy Marks RA RWS HRCA HRPE (1829–98)
Hark, hark! the dogs do bark,
The beggars are coming to town, 1865
Oil on canvas, 95.2 x 144.8 cm (37½ x 57 in)
Signed and dated: *H.S. Marks 1865*

Henry Stacy Marks was born in London in 1829. His father was proprietor of the family coach-building business, Marks & Co., at Langham Place, London. At the age of eighteen, he went to Leigh's School of Art where his contemporaries included Edwin Long and P.H. Calderon. He also studied at the Royal Academy Schools while continuing as a student at Leigh's. In 1852 he travelled to France with Calderon and studied under François Edouard Picot (1788–1868) at his Paris studio and the Ecole des Beaux-Arts. Such varied study was a reflection of his eagerness to learn and his early career encompassed a variety of work including decoration and illustration.

He was drawn to comic Shakespearean subjects and historical genre scenes imbued with gentle satire and wit. His works combine a brilliant and well-observed painterly technique with drama and a quaint humour that retains a certain dignity. In particular he was fascinated by medieval subjects. His career was transformed in 1861 when he exhibited his painting *The Franciscan Sculptor* (1860). Depicting a monk sculpting a gargoyle from a human model it elicited great praise for its humour and characterisation.

The Russell-Cotes collection has two oil paintings by Marks, which represent two phases in his career: his early work of historical genre, subjects he continued to paint throughout his life; and his animal paintings, which combined a fascinating characterisation with patient and detailed observations. The subject of this painting is typical of Marks's work in the 1860s. Based upon a children's nursery rhyme it explores human character and a colourful depiction of medieval life, albeit in a fairy-tale way. There is great attention to detail, such as the cathedral being constructed in the background. The *Art Journal* noted of the work:

> The pictures by the latter artist [Marks] are year by year growing more serious, yet the vein of comedy which formerly sparked in his works still ever and anon rises to the surface.
> *'Hark, hark! the dogs do bark,*
> *The beggars are coming to town'*
> (331), is the nursery rhyme upon which Mr. MARKS doth now dilate. In dolorous train is marshalled a troop of mendicants according to their several species. The lame beggar, the blind beggar, the sanctimonious beggar with long whining yarn, and the beggar who is the venerable patriarch of the tribe – here they all are, and 'the dogs do bark' a greeting.[1]

1. *Art Journal*, 1865, p.169.

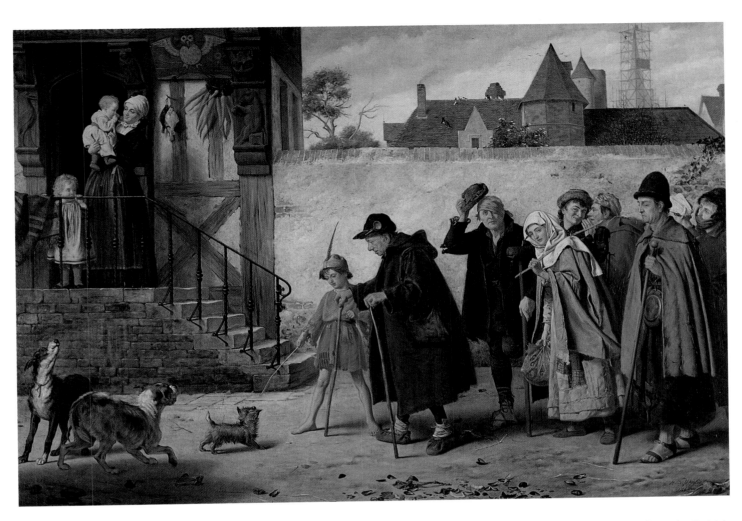

unite all humanity. With the Queen and her consort as model exemplars, the British prided themselves on their domesticity, on the elevation of hearth and home as the centre of life, to a degree unequalled by any other country. Art reflected this development. Critics took pride in the fact that 'England, happy in her homes … and peaceful in her snug firesides', should be 'equally fortunate in a school of Art sacred to the hallowed relations of domestic life'. As the *Art Journal* noted, to such an extent was this true, that it was almost a national development.[45]

Nothing survived of the coarseness that often tainted the work of the Dutch seventeenth-century genre painters and of William Hogarth. David Wilkie had perfected the formula for representing respectable rustic life, and his gentle sentiment and good taste were universally adopted by his Victorian successors. *Home from Work* (c.1870–1; Cat.18) by Arthur Hughes (1832–1915) is a charming example of the category. Dusk is beginning to fall as the labourer and his young son return from the fields. An elder daughter and a baby await them in the garden; and to the rear, a well-kempt thatched cottage suggests an orderly household, a welcome retreat from the cares of the world. The intense feeling, rich glowing colours and precisely observed details – such as the lichen on the tree-trunk and the cowslips in the foreground – are reminders of Hughes's Pre-Raphaelite roots.

In more esoteric vein is Hughes's *The Heavenly Stair* (c.1887–8; Cat.19). Broadly speaking, Hughes's development parallels that of Pre-Raphaelitism as a whole, from

earnest realism to its more imaginative and poetic phase, although Hughes evolved his own highly idiosyncratic category of mystical and romantic subjects. Although the theme of *The Heavenly Stair* is in a sense domestic, it is typical of much of Hughes's later work in being allegorical; in this case, a representation of the arrival of a baby inspired by a passage from Wordsworth's 'Ode on Intimations of Immortality'. The angels in their pretty muslin robes – clearly recalling the maidens in Burne-Jones's *Golden Stair* (1880, Tate Britain) – rejoice in the ever-recurring miracle of birth.

Jolly Strollers (1888; Cat.13) depicted by J. Ellis Wilkinson (*fl.*1874–90) may not share the financial stability of Hughes's families but their mutual affection and contentment are patent as they settle down for the night in a barn. With a glass of beer beside him, the father, clad in white tights and spangles, watches fondly as his

Cat.11 Henry Gillard Glindoni RBA ARWS (1852–1913)
The Beggar, 1886
Oil on panel, 48.3 x 68 cm (19 x 26¾ in)
Signed and dated: *H. G. Glindoni*

Henry Gillard Glindoni was a London painter who studied at the Working Men's College and Castle Street School of Art. Like many other artists who did not have independent means he worked for photographers and printmakers, touching-up, colouring and painting designs. He did, however, succeed in surviving as an artist and became known for elaborate and detailed costume genre scenes set mainly in the eighteenth century.

The Victorian period saw a renewed enthusiasm for the works of William Hogarth whose strong narratives and moral tales appealed to the age of visual story-telling and rigid morality. Glindoni was fascinated by the artist whose influence can be found in *The Beggar*, which adopts Hogarth's caricatures, in particular his self-portrait in which he compares himself to his pet pug. In this painting the dogs reflect the characters of their owners: the beggar's dog is sly-looking with its tail between its legs; the pug apes the pompous face of its owner.

daughter plays with a Mr Punch doll to the amusement of a younger boy who lies wrapped up in his blanket on the floor beside her. The substantial modelling and the use of the square-brush technique in Wilkinson's work are evidence of the French practices whose influence was widely felt in Britain in the last quarter of the century (Fig.2). Few embraced the tenets of French Realism and Impressionism wholeheartedly, but numerous British painters followed the French in forming rural colonies and practising *plein-air* painting. Wilkinson regularly worked at St Ives, Cornwall, which became a popular centre for artists at about the same time as Newlyn, the most famous colony of all, where Walter Langley (1852–1922) and Stanhope Forbes (1857–1947) took up residence in 1882 and 1884 respectively.

The same sophisticated touch and evidence of outdoor observation is found in the work of Edward John Gregory (1850–1909), that 'audacious and ... brilliantly endowed ... chronicler of the prosaic world'.[46] Like his contemporary, William Logsdail (1859–1944) – best known for his unglamorised London street scenes – Gregory's approach was eminently visual and direct, his interest focusing on 'The

Cat.12 William Redmore Bigg RA (1755–1828)
The Sailor Boy's Return from a Prosperous Voyage,
1792
Oil on canvas, 43.2 x 53.3 cm (17 x 21 in)

William Redmore Bigg was born in 1755.
He studied at the Royal Academy, entering as a
student on 31 December 1778. He exhibited
regularly at the Academy from 1780 until 1827,
showing mainly rustic genre subjects centred
around village life. He was elected an Associate
of the Royal Academy on 3 December 1787 and
a full Academician on 10 February 1814.

Several of his paintings were made into
prints, including this one, which was paired with
another painting by Bigg of 1790 entitled
*A Shipwreck'd Sailor Boy Telling his Story at a
Cottage Door*. This was published as a mezzotint

in May 1791, and the present image was
published by T. Gaugain, 15 Five Fields Row,
Chelsea on 26 April 1792 with the title in
English and French (*Le retour du Jeune Matelot
apres un heureux Voyage*). The next and smaller
version, also published by Gaugain, then of
4 Little Compton Street, Soho, dates from March
1794. In a third version of the two prints engraved
by Daniel Orme and published byBoydell & Co.,
Cheapside, London verses have been appended:

The Sailor Boy's Return
'Twas at that Season when the fields resume
Their loveliest hues, array'd in Vernal bloom;
Yon Ship rich-freighted from the Italian shore,
To Thames' fair banks her costly tribute bore,
While thus my Mother saw her ample hoard,
From this Return, with recent treasures stor'd.

The Shipwreck'd Sailor Boy
While memory dictates, this sad shipwreck tell,
And what distress thy wretched friend befel;
Then, while in streams of soft compassion
 drown'd;
The swains lament, & maidens weep around;
While lisping children, touch'd with infant fear,
With wonder gaze, & drop th'unconscious tear.

outward aspect ... of the things and persons of the day' rather than 'their inner significance'.[47] He had no interest in the kind of 'problem pictures' devised by W.Q. Orchardson, John Collier, Frank Dicksee (1853–1928) and others at this time: pictures with a psychological emphasis that finds its correspondence in 'advanced' contemporary novels and the plays of Henrik Ibsen, which first took London by storm in 1889. Impervious to such developments, Gregory remained resolutely extrovert. He produced numerous sketches over many years in preparation for his masterpiece, *Boulter's Lock* (RA 1897; Cat.14), in which his phenomenally gifted eye enabled him to record with great precision the vigour, the flashiness and sheer actuality of late Victorian life. It is noteworthy that the *Saturday Review* saw the picture – whatever the technical differences – as 'radically conceived as a Frith';[48] and it was recognised as one which would serve, like Frith's before it, as a valuable record for posterity.

As in the case of the historical and exotic categories already discussed, a number of the genre paintings in the Russell-Cotes collection take the form of single figures; these are valuable both as character studies and as archetypal demonstrations of the degree of proficiency in technique which both foreign and British artists had attained by the latter part of the century. Portrayals of pretty young women in various guises are a significant element in Victorian art, but they are often redeemed from triviality by the sheer quality of the painting. G.D. Leslie's example, mentioned above, is a case in point, as are William Oliver's (*fl.*1867–82) *Billet-Doux* (Cat.16), showing a young woman clad in a fashionably draped pink-and-white dress, and *Her First Love* (1885; Cat.21) by George Knowles (1863–1931). Although

Cat.13 R. Ellis Wilkinson (*fl.*1874–90)
***Jolly Strollers*, 1888**
Oil on canvas, 100.4 x 158.8 cm (39½ x 62½ in)
Signed and dated: *Ellis Wilkinson 1888*

This painting, which was exhibited at the Royal Academy in 1888, was produced whilst the artist was living at St Ives, near the Newlyn School of artists, an important colony of *plein-air* painters.

Fig.2 R. Ellis Wilkinson's *Jolly Strollers* in his barn studio, 1888. Russell-Cotes Art Gallery and Museum archive.

This photograph shows the painting being worked upon. It depicts the models in costumes within the barn by the window with the canvas on the easel to the right of the scene.

the object of love is a handsome grey-and-white rabbit, there is nothing overtly sentimental about the painting, which is a skilful study of a characterful young girl wearing an artistic embroidered shawl and wide-brimmed straw hat. In *Venetian Water-Carrier* (1890) by Eugène de Blaas (1843–1931), every substance – from the girl's soft glowing skin to the lace trim of her under-dress, and the earthenware jar and copper bucket – is carefully distinguished. *The Piggies' Feeding Time* (1887) by Emile Bayard (1837–91) is of a more humorous type, in which the farm-girl – herself quite plump and porcine – lolls against a gate, laughing at twin piglets as they greedily guzzle their milk.

Pre-Raphaelite realism remained out of favour among more conservative critics and collectors, who regarded it as eccentric and even ugly in comparison to its later development. The Russell-Cotes Art Gallery and Museum contains no examples of the former, but the more poetic and imaginative phase – implicit in the work of Dante Gabriel Rossetti from the beginning – is represented by some major paintings. In a collection which contains so many tributes to female beauty, it is not surprising to find one of Rossetti's most seductive portraits, *Venus Verticordia* (1864–8). It is typical of the kind of soulful aestheticism which Rossetti evolved, its emotional content clearly distinguishing it from the more purely formal harmonies of Albert Moore and his friend, J.M. Whistler.

The most distinctive feature of Rossetti's art is his adoption of the female portrait as his main motif, and the symbolic and iconic significance with which he imbues it. Rossetti was a typical Victorian romantic, diminished in his aspirations and means of expression by the increasing scepticism and materialism of the age. For him, as for

Cat.14 Edward John Gregory RA RI (1850—1909)
Study for *Boulter's Lock, Sunday Afternoon, c.*1897
Oil on canvas on board, 68.5 x 45.7 cm (27 x 18 in)

This painting of Boulter's Lock, near Maidenhead on the Thames, is a study for the finished painting that was begun in 1882, first exhibited in 1897, and is now in the Lady Lever Gallery, Port Sunlight, Liverpool. Boating on the Thames was a very popular form of entertainment around the turn of the century; on Ascot Day in 1888 some 800 boats and seventy steam launches passed through the lock, built in 1830. In 1889, Jerome K. Jerome's famous book *Three Men in a Boat* was first published. Its detailed depiction of contemporary life and amusement on the Thames received praise from the *Art Journal*, which saw it as 'the kind of picture which foreign critics recognise as national; it is in fact a three volume novel in art, the guide book and encyclopaedia of the manners and customs of the English people'.[1]

Edward John Gregory was born in Southampton in 1850. Initially a draughtsman for the Peninsular and Oriental Steamship Company (P. & O.), he decided to become an artist, moving to London in 1869. He studied at the Royal College of Art and the Royal Academy Schools, worked on decorations for the Victoria and Albert Museum and produced drawings for *The Graphic* between 1871 and 1875, early in the life of the illustrated weekly. His painting of *Boulter's Lock* ensured his election as a Royal Academician on 19 January 1898.

Over seventy studies in pencil, chalk and watercolour for this painting are known. Five oil studies are known to exist, three of which are in the Lady Lever Gallery, and give a good indication of the time the artist spent observing the scene. This particular oil study owned by the Russell-Coteses shows the lock from the same position as the finished version but depicts a very different scene. The final version, which measures 215 by 142 centimetres, includes a wide variety of boats, canoes and punts, whereas the study focuses on a single canoe.

1. *Art Journal*, 1897, pp.179–80.

many poets and artists, in place of philosophical and metaphysical systems which were no longer sustainable the love relationship came to represent the paradigm of man's spiritual aspirations. Walter Pater acknowledged love as the goal to which 'More energetic souls' had turned in the nineteenth century as a means 'of making the best of a changed world. Art: the passions, above all, the ecstasy and sorrow of love' were what remained 'in a world of which it was no longer proposed to calculate the remoter issues'.[49]

The female face and figure were to form the crux of what was widely acknowledged as Rossetti's new 'Religion of Art' in which love and beauty are all-powerful. In *Venus Verticordia* (Cat.20) the statement is explicit: Venus is in ultimate control,

Cat.15 Sir Hubert von Herkomer RA (1849–1914)
Lorenz Herkomer, Siegfried and Elsa, 1887–8
Oil on canvas, 144.8 x 113 cm (57 x 44½ in)
Signed and dated lower left: *H H 87–8*

Hubert von Herkomer was born in Waal, Bavaria, but his family emigrated first to America and then to Britain where he spent most of his working life. He distinguished himself as a stylish portraitist and set up an important school of art at Bushey, Hertfordshire, even making films with the advent of early cinema. His lavish lifestyle was epitomised by the building of his studio home, Lululaund, a Gothic mansion of gigantic proportions hewn from imported Bavarian granite. He was an important figure within Victorian art, replacing John Ruskin as Slade Professor of Art at Oxford.

The subject of this painting is a portrait of his father, Lorenz Herkomer (1825–88), a Bavarian wood-carver, and Hubert's two eldest children by his first wife Anna (d.1884), Siegfried (1874–1939) and Elsa (1877–1938). The painting was set in the garden of Herkomer's home at Bushey. In 1877 his father and mother, Lorenz and Josephine, had resettled in Bavaria, but after his mother's death two years later, Lorenz moved back to Bushey. Several portraits by Herkomer of his father exist, yet in all the others Lorenz is shown at work with the tools of his trade, something of which Hubert was very proud. On his regular visits to Bavaria, he celebrated the folk life of the region through his paintings, drawings and prints.

Hubert von Herkomer visited Bournemouth in January 1914 when he was suffering from an illness that was to prove fatal. (He died on 31 March of the same year in Devon where he was taking a seaside cure.) Whilst visiting Bournemouth he had stayed at the Royal Bath Hotel and was invited to visit East Cliff Hall.[1] In Sir Merton Russell-Cotes's autobiography, *Home and Abroad*, he devotes two pages of illustrations to Herkomer, the first a photograph of the artist, the second illustrating two letters sent to Lady Annie Russell-Cotes.[1] It is interesting to note that Merton's anti-German feeling, at its height in 1914, did not preclude his meeting the artist; however, the illustration in *Home and Abroad* reads 'Sir Hubert vom Herkomer, R.A. The great Anglo-Dutch painter.'[2]

1. Sir Merton Russell-Cotes, *Home and Abroad* (2 volumes), privately published, Bournemouth, 1921, pp. opposite 731, 732.
2. *Ibid.*

about to release the dart that will spark the love of Paris for Helen and the consequent long and bloody war between Greece and Troy. She does not exult in her power although she knows she must wield it. In her wistful expression is revealed her awareness of its destructive effects; for Rossetti invariably points to the male–female relationship as one which is infinitely complex, fraught with emotional suffering, a source of pain as well as joy.

As formulated by Rossetti, woman was to become the great icon of the modern Symbolist movement. As both Madonna and Magdalene, saint and *femme fatale*, she was to resurface in varying forms in the work of numerous British artists and designers as diverse as Simeon Solomon (*The Annunciation*, 1892), Aubrey Beardsley (1872–98) and Charles Rennie Mackintosh (1868–1928), all of whom adapted the Rossetti type to their own ends. Younger artists like John Byam Liston Shaw and Eleanor Fortesque Brickdale (1872–1945) were of a generation much influenced by

the retrospective exhibitions of work by Rossetti in 1883, and by Millais and Holman Hunt in 1886. Both Shaw and Brickdale typify the craft-orientated Pre-Raphaelite tradition in training as illustrators and designers as well as artists. Brickdale's exquisite profile portrait has all the clean-cut linearism of a stained-glass panel, and in decorative detail as well as overall design recalls the early Italian painting mentioned in Robert Browning's poem 'A Face', which inspired it.

For many contemporaries, the soulful melancholy and introspection of Rossetti's women seemed to epitomise the human condition in a hostile modern world. As one clergyman concluded, Rossetti 'could not paint even his own sorrow, without painting, in some way, the sorrow of his race and age'.[50] This achievement is one with which his greatest pupil, Burne-Jones was also credited. Blessed with great technical and imaginative powers, he was able to celebrate and interpret the emotional life on a more heroic scale than Rossetti, often in the form of ancient myth, a practice which was to continue in the work of Spencer Stanhope (1829–1908) and his niece, Evelyn De Morgan (1855–1919).

In its review of the Grosvenor Gallery in 1878, the *Art Journal* named several artists including Stanhope and especially De Morgan as 'Thoughtful and gifted disciples' of the 'quasi-classic, semi-mystic school' led by Burne-Jones.[51] Stanhope initially trained under G.F. Watts but was soon drawn to Rossetti and later to Burne-Jones, whose symbolic and mythological subjects inspired his greatest works. In *Love Betrayed* blindfold Cupid, in the form of a slender, trusting young man, is about to fall through a broken bridge leading to his temptress's house, while she awaits his imminent fate with cruel complacency. The conglomeration of quaint grey-brown buildings and terraces, as well as the facial types and poses of the figures, recall Burne-Jones; and the overall linear delicacy, that potent influence on British symbolists, Sandro Botticelli.

Mythological painting, however aesthetic its treatment, fell rapidly out of favour in the early twentieth century. On the occasion of Burne-Jones's death in 1898, the French critic Robert de Sizeranne had insisted that his paintings were as relevant to the needs of contemporary society as anything in *The Graphic* or the *Illustrated London News*,[52] but by 1908 Arthur Symons was unable to see them as anything but meaningless imitations of the early Italians, and failed to detect in them any relevance in them to modern times.[53]

Evelyn De Morgan suffered an even worse eclipse than Burne-Jones, to the extent that for years *Aurora Triumphans* (1886; Cat.36) was passed off as one of his works. It is only recently that her own distinctive contribution to British Symbolism has been recognised and the complex meaning of her allegories unravelled. Like so many of her fellow artists, although not an orthodox Christian De Morgan had strong religious feelings of a more general kind. Through her art she symbolised her dedication to an ideal of spiritual and aesthetic progress in her own life and, by extension, that of the whole human race.

De Morgan reshaped mythology to the requirements of the modern world by drawing on Darwinian evolutionary theory and spiritualism, both of which served to express her belief in the eternal progress of the human soul. *Aurora Triumphans* is one of her more elaborate and successful compositions, rich in gold leaf and decorative surface detail. Three pink-winged angels herald the Dawn, represented by the bright garlanded nude to the right, while the dark-clad figure of Night flees the scene, defeated. The whole provides an allegory of a consistent theme in her work:

Cat.16 William Oliver (*fl*.1867–82)
***The Billet Doux*, 1882**
Oil on canvas, 80.7 x 59.7 cm (31¼ x 23½ in)
Signed and dated: *W. Oliver 1882*

William Oliver was a painter of charming genre scenes. These included titles such as *A Thing of Beauty is a Joy for Ever* and *The Billet Doux*.

'the movement of the soul from a state of spiritual blindness, towards a "dawn" of enlightenment'.[54]

As late as 1967, Quentin Bell could write that most Victorian art was still 'thought to be unworthy of examination … aesthetically and therefore historically negligible'. But as he also points out, it was the nineteenth century which 'invented the national and the municipal art gallery',[55] the majority of which were founded or substantially assisted by private donors. It is in these collections that so many of the great masterpieces of the era were to be preserved until, in the decade following Bell's statement, they began to reclaim the attention of critics and historians.

What gives the Russell-Cotes Art Gallery and Museum its special quality is that East Cliff Hall, begun in 1898, was not designed as an art gallery (although galleries were added in 1916–26) but as a private house, and that it retains the paintings, sculpture, furnishings and fittings installed by its original owners. It was gifted to the town in 1908, but the Russell-Coteses lived there until their deaths, Sir Merton, who died in 1921, surviving his wife by one year. The result is a veritable time-capsule, a lasting monument not only to late Victorian taste, but also to that passionate belief in art and its educative value which is such a distinguishing feature of the period. Also typical are the circumstances of this remarkable bequest, in that it was founded on the commercial success of an hotelier who, in his generosity to the public, followed the example of other great benefactors – self-made men like himself: Robert Vernon (horses and livery stables), who left his collection of British art to the nation in 1847 (now at Tate Britain); John Sheepshanks (Yorkshire wool), whose bequest went to the South Kensington Museum, now in the Victoria & Albert Museum, in 1857; Lord Leverhulme (soap) and Sir Henry Tate (sugar).

At East Cliff Hall, in true Victorian fashion, pictures of all categories – history, genre, portraits, landscape and animal subjects – hang frame-to-frame along the staircase and landings. Equally diverse selections adorn the richly decorated rooms with their stained glass, shelving and other fittings, painted and stencilled walls and ceilings and cabinets of ornaments, each element contributing to the rich profusion of this unique interior. A striking aspect of the collection is the prominent part played by sculpture; a reminder of the elevated position that it occupied in the Victorian hierarchy of art, and of its importance to a would-be connoisseur like Russell-Cotes, who would have regarded the status of his collection as substantially diminished without it.

In assembling his collection, Russell-Cotes displayed a conservative taste typical of his age and class. No modern movement is represented. He may have shared Frith's view that Impressionist paintings were little more than 'constant outrages on popular prejudice';[56] and his belief in the degeneracy implicit in Post-Impressionism is recorded in no uncertain terms in his autobiography. Despite this limitation, the Russell-Cotes collection shows a true art-lover's appreciation of a wide variety of subjects and techniques; and above all, that *sine qua non* of all great collections, an ability to discern quality, regardless of changing artistic fashions. It is noteworthy that in 1878 the *Art Journal* found the prosaic anecdotalism of Frith's art outdated in an age when artists and critics were laying claim to 'affinities' and inner souls, and aspirations after the ideal.[57] But to Russell-Cotes's credit, both of these developments are well represented in his collection. He saw no conflict in choosing from a diversity of artistic categories, so long as that choice was of the best; and through the exercise of his own independent judgement, he ensured that that was indeed the case.

The resulting display is a glorious celebration of much of what Victorian artists had achieved. Russell-Cotes's faith in that achievement remained unshakeable. Indeed, while despairing of the direction which modern art had taken, he seized every advantage which a falling market presented, acquiring at bargain prices works by once great artists who had become unfashionable.[58] In recent years, his faith has proved to have been more than justified, ensuring in perpetuity his own reputation and the eternal gratitude of subsequent generations.

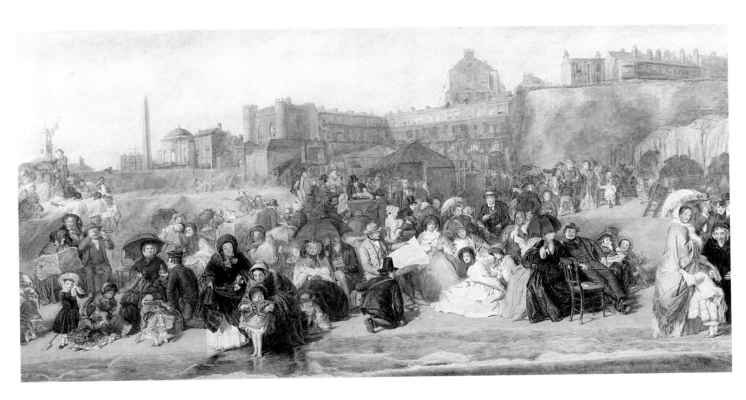

Cat.17 William Powell Frith RA (1819–1909)
Ramsgate Sands or 'Life at the Sea-Side', **1905**
(after his 1854 painting)
Oil on canvas, 76.2 x 155 cm (30 x 61 in)
Signed and dated lower left: *W. P. Frith 1905*

'My summer holiday of 1851,' wrote Frith, 'was spent at Ramsgate. Weary of costume-painting, I had determined to try my hand on modern life, with all its drawbacks of unpicturesque dress. The variety of character on Ramsgate Sands attracted me – all sorts and conditions of men and women were there.'[1] It took Frith several years to complete the final version of his grand panorama, which appeared in 1854. Between 1851 and 1854 Frith returned to Ramsgate to draw the surrounding buildings and people on the beach, photography at this time not being advanced enough to provide the detailed images that he required. Drawings of incidents and characters

that caught his attention were put together to create this fascinating and detailed portrayal of seaside life. The subject matter itself was considered by many to be unsuitable for an established artist and Frith recalled, 'One man, an artist, said it was "like Greenwich fair without the fun"; another, that it was "a piece of vulgar Cockney business unworthy of being represented even in an illustrated newspaper."'[2] It was also unusually difficult for the artist to find a private buyer for the work: 'After half a dozen rejections,' he wrote, 'I refused to listen to the advice of my friends to "avoid picture dealers", and the picture was bought at the price of a thousand guineas by Messrs. Lloyd.'[3] As a painting it is a fascinating and detailed record of leisure in the 1850s, as the *Art Journal* commented at the time: 'here it is, and year by year it will become more valuable as a memento of the habits and manners of the

English "at the sea-side", in the middle of the nineteenth century.'[4]

When it appeared at the Royal Academy summer exhibition of 1854, as *Life at the Sea-Side*, there was uncertainty about the reaction of critics. The picture was a great success, however, and at a private view Queen Victoria expressed an interest in buying the work. On being told it was already purchased by Lloyd, she bought the work from him for no gain on his part other than from the lucrative sales of prints from the work. The painting is presently in the Royal Collection. The popularity of the work caused Frith to paint a few copies of the original; this version was painted in 1905 and bought by Sir Merton Russell-Cotes.

1. William Powell Frith, *My Autobiography and Reminiscences*, London, 1887, vol.i, p.243.
2. *Ibid.*, p.246.
3. *Ibid.*, pp.252–3.
4. *Art Journal*, 1854, p.161.

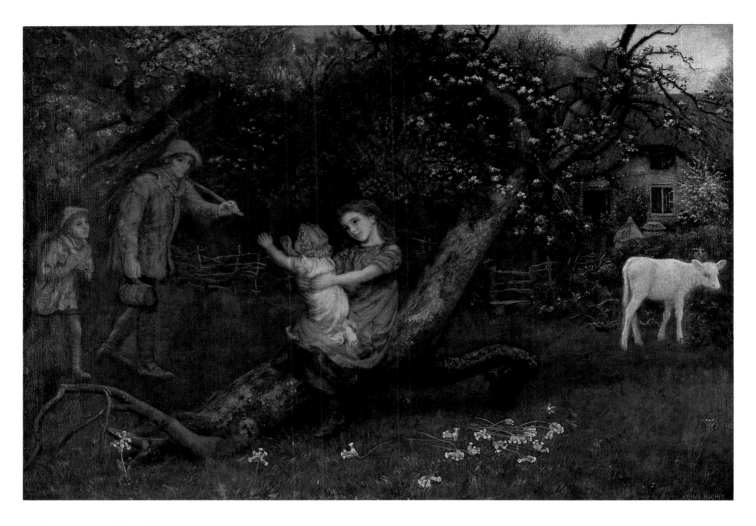

Cat.18 Arthur Hughes (1832–1915)
Home from Work, c.1870–1
(possibly retouched in 1873, reworked in 1913)
Oil on canvas, 76 x 109 cm (30 x 43 in)
Signed and dated lower right: *ARTHUR HUGHES, 1870–1*

Arthur Hughes was born in London in 1832.
In 1847 he entered the Royal Academy Schools
where he studied under Alfred Stevens (1817–75).
His interest in the Pre-Raphaelite Brotherhood
began in 1850 after reading their journal,
The Germ. Later that year he met Holman Hunt,
Rossetti and Madox Brown. In 1852 he exhibited
his first Pre-Raphaelite painting, *Ophelia*, at the
Royal Academy. Although receiving support from
his fellow artists his disposition was retiring and
he worked for much of his life in semi-obscurity.
This accounts for his neglected position within
the Pre-Raphaelite movement, to which he was an
important contributor with works such as *The Long
Engagement* (1853–5), *April Love* (1855–6) and
The Knight of the Sun (c.1859–60). His later

paintings are considered less important than his
early Pre-Raphaelite works although they retain
their richness of colour and characteristic subject
matter. Within his paintings of simple pleasures
and literary themes, Hughes displays a remarkable
fidelity to nature and the fictional characters stand
in convincing and highly detailed depictions of
landscape.

Home from Work, or *Evening* as it was called at
its first exhibition at the Royal Academy in 1871,
appeared with the following quotation from
Shakespeare's *Henry VIII*: 'So service shall with
steeled sinews toil,/and labour shall refresh itself
with hope.' In Glasgow in 1873 it was
accompanied by the following quote from the same
play: 'And Labour shall be satisfied with Hope.'
The painting depicts a father and son returning to
the family home. A study dating from 1870 shows
that the mother was also to be seen but was
painted out in the finished version at a later date.
The young girl was originally looking at her mother.
Hughes reworked the picture in 1913 and wrote:

'Among other work I have been renovating a very
old and forgotten one of the labourer and son
coming home where his daughter, and babe, ready
for bed, await him in the orchard. One end was cut
off to shorten it … it will be a great deal better
than ever it was.'[1]

The Pre-Raphaelite influence is clearly apparent
in this rustic idyll, which was warmly praised by
Ford Madox Brown who described it as 'an orchard
in apple blossom, some children in a garden, and
father and son coming home in their working
costume, as though they have been working in the
fields all day … It was hung in the best part of the
Academy, but no one took any notice of it. But it
was undoubtedly one of the best in the Academy.'[2]

1. Arthur Hughes, letter to Agnes Hale-White,
22 October 1913. Tate Gallery archive.
2. Ford Madox Brown to Harry Quilter (1886),
in Harry Quilter, *Preferences in Art, Life and Literature*,
London, 1892, p.72.

Cat.19 Arthur Hughes (1832–1915)
The Heavenly Stair, *c.*1887–8
Oil on canvas, 178 x 88.5 cm (70 x 34¾ in)
Signed and dated lower right: *ARTHUR HUGHES, 1887–8*

At its first exhibition at the Royal Academy in
1888 *The Heavenly Stair* appeared with the
following quotation from George MacDonald:
'Little one who straight/has come down the
heavenly stair.' In Liverpool in autumn of the same
year it was shown with lines from Wordsworth's
'Ode on Intimations of Immortality':

Our birth is but a sleep and forgetting:
The Soul that rises with us, our life's Star,
Hath had elsewhere its setting,
And cometh from afar:
Not in entire forgetfulness,
And not in utter nakedness,
But trailing clouds of glory do we come
From God, who is our home.

The painting depicts the birth of a child, as
Hughes describes: 'a mother kneeling at the foot
of the stairs having just received a small baby from
Angels who still linger on the landing above – the
father just entered doffs his cap reverently to the
new baby.'[1]

1. Arthur Hughes, letter to William Bell Scott, May 1888,
published in William E. Fredeman (ed.), *A Pre-Raphaelite
Gazette: The Penkill Letters of Arthur Hughes to William
Bell Scott and Alice Boyd, 1886–97*, John Rylands Library,
Manchester, 1967, pp.17–18.

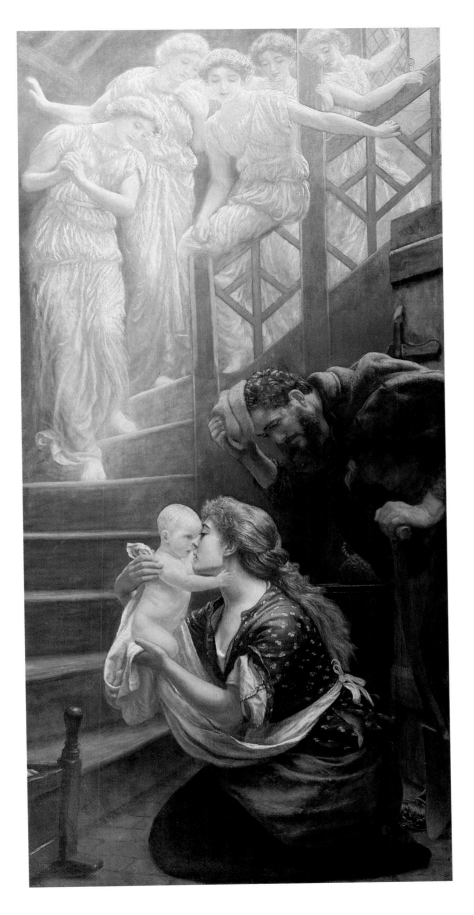

Cat.20 Dante Gabriel Charles Rossetti (1828–82)
Venus Verticordia, 1864–8
Oil on canvas, 83.8 x 71.2 cm (33 x 27½ in)
Signed lower left with initials in monogram: *DGR*

She hath the apple in her hand for thee,
Yet almost in her heart would hold it back;
She muses, with her eyes upon the track
Of that which in thy spirit they can see.
Haply, 'Behold, he is at peace,' saith she;
'Alas! the apple for his lips, – the dart
That follows its brief sweetness to his heart, –
The wandering of his feet perpetually!'

A little space her glance is still and coy;
But if she give the fruit that works her spell,
Those eyes shall flame as for her Phrygian boy.
Then shall her bird's strained throat the woe fortell,
And her far seas moan as a single shell,
And through her dark grove strike the light of Troy.[1]

The title for the painting refers to one of Venus's many surnames and was taken from Lempriere's *Classical Dictionary*: 'VERTICORDIA, one of the surnames of Venus, the same as the Apostrophia of the Greeks. This name was given her because her assistance was implored to turn the hearts of the Roman matrons, and teach them to follow virtue and modesty. *Ovid. 4. Fast.* v.157, thus describes the origin of the name.'[2] It is an unusual choice for the painting whose various interpretations explore the highly symbolic representation of sexual desire.

Rossetti used two models for the painting, the first recalled by his brother William: 'I can recollect that my brother, being on the look out for some person to serve as a model for the head and shoulders of his Venus, noticed in the street a handsome and striking woman, not very much less than six feet tall (almost all the ladies from whom he painted with predilection were of more than average stature). He spoke to this person, who turned out to be a cook serving in some family in Portland Place, and from her he at first painted his large "Venus Verticordia". That was the only picture, I think, for which the handsome *Dame de cuisine* sat to him.'[3] The portrait was repainted in 1867 and the features of the more familiar Alexa Wilding were substituted. Wilding was 'a damsel of respectable parentage

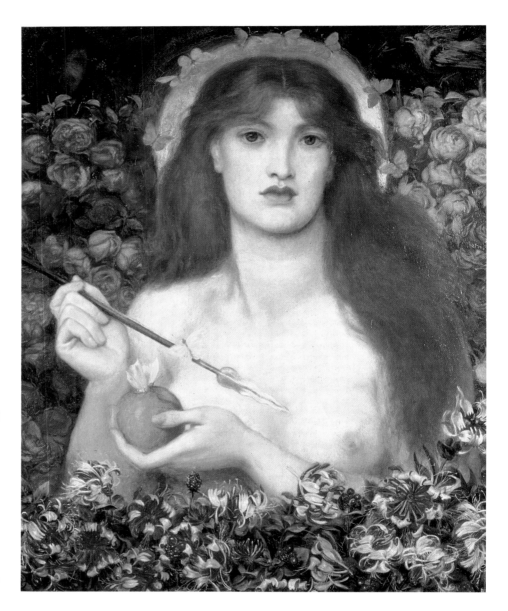

whom Gabriel had seen casually in the street and who now sat for him.'[4] She became the model for many of his later paintings including *Lady Lilith* (1864–8), *Veronica Veronese* (1872) and *La Ghirlandata* (1873).

The work was commissioned by Mr John Mitchell of Bradford in April 1864 and finally completed in 1868. The length of time that Rossetti struggled with the work is an indication of its importance to him and the often conflicting imagery and symbols within the work. These are in part contradictory and the picture's meaning remains open to interpretation. Whether she is a *femme fatale*, a goddess 'implored to turn the

hearts of the Roman matrons' or a symbolic reflection of Rossetti's confusion in his own private life has been discussed by many authors. The potency and associations of the individual symbols are reasonably clear: the roses and honeysuckles represent love, the latter more particularly, sexual love and lust. The two symbols that Venus holds can be seen as contradictory, however; the golden apple caused the fall of Troy, Paris is the 'Phrygian boy' of Rossetti's sonnet and Cupid's dart. One foretells love, the other destruction caused by obsessive love. The iconograph is further developed in the blue bird, which at the top right of the picture is associated with the brevity of existence while the butterflies have been seen as the souls of dead lovers. There are a number of sketches and versions of this work which further indicate Rossetti's fascination with this subject.[5]

1. Rossetti completed this sonnet for the painting in January 1868.
2. John D.D. Lempriere, *Bibliotheca Classica: or a Classical Dictionary*, Reading, 1788. Many later editions were available in the later half of the nineteenth century.
3. W. M. Rossetti, 'Notes on Rossetti and his Works', part II, *Art Journal*, 1884, p.167.
4. William Gaunt, *The Pre-Raphaelite Dream*, London, 1943, p.248.
5. See Virginia Surtees, *The paintings and drawings of Dante Gabriel Rossetti (1828–1882): a catalogue raisonné*, Oxford, 1971, nos 173A–F, R.1–2.

Cat.21 George Sheridan Knowles RI RBA ROI RCA (1863–1931)
***Her First Love*, 1885**
Oil on canvas, 83.8 x 66 cm (33 x 26 in)
Signed and dated: *G. Sheridan Knowles 1885*

George Sheridan Knowles was a popular genre artist who dealt with sentimental scenes often set in the Middle Ages, the eighteenth century or the far reaches of the British Empire. These include works such as *The Wounded Knight, Home Again* and *The Love Letter*.

Sir Merton Russell-Cotes bought the work from the Walker Art Gallery in Liverpool at its Autumn Exhibition, which often featured work that had been shown at the Royal Academy in the summer.

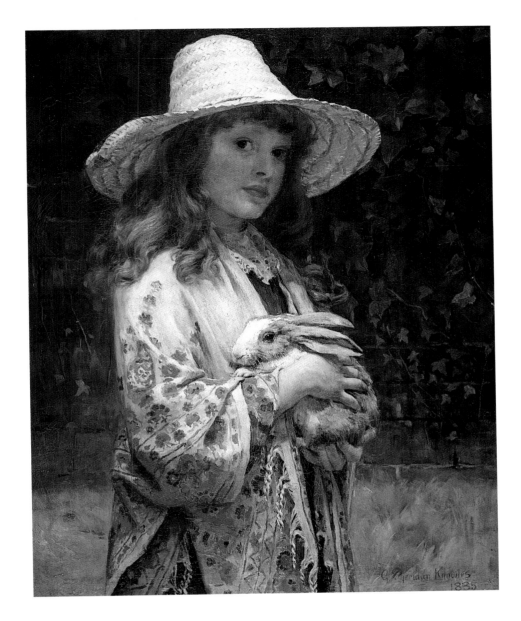

DISPLAY AND EXHIBITION
in the VICTORIAN ERA

MARK BILLS

When a Victorian artist had completed a painting in the privacy of the studio, it then became time to present it to the outside world. A patron may already have seen the work incomplete or it may have been commissioned and the patron would not only have seen it but probably already expressed an opinion about it. For the most part, however, it remained unseen until it was dressed for the occasion in a suitable frame and put into a gallery where, it was hoped, it would be scrutinised by many, reviewed and possibly sold. There were, of course, several options open to the artist who could choose to present the finished work in the studio in which it was painted; display it through a picture dealer's gallery; rent an exhibition space; or send it to one of the annual exhibitions organised by art societies. The determining factors were both artistic and economic. An artist wanted a good reputation and to be favourably reviewed by critics. On the other hand there was the desire for material rewards, or at least the avoidance of poverty, which did not always go hand in hand with critical acclaim. Where and what the artist publicly showed was crucial to his important relationships with critics and patrons.

Generally speaking the distinction between commercial and artistic success was not as it is today and art was not seen in the same way. In her study of Victorian periodical reviews, Helene E. Roberts noted:

> The periodicals reveal that to the Victorians a work of art was not usually a hallowed object evoking awe; art was more frequently looked upon as entertainment, a show and a commodity to be bought and sold. To the critics writing for the Victorian periodicals the artist seemed not so much a lonely genius, unknown and unappreciated, but a producer of goods that brought entertainment and edification, and that, if purchased, would embellish the home and bring pleasure to its inhabitants.[2]

Yet if this was true generally it was certainly not the case with certain critics. Art's function was less ambiguous than it is today and its role within the market place more transparent, but chasing purely financial gains and lowering standards to play to crowds and potential patrons were equally frowned upon. Harry Quilter, art critic for the *Spectator* and editor of the short-lived *Universal Review*, wrote of the important considerations when pricing work.

> I was speaking to a young artist the other day about an averagely bad picture which he had painted, and for which he wanted a certain number of hundred pounds … and I ventured to remonstrate with him as to the price … This was his answer: 'My dear fellow, a picture is worth what it will bring, and how can you find out what it will bring unless you put a big price on it. If it doesn't sell at _____ (naming the exhibition), it will go to Manchester, and there I shall ask so much, and so on, and so on.' … here is

'[THE ARTIST'S] WORKS MUST BE SEEN TO BE APPRECIATED AND UNLESS HE HAS THE MEANS FOR EXHIBITING THEM, THEY MUST ROT AND HE MUST STARVE.'[1]

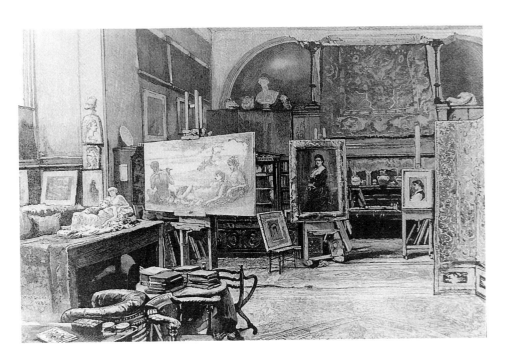

Fig.3 'The Studio' of Lord Leighton, reproduced in the *Magazine of Art*, 1881, p.173.

the determining factor in most artists' minds at the present day. An idea, mind you, which is not natural to them, but which has been carefully planted and cultivated by their fashionable patrons.[3]

The cynicism that Quilter describes was one of several opinions and emphasised the negative aspects of a period of art when patronage flourished. The relationship between artist, critic, public and patron was altogether more complex and the path of the artist less clear cut than Quilter suggests. On the whole artists desired recognition, even those who achieved the highest formal status and monetary rewards. Edwin Long, for example, whose personal wealth was ensured by his mass popularity, remained embittered that he did not receive equal acclaim from the art press. Patrons who were often new to buying art, unlike the connoisseurs of the previous century, wanted something that they could easily relate to and was a sound financial investment. This meant buying from an artist who had a reputation and most probably was a member of an important art society which allowed him to carry letters after his name. All these elements came together in the exhibition venue, whether it be the studio or a picture gallery.

During the Victorian era, the artist's studio became an increasingly important venue in which to display work to potential patrons. For many middle-class patrons, who were used to the sumptuous surroundings of the London galleries and who wished to see the work framed in a suitably elegant setting, the display was of utmost importance. The venue and context within which the work was shown gave a potential purchaser confidence and even offered something to which to aspire in his or her own home. Consequently studios became grander to assure patrons of the importance of the art they displayed and the soundness of the purchaser's financial investment. A succession of grand studio houses were built in the late nineteenth century and were illustrated in the art press and popular periodicals. From the 1860s, beginning with Val Princep's and Frederic Leighton's houses at Holland Park, the trend for lavish studio houses progressed to the end of the century (Fig.3). Sir Merton Russell-Cotes, like many patrons, would visit the

Fig.4 Frederick Goodall's studio, from the *Art Journal*, 1881, p.109.

Fig.5 Edwin Long's studio, from the *Art Journal*, 1881, p.110.

grand studios of the leading contemporary artists, make purchases, be inspired by the rich and idiosyncratic interiors and hob-nob with the celebrities of the art world. Show Sundays, when artists displayed their Academy works before the opening of the Summer Exhibition, began in the 1870s. They soon extended to Saturdays and many other weekends and proved extremely popular: at the height of his fame Luke Fildes boasted in excess of 1000 visitors in a single day. In his autobiography, *Home and Abroad*, Russell-Cotes recalls his visits to many artists' studios, including Albert Moore's in Spencer Street, Westminster, Frederick Goodall's (Fig.4), which was 'decorated with all kind of Eastern trophies',[4] and Edwin Long's (Fig.5), 'one of the finest studios I have entered, both for size and light'.[5] Sir Merton's awe for the artists' homes that he visited was manifested not only in the works that he purchased but also in the design of his own house and museum in Bournemouth. In particular, the Moorish Alcove at the Russell-Cotes Art Gallery and Museum, if more theatrical, is evocative of the Arab Hall at Leighton House.

Yet if the elaborate studio was evidence of success, artists first achieved their fame within the art societies and at the major annual London exhibitions. Hiring out gallery space in exhibition emporiums such as the Queen's Bazaar and Egyptian Hall may have aided an artist financially, if the pictures sold well, but it did mean competing against examples of archaeology and natural history, nor did these locations have the reputation of the major exhibition venues. The most important exhibition space in the Victorian period was undoubtedly the Royal Academy. Founded by Royal Charter in 1768 after many years, it established a pivotal position in the English art world. Its limited membership of forty Academicians and twenty Associates raised accusations of elitism, particularly with regard to the privileges that members enjoyed. They of course voted on membership and selected work for the annual exhibition which was first held in 1769. Several galleries were set up to rival its dominance and established important alternatives, yet its own position remained.

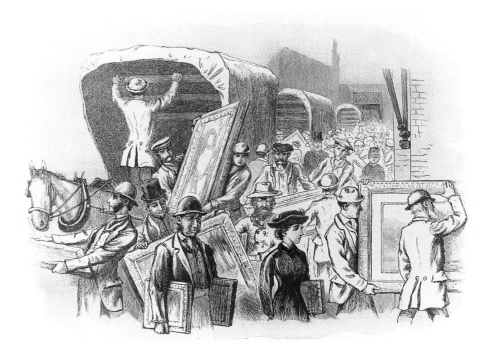

Fig.6 *Taking In*, from 'Sending-in Day at the Royal Academy', *Art Journal*, 1881, p.193. Wood-engraving by anonymous artist.

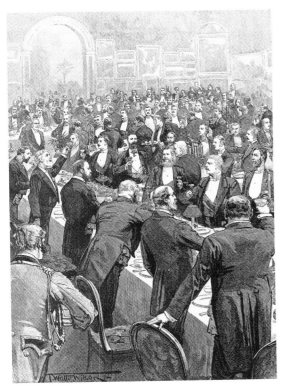

Fig.7 *The Queen*!, from M.H. Spielmann, 'From Glimpses of Artist-Life: The Royal Academy Banquet', *Magazine of Art*, 1887, p.229. Wood-engraving drawn by T. Walter Wilson ROI (1851–1912) and engraved by R. Taylor.

In 1837, the year of Victoria's coronation, the Royal Academy moved to Trafalgar Square where it stayed until 1869 when it moved again to Burlington House, its present home. The most important occasion in its calendar was its annual Summer Exhibition. To have a picture hung in a good place in the Exhibition was worth 'a year's income to a young painter'.[6] The Royal Academy Summer Exhibition opened on the first Monday in May until the first Monday in August. In the 1880s and 1890s the average attendance was 355,000. This event dominated and influenced the art world and captured the popular imagination; its opening was even described as being in the same category as Christmas Day.[7] It was reviewed by a mass of periodicals (in their hundreds), from the popular press such as *The World*, *The Graphic* and *Punch* to literary and artistic journals such as the *Athenaeum* and the *Art Journal*. It represented success for the artist and the standard by which patrons decided on purchases. The only artists who were guaranteed places in the Exhibition were members of the Royal Academy and consequently it was the work of these privileged sixty that was most eagerly sought by collectors. In 1848, the *Art Journal* illustrated this succinctly in an anecdote relating to that year's Exhibition:

> Not long ago a gentleman applied to an artist to paint him 'full length'; all preliminaries being arranged, he said, 'Of course you will guarantee me being hung at the Exhibition.' 'I cannot do so,' replied the artist, 'not being a member, I can guarantee nothing of the kind; but I can pledge myself to send your portrait to the Royal Academy, and it is not likely they will reject it.' The gentleman said he would consider. The result of his consideration is, that his portrait – full length – is now in the Exhibition; painted in a very gay costume, by a member of the Academy, who, of course, did guarantee its being exhibited.[8]

The Royal Academy provided a mark of approval to patrons. Indeed, when Sir Merton Russell-Cotes visited the annual Autumn Exhibition held at Liverpool's Walker Art Gallery, he 'invariably … made purchases of one, two, three or even more pictures … chiefly works that had been in that year's Royal Academy'.[9]

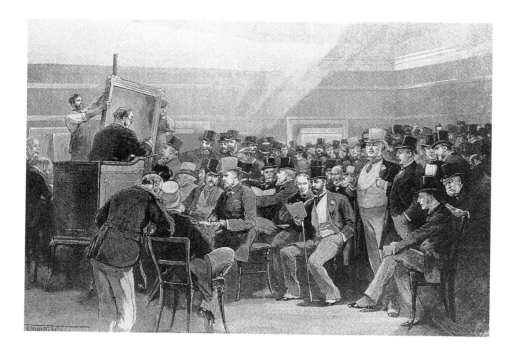

Fig.8 *A Sale at Christie's*, from M.H. Spielmann, 'From Glimpses of Artist-Life: Christie's', *Magazine of Art*, 1888, p.229. Wood-engraving drawn by T. Walter Wilson ROI (1851–1912) and engraved by R. Taylor.

The chief alternatives to the Royal Academy in the early to mid-Victorian period were the British Institution and the Suffolk Street galleries of the Society of British Artists, founded in 1823. These offered large exhibition spaces and provided a valuable source of income and exposure to new artists who did not find a place at the Academy. The British Institution began its life in 1805, showing its first annual exhibition of contemporary oil paintings in 1825 and continuing to do so until its closure in 1867. It received regular reviews in the press but, like Suffolk Street, was seen as a shadow of the Academy, not an artist's first choice, where the work was likely to be second-rate.

In the last quarter of the nineteenth century, three major alternatives to the Academy emerged. In order to showcase artists neglected by that august institution they needed to rival its attendance figures and reputation. 'Those attempting to launch successful commercial art galleries in London in the latter half of the nineteenth century realised that the way to impress their superiority upon an exhibition-going public was to build the most spectacular premises possible.'[10] The Grosvenor Gallery, the creation of Sir Coutts Lindsay which opened its doors in 1877, was a lavish exhibition space that showed the work of important artists of the period who were not favoured by the Academy. It predominantly displayed paintings from the later phase of Pre-Raphaelitism and included works by Edward Burne-Jones and Evelyn De Morgan (*Aurora Triumphans* was first exhibited there), and artists associated with the so-called Aesthetic movement such as Albert Moore and Whistler. As a result it created a new art public and a venue for works of the movement.

The gallery was a success but its later commercial developments were felt to denigrate the mission of the gallery by its two assistant directors, Charles Hallé and Joseph Williams Carr, who set up the New Gallery in 1888. Its aims were similar to those of the Grosvenor and it had even more sumptuous interiors. The Grafton Gallery, which similarly appealed to a fashionable set and artistic elite, was established in 1893 and continued into the next century despite financial difficulties.

There was also a plethora of dealers' galleries centred around Bond Street. These provided important commercial opportunities for artists and a place where collectors of contemporary British art could purchase pieces for their collection. The most famous of the dealers was undoubtedly the firm of Christie, Manson and Woods (Fig.8). Sir Merton Russell-Cotes bought and sold much of his collection through Christie's and became a personal friend of Thomas Woods, who lived for a time in Bournemouth.[11] Agnew's was also an established firm which commissioned and exhibited modern works at their premises in Old Bond Street. Russell-Cotes purchased many works here, as Agnew's ledgers testify. These include David Bates's (1840–1921) *Salmon Leap on the Lleds*, purchased on 13 September 1886, John Watson Nicol's (*fl.*1876–1924 d.1926) *When a Man's Single* on 12 August 1889, and *The Sea Cave* by William Edward Frost RA, bought twice on 30 July 1880 and 22 September 1891. Other galleries such as Dowdeswell's and Fairless and Beeforth's Galleries were also frequented by Russell-Cotes and other collectors of the period.

The Doré Gallery was a commercial gallery set up not to sell the original works of the artists that it commissioned but prints after them. It aimed at creating pictorial and visual sensations, albeit on a smaller scale, like those that the larger galleries such as the Grosvenor had created. The Doré Gallery was established in 1868 to display the large religious canvases of Gustave Doré (1832–83) and continued until his death. Edwin Long was then commissioned to paint a series of works for the gallery, five of which are now housed at the Russell-Cotes Art Gallery. As the collector recalled: 'the public demanded a new sensation, and after serious consideration induced Long to paint a series of pictures … The result was a series of exceptionally marvellous subjects superbly painted which caused the Doré Gallery to become a still more popular resort.'[12] The first of the works to be painted was *Anno Domini* (1883; Cat.23), an enormous image of the flight into Egypt with all the splendours of the ancient world. The picture drew great crowds who, as at the Academy and the Grosvenor, paid a shilling entry fee.

Once works had been sold their display continued, either in the home of the private collector or the walls of a public gallery. Sir Merton Russell-Cotes collected for both reasons and in this sense was typical of philanthropists of the period who believed in art as an uplifting and positive moral influence on the wider public. The Russell-Cotes Art Gallery and Museum illustrates at once the private and public face of displaying works of art in the Victorian era. In the private rooms of the house, as opposed to the large gallery areas, the hangs fit into the décor and are typical of the late Victorian period (Fig.9). In his article on 'How to Hang Pictures', Lewis Day advised against the overly cluttered trend of gallery hanging, although he recommended positioning up to three rows of pictures against a dark textured background.[13] The texture might be created with stencilling and even gold backdrops were recommended: both are in evidence at East Cliff Hall, the central building of the Russell-Cotes Art Gallery and Museum (Fig.10). Gold spoke of affluence and was the main choice for picture frames of this period, for reasons an article of 1886 made explicit: 'Gold seems to enrich everything it touches, and set beside colours "brings them out" with prodigious effect … gold is *neutral*. It somehow, too, suggests the notion of an abstract boundary or zone between the vulgar surrounding world and the sort of spiritual life in art.'[14] The frame was an important embellishment to the work and decoration could add symbolic meaning as

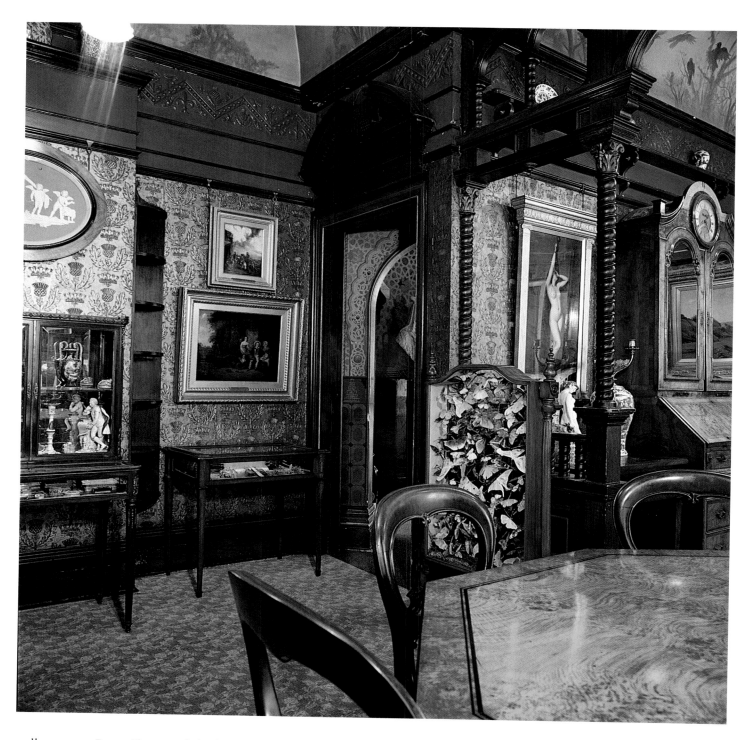

well as status. Byam Shaw used the base of the frame of *Jezebel* (Cat.33) to describe her fate and the Rossetti frame of Luke Fildes's *English Girl* is almost pseudo-religious in its iconic connotations.

Although on a more modest scale private hangs did reflect the general tendency set by the exhibition hangs of the period. The Royal Academy displayed paintings one above the other, side by side, cheek by jowl, utilising every inch of space. Clearly this had an adverse effect on many of the works and the terms 'skied' and 'floored' emerged to describe paintings that were hung extremely high

Fig.9 The Study of East Cliff Hall, *c*.1896. Russell-Cotes Art Gallery and Museum. Note the bronze and gold wallpaper.

or low on the gallery walls (Fig.11). The phrase 'on the line' referred to work at eye-level, the most desirable position for a painting and one which was dominated by the Royal Academicians who were entitled to have up to eight pictures shown in this highly valued space.

When the Russell-Cotes collection was given to the people of Bournemouth in 1908, the public galleries followed a similar hang. The aesthetic principles which emerged in the late nineteenth century and, like modernism, maintained that works require space around them, were not to be found at the Russell-Cotes. A dense hang had the advantage of showing large amounts of work and in its ordering also reflected the hierarchy of the art world as exemplified on the walls of the Royal Academy as well as the commercial importance of art. In cramming as much art together at one time as possible it indicated the vastness and material value of the collection and created a sense of awe around the museum as a whole.

The display and exhibition of art in this period reflected the Victorians' particular

Fig.10 The Main Hall of East Cliff Hall, *c*.1907. Russell-Cotes Art Gallery and Museum.

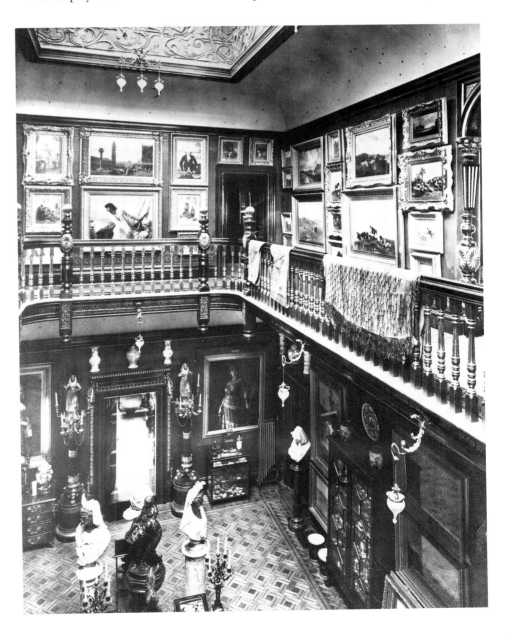

Fig.11 *In Full Swing*, from M.H. Spielmann, 'From Glimpses of Artist-Life: The Hanging Committee', *Magazine of Art*, 1887, p.196. Wood-engraving drawn by T. Walter Wilson ROI (1851–1912) and engraved by R. Taylor.

Cat.22 Sir Samuel Luke Fildes RA (1843–1927)
***An English Girl*, 1882**
Oil on canvas, 75 x 45.7 cm (29½ x 18 in)
Signed and dated lower right: *Luke Fildes 1882*

Sir Luke Fildes was one of the leading painters of the Victorian period. His reputation was initially gained through his drawings for an illustrated weekly, *The Graphic,* and for Charles Dickens's last novel, *The Mystery of Edwin Drood.* He began to paint in oils in the 1870s and found success as a painter of social realism in pictures such as *The Widower* (1876) and *Admission to the Casual Ward* (1874), which was based on an 1869 drawing for *The Graphic, Houseless and Hungry.* He later painted many genre scenes that became icons of the Victorian period, such as *The Village Wedding* (1883) and *The Doctor* (1891), and scenes of Venice in the 1880s which bore a similarity to the style of Eugène de Blaas.

This painting by Fildes was initially thought to be of a Venetian subject, although a letter from the artist written in 1926 noted that 'it would be better to call it "An English Girl".'[1]

1. Sir Luke Fildes, letter to Richard Quick, 18 February 1926, Russell-Cotes Art Gallery and Museum archive.

view of art and the role of artists. Art was set within a much more ordered system with a much more defined role. Its exhibition reinforced this hierarchy, in which the Royal Academy dominated. Collections such as the Russell-Cotes set themselves up within this context. In gifting its collection of British art to the public it displayed it in the way in which it had first been exhibited and closed its doors to the twentieth century. Its rich hangs in public and private spaces provide an insight into historical display and the role and importance of art in the Victorian period. Walls of paintings and groupings of sculpture declare the richness of its material possessions yet also exude the belief in the importance of cultural and moral values that are manifest in its art. It is the benefactor, showing wealth and taste whilst offering enlightenment and improvement to its many visitors.

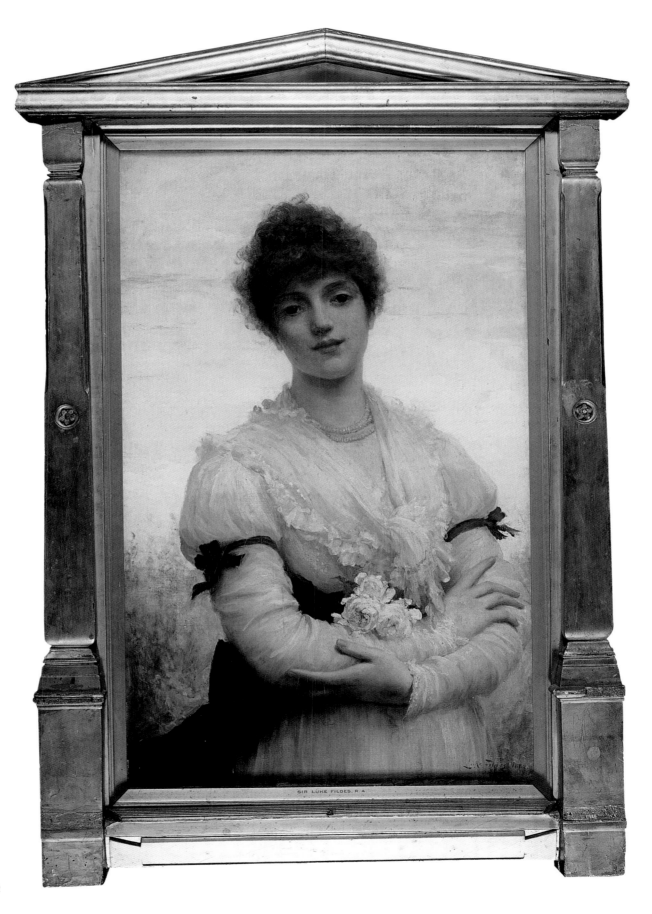

SIR LUKE FILDES. R.A

Cat.22

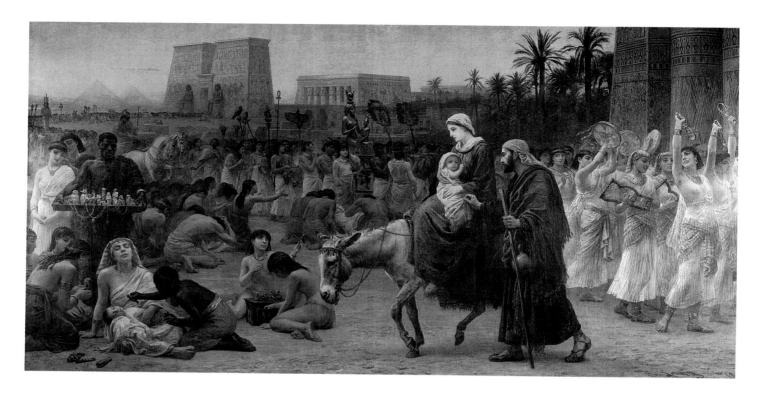

Cat.23 Edwin Longsden Long RA (1829–91)
Anno Domini or ***The Flight into Egypt***, 1883
Oil on canvas, 243 x 487 cm (96 x 192 in)
Signed and dated lower right: *E Long 1883*

In his introduction to the catalogue of the
Lawrence Gallery, the critic George Augustus Sala
explains the main focus of this enormous painting.
'The predominant and all-pervading idea of the
"Flight into Egypt" is to indicate by direct pictorial
contrast, by the arrival of the Holy child and His
parents to a country reeking with idolatry, the
coming into contact of the old and new faiths,
and to imply the conflict which, ere long, must
inevitably arise between Paganism and
Christianity.'[1] Unusual in its treatment of the
subject in having the two distinct and contrasting
elements outlined by Sala, it was painted on a
grand scale and caused a sensation at the
Lawrence Gallery on Bond Street – owned by the
fine art publishers and dealers Fairless and
Beeforth – when it was first exhibited there in
January 1884. Visitors paid a shilling to see this
imposing evocation of ancient Egypt and bought
prints of it in vast quantities. Indeed the work
remained on permanent display on Bond Street
for twelve years at three different galleries owned
by Fairless and Beeforth.

1. G.A. Sala, *Anno Domini, Painted by Edwin Long, R.A.
also Zeuxis at Crotona, etc.*, Lawrence Gallery catalogue,
London, 1885, p.3.

Fig.12

Fig.12 Edwin Longsden Long RA (1829–91),
Anno Domini or *The Flight into Egypt*, 1883.
Line engraving.

CHAPTER THREE

PRIVATE PLEASURES?
Paintings of the nude in the Russell-Cotes collection

ALISON SMITH

Many of today's visitors to East Cliff Hall, the palatial villa commissioned by hoteliers Merton and Annie Russell-Cotes to house their extensive art collection, are as struck by the wealth of imagery devoted to the female nude as they are by the sumptuous interior decorations and magnificent setting overlooking the English Channel. Here icons of female sensuality such as Dante Gabriel Rossetti's *Venus Verticordia* and John Byam Shaw's *Jezebel* vie with representations of womanly pathos and virtue for the viewer's attention. 'Seraglio' might indeed seem a more appropriate word for describing the house and its contents than 'a notable collection of modern works of art', the formal designation used by Merton Russell-Cotes to characterise his gift to Bournemouth in 1908.

But to define the Russell-Coteses' interest in the nude as pruriency in the guise of public duty would be to misrepresent the aesthetic values to which they aspired, not to mention the plurality of debates surrounding both the private and public role of the nude in late-Victorian and Edwardian art and society, debates which reveal a more complex approach to the subject than the generalisations concerning Victorian hypocrisy and prudery which persist today. The Russell-Coteses' taste was in fact typical of most regional collectors of the time, focused primarily on British painting and on works displaying a detailed facture as sanctioned by the Royal Academy and prestigious exhibitions such as the annual Autumn Exhibition at the Walker Art Gallery in Liverpool, from which many of the couple's purchases were made. Nudes tended to comprise a select but significant component of such collections, on the one hand being an index of luxury and cosmopolitanism on the part of the wealthy, on the other a patriotic gesture in that, according to academic theory, the subject was regarded as a measure of a nation's capacity to produce high art. The small but choice range of nudes in the Russell-Cotes collection included a number of works by foreign artists, notably Luis Faléro (1851–96; Cat.24) and Charles Landelle, but they were in the main important examples of what Merton Russell-Cotes termed 'English Classicism', a style epitomised by Albert Moore's 'tall, well formed … perfect types of English womanhood', but which also encompassed the romantic figures of George Romney; Fig.13, Etty and his followers Frost and Pickersgill.[1] For Russell-Cotes the significance of then unfashionable painters like Etty, at a time when the romantic English nude had given way to an academic Continental style of representation and a greater eclecticism in terms of subject matter, resided in his position as the first British artist to specialise in the subject, a view shared by other distinguished collectors of the period, such as Lord Leverhulme, who had amassed over thirty paintings by the artist which adorned the walls and landing of his Hampstead house, 'The Hill'.[2]

CHAPTER THREE

PRIVATE PLEASURES?
Paintings of the nude in the Russell-Cotes collection

ALISON SMITH

Many of today's visitors to East Cliff Hall, the palatial villa commissioned by hoteliers Merton and Annie Russell-Cotes to house their extensive art collection, are as struck by the wealth of imagery devoted to the female nude as they are by the sumptuous interior decorations and magnificent setting overlooking the English Channel. Here icons of female sensuality such as Dante Gabriel Rossetti's *Venus Verticordia* and John Byam Shaw's *Jezebel* vie with representations of womanly pathos and virtue for the viewer's attention. 'Seraglio' might indeed seem a more appropriate word for describing the house and its contents than 'a notable collection of modern works of art', the formal designation used by Merton Russell-Cotes to characterise his gift to Bournemouth in 1908.

But to define the Russell-Coteses' interest in the nude as pruriency in the guise of public duty would be to misrepresent the aesthetic values to which they aspired, not to mention the plurality of debates surrounding both the private and public role of the nude in late-Victorian and Edwardian art and society, debates which reveal a more complex approach to the subject than the generalisations concerning Victorian hypocrisy and prudery which persist today. The Russell-Coteses' taste was in fact typical of most regional collectors of the time, focused primarily on British painting and on works displaying a detailed facture as sanctioned by the Royal Academy and prestigious exhibitions such as the annual Autumn Exhibition at the Walker Art Gallery in Liverpool, from which many of the couple's purchases were made. Nudes tended to comprise a select but significant component of such collections, on the one hand being an index of luxury and cosmopolitanism on the part of the wealthy, on the other a patriotic gesture in that, according to academic theory, the subject was regarded as a measure of a nation's capacity to produce high art. The small but choice range of nudes in the Russell-Cotes collection included a number of works by foreign artists, notably Luis Faléro (1851–96; Cat.24) and Charles Landelle, but they were in the main important examples of what Merton Russell-Cotes termed 'English Classicism', a style epitomised by Albert Moore's 'tall, well formed … perfect types of English womanhood', but which also encompassed the romantic figures of George Romney; Fig.13, Etty and his followers Frost and Pickersgill.[1] For Russell-Cotes the significance of then unfashionable painters like Etty, at a time when the romantic English nude had given way to an academic Continental style of representation and a greater eclecticism in terms of subject matter, resided in his position as the first British artist to specialise in the subject, a view shared by other distinguished collectors of the period, such as Lord Leverhulme, who had amassed over thirty paintings by the artist which adorned the walls and landing of his Hampstead house, 'The Hill'.[2]

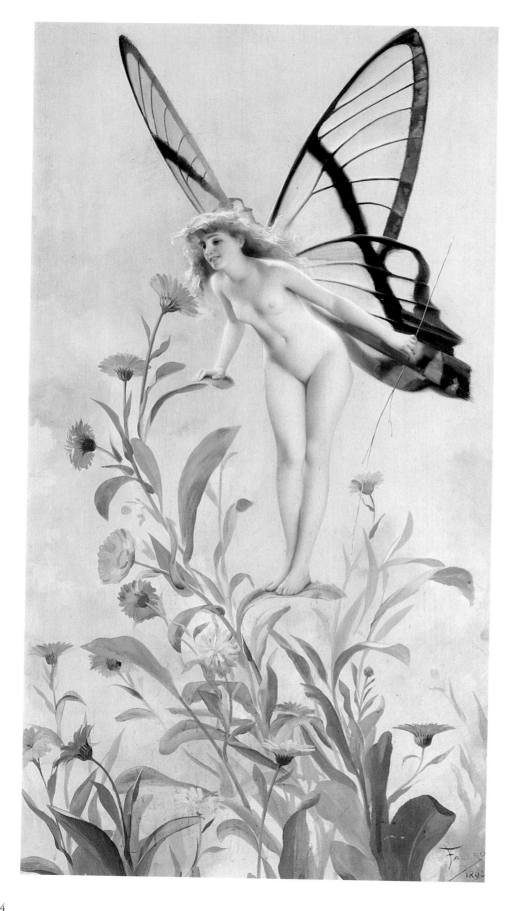

Cat.24 Luis Riccardo Faléro (1851–96)
The Butterfly (Ariel), **1893**
Oil on canvas, 73.7 x 40.6 cm (29 x 16 in)
Signed and dated lower right: *FALERO 1893*

Faléro was born in Spain in 1851. He abandoned
his first career in the Spanish navy to pursue a life
in art, studying in Paris and finally moving to
London where he eventually died in 1896. From
1883 he had a studio in fashionable Hampstead
and regularly exhibited at the Royal Academy.
He is known for his highly detailed and smooth
depictions of naked female flesh which he
combined with a great interest in astronomy.

The spirit of bourgeois individualism which emboldened patrons like Russell-Cotes, Leverhulme and Henry Tate (founder of the Tate Gallery in 1897) to specialise in the nude was thus corroborated by their commitment to modern British art as realised in the munificence of their bequests, and above all by their concern to cultivate a broad appreciation for art. While private ownership of the nude was ratified by law (the Obscene Publications Act of 1857 had guaranteed the immunity of art in private hands from prosecution), however, works in the public sphere were more exposed to official scrutiny and regulation. Artists and connoisseurs were gen-

Fig.13 George Romney (1734–1802),
Lady Hamilton as Venus (1793), drawing.
 Reproduced in Sir Merton Russell-Cotes,
Home and Abroad, opposite p.747, with the
inscription: 'Presented to me by Dr. Arabella
Kenealy, the talented authoress, daughter
of the famous Dr. Kenealy, who was counsel for
"The Claimant" in the celebrated Tichborne case.'

erally trusted to approach images of the undraped figure with contemplative composure but audiences uneducated in the intricacies of art criticism tended to be regarded with suspicion lest they conflate ideal form with naked fact. Refuting philanthropic notions of the improving influence of art on the masses, for instance, a writer in *Vanity Fair* cited as evidence the behaviour of crowds in the National Gallery on public holidays: 'I know only too well how the rough and his female companion behave in front of pictures such as Etty's bather. I have seen the gangs of workmen strolling round, and I know that their artistic interest in studies of the nude is emphatically embarrassing.'[3]

Although not oblivious to such remonstrations, Russell-Cotes aimed to pitch himself above the aspersions cast by critics of the nude in the public domain. To this end he was assiduous in cultivating the artistic knowledge required to project himself as an informed advocate and adjudicator of what he referred to as the 'Human Form Divine'.[4] Not only did he collect paintings of the nude but also marble and bronze statuary, ceramics and drawings, and he even commissioned replicas of famous works such as Henry Justice Ford's copy of Anna Lea Merritt's *Love Locked Out* (Cat.28).[5] Both the variety of his collection of nudes and the ostensibly singular judgements expressed in his memoir *Home and Abroad* were in fact standard for the time, probably modelled on the opinions of those artists and critics he sought to emulate, and were also likely to have been informed by the public debate on the morality of the nude that had raged since the late 1870s. Russell-Cotes may have been acquainted with the ideas of P.H. Rathbone, a founder member of the Liverpool Autumn Exhibition of which both Merton and

Annie had been long-standing supporters. In 1878 Rathbone had spoken out in public in defence of the nude as an agent of national purity on the ground that it instilled sexual restraint in men and a pure respect for women, so long as it was 'represented by thoroughly trained artists'.[6] Merton was possibly also familiar with P.G. Hamerton's influential *Man in Art* of 1892, which put forward a similar argument, namely that in a society given over to scientific and materialistic pursuits, the ideal nude remained a perennial source of the 'divine truth' and artistic excellence.[7] The idea that the nude, if correctly drawn and posed, was pure, normative and the very model of propriety clearly appealed to the sensibilities of collectors like Russell-Cotes. During the 1890s the cultural and moral benefits of the subject were presented to gentlemen in the form of fine art publications such as *The Nude in Art: a collection of forty-five photogravures reproduced from original paintings, selected from the most famous examples of the nude*, published by H.S. Nichols in a limited edition in 1896. This assembly of what would now be considered titillating sado-erotica – including works by Faléro, Edward Poynter and Solomon J. Solomon (Cat.29), all artists patronised by Russell-Cotes – would have been perfectly legitimate in purporting to uphold academic conventions of representation.[8] Indeed the compilation was prefaced by a high-minded sermon by the writer Clarence Lansing which declared: 'The mission of the book is a high and noble one. Its aim is to offer to its patrons the best example of what is refined, noble, and pure in art, as distinguished from the immoral, suggestive and impure, and thus to assist in the formation of a correct and discriminating taste.'[9]

In loaning his collection to municipal galleries, Russell-Cotes made the symbolic step of sublimating his private predilections into an act of public service. This gesture owed much to John Ruskin's ideas concerning the ameliorating influence of art on the culturally improverished, realised in his own museums near Sheffield and in other galleries established by radical benefactors on similar didactic terms. A number of Ruskinians, including T.C. Horsfall, founder of the Manchester Art Museum at Ancoats in 1886, had opted to exclude the nude from exhibition, believing that it detracted from the educative mission of the enterprise. This view had brought Horsfall into conflict with Frederic Leighton, President of the Royal Academy, who promoted the display of the nude in public on the grounds that aesthetic appreciation was a transferable skill as well as a prerequisite for a disinterested appraisal of beauty in art.[10] Therefore, in offering his paintings for loan Russell-Cotes was likely to have been seeking a middle path between his Ruskinian conviction in the social benefits of art and Leighton's aestheticism. As a Justice of the Peace he may also have been versed in the legal notion of the 'public good', which laid down that a person was justified in exhibiting works of a so-called obscene nature in public provided these could be proved to be necessary or advantageous to religion or morality.[11]

Although the Russell-Coteses had placed nudes on semi-public display at the Royal Bath Hotel in Bournemouth, with the loan scheme they faced a wider audience than those who, in Oscar Wilde's words, could afford to pay 'hotel prices'.[12] In 1899 Etty's *Dawn of Love* (Cat.25), an important example of the painter's sensuous treatment of the female nude first exhibited at the British Institution in 1828 (under the title *Venus now wakes, and wakens love* from Milton's masque *Comus*), was exhibited along with other pictures from the collection at the Glasgow Corporation Gallery. This voluptuous image in the manner of Titian and Rubens, in which a

Cat.25 William Etty RA (1787–1849)
The Dawn of Love, 1828
Oil on canvas on panel, 49 x 59.7 cm (19¼ x 23½ in)

The painting was originally titled *Venus now wakes and wakens love* when it was exhibited at the British Institution in 1828. The lines are from Milton's *Comus*:

> Night hath better sweets to prove,
> Venus now wakes, and wak'ns Love.
> Come let us our rites begin,
> 'Tis only day-light that makes Sin
> which these dun shades report.
> Hail goddesse of Nocturnal sport.[1]

The sensual subject of this and many other paintings by Etty scandalised many Victorians. He died only twelve years after Victoria's ascent to the throne and in his Neoclassical imagery and frankness he belongs in many ways to an earlier age. *The Dawn of Love* is one of Etty's most important paintings and is typical of his work in its sensual and voluptuous representation of classical imagery. A small study for the work, which sketches out the composition and positioning of the two figures, is in the Victoria and Albert Museum, London.[2]

1. John Milton, *Comus: A Maske presented at Ludlow Castle, 1634.etc.*, London, 1637.
2. The sketch measures 5 x 7.6 cm, pencil on paper, inv.no.7650.12.

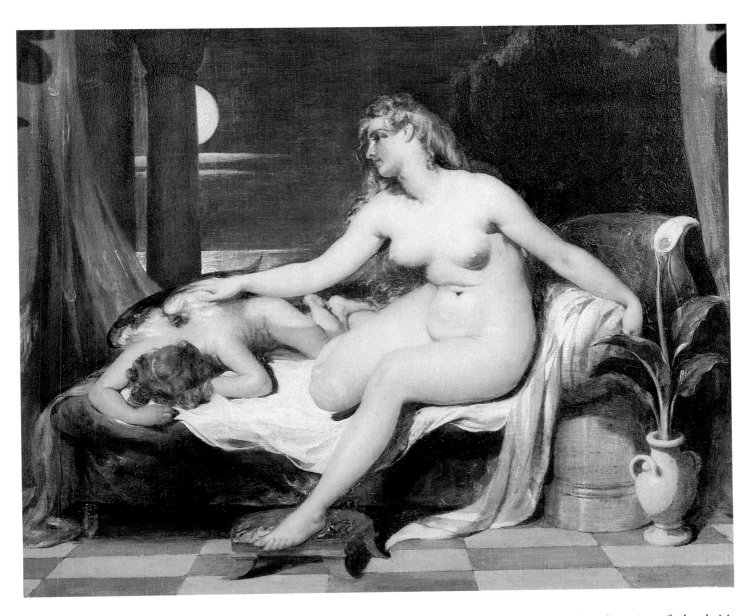

blushing Venus caresses Cupid by moonlight, aroused the indignation of a local citizen who questioned the probity of displaying such a carnal image in a letter, signed 'East Ender', addressed to the editor of the *Glasgow Evening Times*.[13] The publication of this missive ignited a spate of correspondence from both critics and defenders of the painting, with each side competing for the moral high-ground. The final letter to be printed, signed 'Social Purity', argued that because the People's Gallery existed for educative purposes, the responsibility for selection should reside with competent judges of art, not town councillors who had been inconsistent in exhibiting Etty's painting while having recently condemned 'the paintings and posters of private persons, against whom no charge … could be framed at common law'.[14] Here the writer was referring to a furore which had broken out in 1894 when the Chief Constable of Glasgow, backed by local magistrates, had ordered a local printseller to remove from his shop window a series of photogravures after celebrated paintings of the nude. Among the prints were images by Academicians such as Leighton, Poynter and Arthur Hacker – artists all represented at different times in

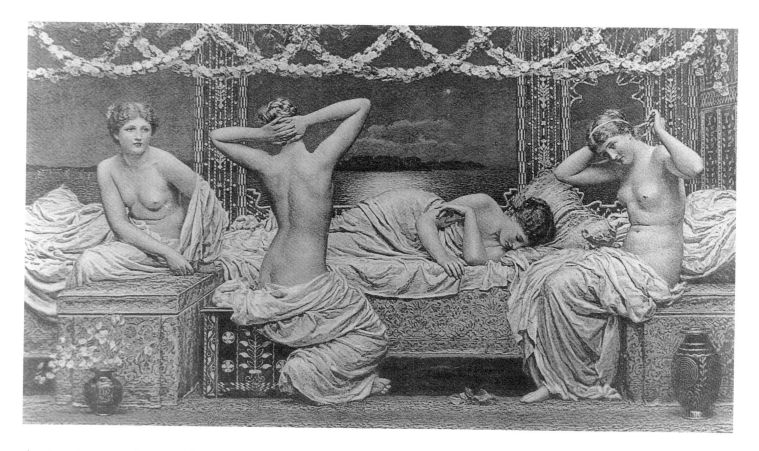

Fig.14 Albert Joseph Moore ARWS (1841–93), *A Summer's Night*, 1890. Oil on canvas. Walker Art Gallery, Liverpool.

the Russell-Cotes collection. The matter was only resolved through the intervention of art-world officials including Leighton and Poynter, which led to the Glasgow police 'being soundly rated' and 'a great deal of fun made of Scottish prudery'.[15] Russell-Cotes's even-handed approach in reporting the 1899 case in his memoirs was probably adopted with the knowledge that as a benefactor and defender of the 'public good' he was not accountable at law. Moreover, his stance betrays a concern to project himself as a kindred soul to the high-minded Olympians: one who derived no 'foul thought' from the painting.

Nevertheless, with a social position to maintain, the Russell-Coteses could not be totally indifferent to public criticism. A few years before this incident Merton Russell-Cotes was compelled to back down from purchasing Albert Moore's *A Summer's Night* (Fig.14), exhibited at both the Royal Academy and Liverpool in 1890, due to objections from Annie who felt that the painting, recently described as Moore's 'most ambitious and seductive celebration of the female body', would offend patrons of the Royal Bath Hotel in which it was to hang.[16] The wives of prominent collectors were often held responsible for their husbands' caution with regard to the nude, but there is no evidence that Annie opposed her husband's tastes; rather, like him, she was anxious to safeguard their reputation as respectable hoteliers and civic worthies (Russell-Cotes's knighthood was not conferred until 1897). In gifting their collection to Bournemouth in 1908, now housed in reduced form in John Frederick Fogerty's resplendent house-cum-gallery, they decided upon a gradual transition from private to public ownership. During their lifetimes access to the gallery was limited to two hours on the last Wednesday of each month on the purchase of a ticket in advance, an established practice for excluding what were con-

Fig.15

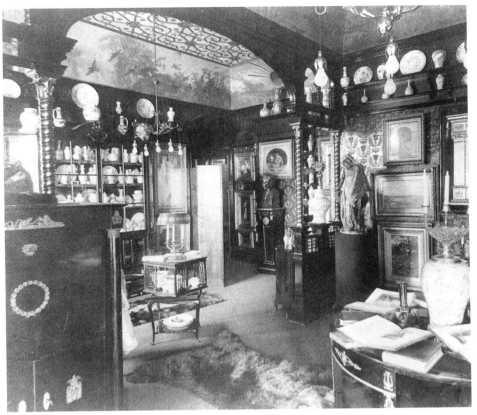

Fig.16

Fig.15 A detail of *Venus Rising*, from the frieze in the Red Room of East Cliff Hall executed by John and Oliver Thomas.

Fig.16 The study of East Cliff Hall, *c.*1907. Russell-Cotes Art Gallery and Museum.

sidered to be socially undesirable elements.[17] Such restrictions can be seen as a compromise that preserved the idea of free choice while upholding the mantle of civic-minded magnanimity. While private 'fantasy' spaces such as Russell-Cotes's bedroom, with its painted wall-decorations of Venus and her heavenly entourage (Fig.15), allowed for the indulgence of intimate feelings, semi-public areas like the study, which visitors were allowed to enter, displayed nudes as precious *objets d'art* for quiet perusal. A 1907 photograph of the study (Fig.16) shows a number of nudes placed in prominent positions: Etty's *Dawn of Love*, Frost's *The Sea Cave* and Albert Moore's *A Wardrobe*.

While small intimate images such as William Breakspeare's *Nude* (apparently referring to St Paul's appeal for unity in the church; Cat.30) were probably confined to peripheral rooms, the more spacious public areas and galleries were disposed to elicit a purer, more detached response, as evinced by the white marble busts and statuary elegantly arranged around the Main Hall. The edifying purpose of these spaces was emphasised by features such as William Scott Morton's plaster renditions of the Parthenon frieze at the top of the stairwell, and the series of inscriptions Russell-Cotes devised for the gallery extension of 1916–26. Emblazoned above the entrances to each gallery in elaborate Gothic script, these proclaim the standard sentiments on the enhancing effect of the beautiful: 'The eye rejoices in the beautiful from hour to hour'; 'Man's ideal of Nature is reproduced in Art'. The latter words may have been conceived deliberately by Russell-Cotes to complement Edwin Long's *The Chosen Five* (*Zeuxis at Crotona*; Cat.27), purchased in 1885, the year of its exhibition, with its theme of imperfect nature reconstituted through artistic analysis into an image of female perfection. This

Cat.26

Cat.26 Frederick Goodall RA (1822–1904)
*Susannah, c.*1886
Chalk drawing, 143 x 82 cm (56¼ x 32¼ in)

Goodall often produced full-sized finished
chalk drawings prior to their depiction in oil on
canvas. This drawing of Susannah was used in
preparation for his 1886 Royal Academy painting.
The *Athenaeum* found her 'a portly matron of an
English type',[1] and the *Art Journal* stated that
there was nothing offensive in the nudity of
Susannah but was critical of the quality of the
work, noting that there was 'nothing [that] need
offend the British matron … but a good deal that
might be objected to by the captious critic.'[2]

1. *Athenaeum*, 12 June 1886.
2. *Art Journal*, 1886, p.250.

Cat.27 Edwin Longsden Long RA (1829–91)
*The Chosen Five (Zeuxis at Crotona),*1885
Oil on canvas, 152.4 x 243.8 cm (60 x 96 in)
Signed and dated lower left (on Zeuxis's footstool):
Edwin Long, 1885

The subject for this painting is the depiction of
Helen of Troy by the artist Zeuxis. The narrative
was taken by Long to create this and a companion
painting, *The Search for Beauty*.[1] His main sources
for the paintings are the writings of Cicero and
Pliny the Younger.[2] The story tells of the citizens
of Crotona who build a temple to their protecting
goddess Hera and commission the artist, Zeuxis
of Hereclea, to decorate it with an image of Helen.
Zeuxis achieves this onerous task by selecting the
five most beautiful women of Crotona as models
for his painting. 'For he knew that he could find
no single form possessing all the characteristics of
perfect beauty, which impartial Nature distributes
among her children, accompanying each charm
with a defect, that she may not be at a loss what
to give the rest by lavishing all she has to afford
on one.'[3]

1. *The Search for Beauty* is identical in date,
size and medium.
2. Cicero, *de Inventione*, II, i–iii; Pliny the Younger,
Epistles, 35–9.
3. Cicero, *de Inventione*, II, iii.

Cat.27

idea is conveyed visually by the juxtaposition of real and fictive bodies: the maidens of Crotona idly awaiting their turn on the podium, set against the mirror image of Helen emerging on the easel, with studies for her shown scattered across the floor. The models' impassive expressions and academic postures, together with the dry surface and clear outlines of their figures, suggest the dissolution of the boundaries separating flesh and paint through Zeuxis's act of judgement and selection. The decorum of the scene is maintained by the segregation of the women from the bronze icons of male nudity in the further room, the *Dancing Faun* from Pompeii possibly a pun on the theme of realisation, appearing more animate than the frozen figures in the foreground. The public nude had to appeal to the decency of both men and women, and for Russell-Cotes perhaps the highest accolade came when Princess Beatrice expressed admiration for Long's painting when she opened the new gallery in February 1919.

References to Greek sculptural whiteness were a necessary corollary of purity in the nineteenth century, in contrast to colour which connoted physicality, sexuality and racial inferiority, exactly what the ideal figure was designed to exclude. Thus, while Long's *Chosen Five* and Arthur Hill's *Captive Andromeda* were considered acceptable by critics by virtue of their linear sculptural values, the vibrant colour of Edward Matthew Hale's *Psyche before the Throne of Venus* (Cat.32) and Byam Shaw's *Jezebel* (Cat.33) was condemned as vulgar, elevating the sexuality of the model above the idea envisaged by the artist. Russell-Cotes's perception of the figure can broadly be described as 'classic-romantic', encompassing both a reverence for

abstract sculptural qualities, hence the high proportion of nude statues in the collection, and an enthusiasm for glowing flesh colour. Drapery was another area of contention at the time, in keeping with Cicero's well-known dictum, 'Graeca res est nihil velare' ('the Greek style is to drape no figure'). Russell-Cotes's penchant for wet-fold drapery, as evinced by his enthusiasm for Hill's *An Egyptian Water-Carrier* (Cat.31) and Hale's *Psyche*, would have been justified as proof of his antiquarian interests, particularly the way *draperie mouillée* revealed underlying form in ancient Greek sculpture. But diaphanous drapes were also liable to censure as suggestive concealment was considered indecent – 'the worst form of immodesty' according to Lansing. Indeed Hale's scantily clad goddess was accused of appearing brazen when exhibited at the Grosvenor Gallery in 1883, which did not deter Russell-Cotes either from purchasing the work in 1897 or from requesting Byam Shaw to clothe his sensual nude *Jezebel* in provocative dress around the same time. This painting is strikingly similar in conception to Hale's red-haired dominatrix, but had remained unsold following its exhibition at the Academy in 1896 due to objections against showing the queen's nudity.[18]

Such inconsistencies in the way Russell-Cotes evaluated the nude reveal the tensions inherent in his dual stance as a private connoisseur and public benefactor. The female body was always in danger of betraying the sexual and thus had to be regulated through both aesthetic and moral judgement. In fact the daring nudes in the Russell-Cotes collection received little critical attention other than that already mentioned, being protected by restricted access and no doubt the presence of the collector as an authoritative guide at public viewings. Controversy only developed in the seemingly more 'libertarian' twentieth century when the collection was directed towards a broader viewing constituency. In 1953 Long's *Anno Domini* or *The Flight into Egypt*, an enormous painting depicting the Holy Family amidst heathen idol-worshippers in ancient Egypt, was loaned to the local Summerbee Secondary School, being too cumbersome for an already over-crowded gallery. A wall was built to hold the picture but on the advice of the headmaster the image was draped with butter muslin to mask the nude and semi-nude women in the foreground (Fig.17), causing a dispute to erupt between the art gallery and the town Education Committee, who in 1956 ordained that the picture be removed on the grounds that it was 'prejudicial to good teaching or conduct'. Ironically a painting purchased for its didactic-religious message, and intended to hang permanently in the Russell-Cotes Art Gallery after it opened to the public, was subsequently denigrated as 'a swollen hunk of Victorian vulgarity', and as a consequence the collection began to assume a rather louche reputation.[19] Some late additions to the collection made around mid-century, such as Collier's *Incantation* (bequeathed 1941) and Rossetti's *Venus Verticordia* (purchased 1946), although totally in keeping with Russell-Cotes's original aesthetic aspirations, could only have reinforced this view. The question which inevitably arises at the dawn of a new century, when the galleries have been restored to their original exotic splendour, is whether the nude in this most private of public collections can ever be recovered as the elevated subject the Russell-Coteses intended it to be?

Fig.17 Edwin Longsden Long RA (1829–91), detail from *Anno Domini* or *The Flight into Egypt*, 1883.

Cat.28 Henry Justice Ford (1860–1941)
after Anna Lea Merritt (1844–1930)
***Love Locked Out*, 1889**
Oil on canvas, 109 x 58 cm (43 x 22¾ in)

Anna Lea Merritt's painting caused a sensation
when it was exhibited at the Royal Academy
Summer Exhibition of 1890. It also represented
an important step forward for women artists in
being the first work to be acquired for the Chantrey
Bequest, which became the Tate Gallery collection.
The artist described the scene she depicted:

> The thought had been inspired years before as
> a monument to my husband. In my thought the
> closed door is the door to the tomb. Therefore
> I showed the dead leaves blowing against the
> doorway and the lamp shattered ... I feared
> people liked it as a symbol of forbidden love
> while my Love was waiting for the door of Death
> to open and unite the reunion of the lonely pair.[1]

This painting is a faithful copy by Henry Justice
Ford of the original, now in Tate Britain.
Ford was a children's illustrator and friend of the
Pre-Raphaelite painter Edward Burne-Jones.[2]

1. Anna Lea Merritt's manuscript autobiography.
Tate Britain archive.
2. Henry J. Ford, letter to the curator, Norman Silvester,
30 October 1935. Russell-Cotes Art Gallery and Museum
archive.

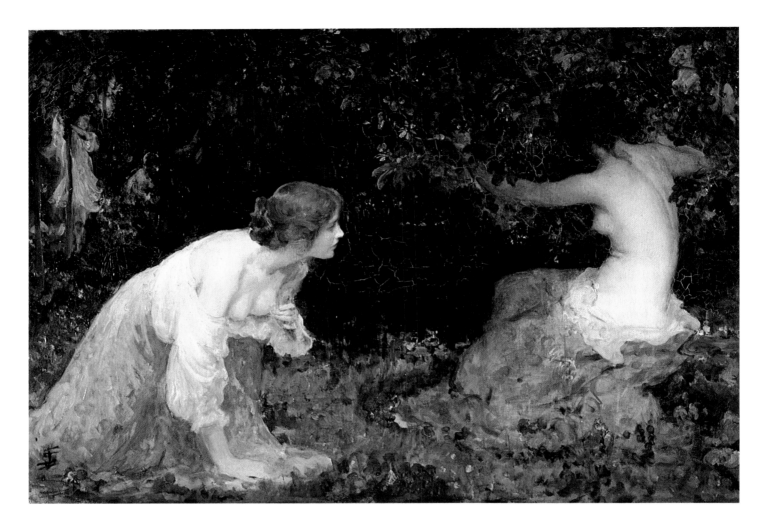

Cat.29 Solomon J. Solomon RA PRBA (1860–1927)
The Bathers Alarmed
Oil on canvas, 55.9 x 81.3 cm (22 x 32 in)
Signed lower left: *S.J.S.*

Solomon Joseph Solomon studied at the Munich
Academy and at the Ecole des Beaux-Arts, Paris
under Alexandre Cabanel. He exhibited at the
Royal Academy from 1881 and is known mainly
for his prolific output of portraiture. His other
works are mythological and biblical scenes such
as this distinguished nude.

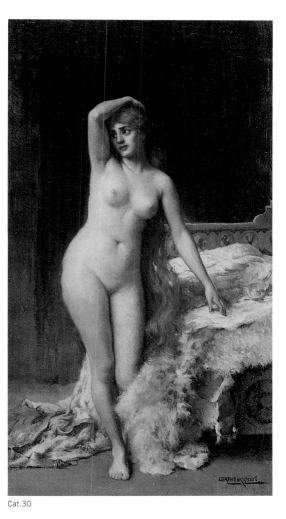

Cat.30

Cat.30 William A. Breakspeare (1855–1914)
Nude (1 Corinthians, I, 15)
Oil on panel, 28.5 x 14.5 cm (11 x 5½ in)
Signed: *W. Breakspeare*

'… Lest any should say that I had baptised
in mine own name …' 1 Corinthians, I, 15.

Cat.31 Arthur Hill RBA (*fl.*1858–93)
An Egyptian Water Carrier, 1881
Oil on canvas, 67.3 x 37 cm (26½ x 14½ in)
Signed and dated: *Arthur Hill 81*

The Russell-Cotes Art Gallery and Museum
contains two unabashed nudes by Arthur Hill
in its collection. *An Egyptian Water Carrier* depicts
a female figure wearing a diaphanous gown, which
makes it inconceivable as a piece of standard
genre painting. In his other nude, *Captive
Andromeda* (1876), the naked figure is similarly
overtly sexual and her manacles appear as objects
of a fetish.

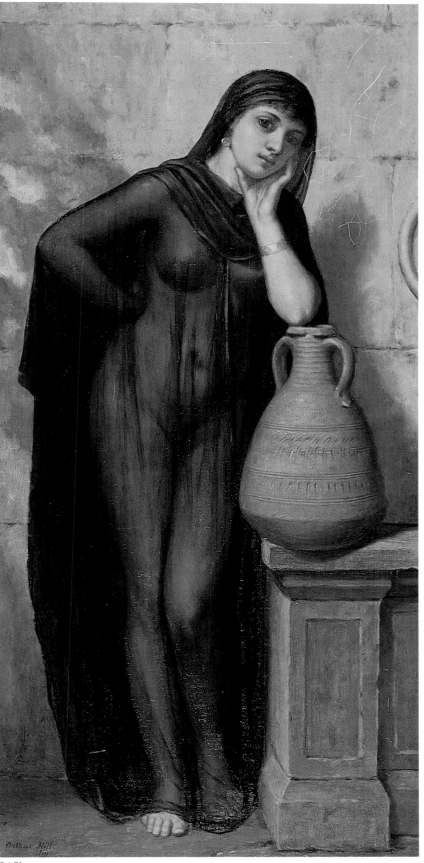

Cat.31

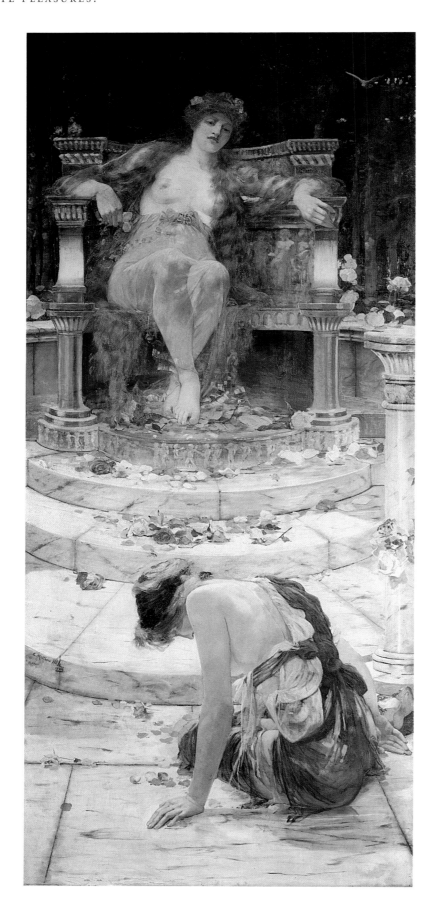

Cat.32 Edward Matthew Hale ROI (1852–1924)
Psyche at the Throne of Venus, 1883
Oil on canvas, 199 x 88.9 cm (78¼ x 35 in)
Signed lower left, on marble steps: *E Matthew Hale 1883*

Edward Matthew Hale studied in Paris between
1873 and 1875, training under Cabanel and
Carolus Duran. *Psyche at the Throne of Venus* was
exhibited at the 1883 annual Grosvenor Gallery
exhibition with the following description:

> Psyche, a king's daughter, by her exceeding
> beauty caused the people to forget Venus;
> therefore the goddess would fain have destroyed
> her: nevertheless she became the bride of Love,
> yet in an unhappy moment lost him by her own
> fault, and wandering through the world she
> suffered many evils at the hands of Venus,
> for whom she must accomplish fearful tasks.
> But the gods and all nature helped her,
> and in the process of time she was reunited
> by the Father of gods and man.[1]

Hale had dealt with the same subject four years
earlier when he exhibited *Psyche's Toil in Venus'
Garden* at the Grosvenor Gallery (No.17). The
Magazine of Art found her 'a belle of the London
streets with canary-coloured hair and blackened
eye-lashes'.[2] *Psyche at the Throne of Venus* was
more particularly based upon an adaptation of the
myth that appeared in the poem *Earthly Paradise*
(1868–70) by William Morris (1834–96). It was
not well received at its exhibition at the Grosvenor
Gallery. The *Art Journal* described it as 'a large
canvas, chiefly devoted to the display of the nude;
attractive in colour, but unnatural in pose and
vulgar in sentiment.'[3]

1. Grosvenor Gallery catalogue,
summer exhibition 1883, p.8.
2. *Magazine of Art*, 1879, p.164.
3. *Art Journal*, 1883, p.203.

Cat.33 John Liston Byam Shaw ARWS RI (1872–1919)
Jezebel, 1896
Oil on canvas, 147.6 x 80.5 cm (58¼ x 31¾ in)
Signed lower right: *BYAM.SHAW.96.*

John Liston Byam Shaw was born in Madras in 1872. The family later moved to England where he trained at the Royal Academy Schools. He was part of a later generation of artists who were influenced by the Pre-Raphaelites, an influence very apparent in this painting. He was also a prolific illustrator with a strong feeling for design which shows evidence of the Art Noveau style. The lyricism of his design does not undermine the realism of the carefully studied and painted figures, however, and his training at the Royal Academy is evident. The subjects and style of Shaw's work were Pre-Raphaelite and he based many of his paintings on Rossetti's poems. Here the Old Testament story of Jezebel is treated with a sensuality of colour and form typical of the later Pre-Raphaelite influence. The strong compositional design of the work was extended by Shaw to cover the frame, where reliefs depict Jezebel's death by being thrown to the dogs.

The sensuality of the picture initially caused problems for the artist who was unable to sell it. The model for Jezebel was Miss Rachel Lee, a close companion to Shaw throughout his life, who appeared nude in the painting when it was first exhibited at the Royal Academy in 1896. As Rex Vicat Cole explained, '"Jezebel" … was exhibited at the Academy, but for years remained unsold. Certain people objected to Jezebel's nudity. An offer came subject to this being altered – money was scarce, and the artist unfortunately gave in. The picture as repainted hangs in Bournemouth Art Gallery.'[1]

Shaw himself wrote about the alterations that he made. 'I have put the gold on Jez: and am going to paint designs on top. Of course, it means painting it all up a higher key, but that is all the better. Moira [Professor G E Moira RWS] suggested to me to put Jezebel into a much more mysterious light and shade, so the next day I had to slash at it all over again and took out nearly all I had done since you left, but I think it looks better.'[2] Later he expressed his satisfaction at the work carried out: 'Of course, it is unnecessary to inform you that I am having Jez's canvas altered. I think it is an improvement.'[3]

1. Rex Vicat Cole, *The Art and Life of Byam Shaw*, London, 1932, p.53.
2. Byam Shaw quoted in Cole, op.cit., pp.53–4.
3. *Ibid.*, p.56.

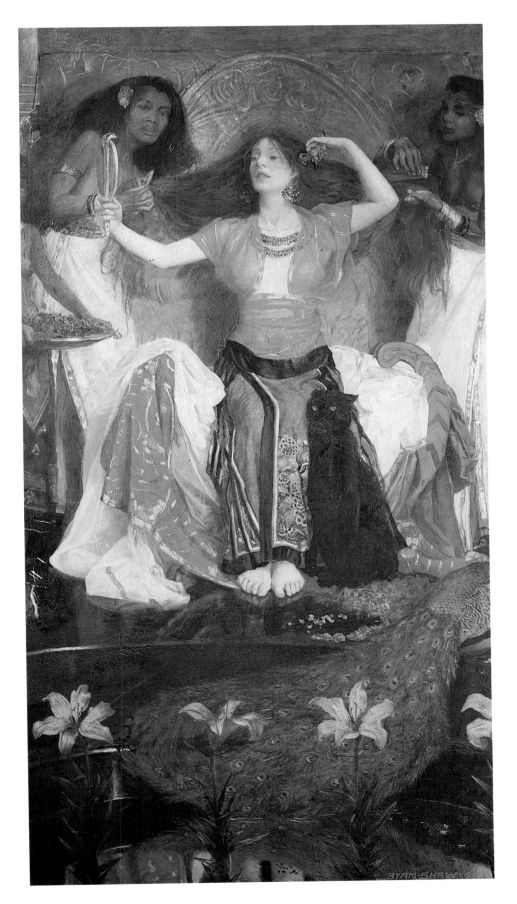

WE ARE NOT A MUSE
Women artists and the Russell-Cotes collection
PAMELA GERRISH NUNN

T he Russell-Cotes collection is unusual in many ways, and one of the most interesting is its large number of works by women. This is conspicuous in comparison with other like collections, resulting in an impressive and valuable selection of the art of nineteenth-century (and twentieth-century) female artists. The typical Victorian collector of contemporary art did not patronise women to any noticeable degree, despite the question of women artists being much debated during the Victorian era, their training opportunities being the object of prolonged wrangling, their ambitions polarising feminist and conservative opinion, and their exhibition appearances provoking endless perorations on the different creative capacity of men and women. For all this, the numbers of women becoming known and successful artists increased markedly as the century developed.[1] Dianne Sachko MacLeod's research has shown, if only by default,[2] that in collections such as the McCullochs', who distinguished themselves as purchasers of new art in the 1890s, the presence of work by female artists was negligible. The valued items were those by the big names such as Frederic Leighton, John Everett Millais, Edward Burne-Jones and George Frederick Watts, and the favoured exponents of whatever trend the collector followed were male, since men's work carried the credibility that led to exchange value. The Russell-Coteses' example has led, however, to this receptiveness to the female artist being maintained in the continuing life of the collection, with further works by women being given or acquired since the founders' deaths: when the widower of Noel Laura Nisbet (1887–1956) gave her self-portrait to the Russell-Cotes Art Gallery and Museum in 1956, he did so because he knew it would be both sincerely appreciated and usefully contextualised (Cat.34).

Although the Russell-Coteses wanted to 'get on' and become noticed in their community, their aim was rather to rise to the very top of the middle class than to slip in to the bottom of the upper class. They did not mean to show their works of art in a pseudo-aristocratic setting which would obtain them entry to the elite – theirs was a genuinely and sincerely bourgeois taste, both unpretentious and catholic. The unpartisan character of the Russell-Coteses' preference therefore ranged through the anecdotal and sentimental, the romantic and the Orientalist, the Neoclassical and topographical, with paintings and sculptures sitting undifferentiated alongside other cultural artefacts such as furniture and ceramics, emphasising the commodification of art typical of the nineteenth century. In the industrialised society that was 'the workshop of the world', paintings were so much product, however unfunctional and luxurious, which the well-off person could buy to embellish his or her personal environment.

This approach favoured the work of female painters, whose rise was spurred by the search for more earning opportunities for middle-class women. Given the socially

Cat.34 Noel Laura Nisbet RI (1887–1956)
Self-Portrait
Oil on canvas, 40.6 x 30.5 cm (16 x 12 in)

Noel Laura Nisbet was an artist and illustrator who worked in both water-colours and oils. Influenced by the manner of Frank Brangwyn (1867–1956), she developed her own distinctive style in the depiction of fairy tales and allegories.

Four of these paintings were bought to exhibit in the Russell-Coteses' Morning Room to complement Anna Zinkheisen's high-camp mythological ceiling (1949).[1] On her death in 1956, her husband, the artist Harry Bush, presented this penetrating self-portrait to the collection.

1. Norman Silvester wrote to Laura Nisbet that they 'suit the room so well that one might imagine you had been commissioned to paint them for it' (25 May 1950, Russell-Cotes Art Gallery and Museum archive). The artist replied that 'I am *very* pleased to be placed in the room with the ceiling painting by Anna Zinkheisen' (28 May 1950, Russell-Cotes Art Gallery and Museum archive).

restricted position of the majority of women artists, their tendency to work in the small to medium scale and the lower prices they were generally expected to ask, collectors such as the Russell-Coteses could easily find their work congenial. Equally, female artists, though often identified with one genre or another, were rarely seen to represent one school or 'ism' or another so served a collector with wide-ranging tastes very well. The collector more orientated towards the latest fashion or with narrower, more decided preferences than the Russell-Coteses would take much less interest in the work of women than Merton and Annie evidently did. It seems as if the Russell-Coteses bought as independently as people could who were badgered by agents and buttered-up by salesmen, on the whole purchasing simply what they liked.

This expansiveness has been perpetuated in the acquisitions that have swelled the collection since their deaths. The earliest work by a woman is Miss Dewsbury's charming painting typifying early nineteenth-century taste in its delicacy of touch

and sylvan setting (Cat.35). Very few professional female artists were known in these pre-Victorian decades: the Sharples women and the sisters Sharpe, Nasmyth and Rayner exemplified the social conditions under which women generally entered the profession in the Georgian period.[3] At this time, a family precedent or link brought a woman into painting, drawing or engraving (very rarely sculpting, though see below)[4] as junior, apprentice or assistant to a father, brother or husband. Regional artistic circles allowed for these women to become established and successful locally, in cities such as Bristol and Edinburgh. Though the distinction between amateur and professional was less clear in these centres than it later became in the art world that focused on the capital, there was no general expectation that women would become professional artists and no systematic provision made for those that did. Even so, clearly the conceptual possibility did exist where circumstances made it desirable for the individuals concerned. But, as Sarah Tytler remarked in 1874: 'of all the women painters whom I have chronicled, I am not aware of one … who did not overcome the difficulty, by the advantage of an early familiarity with art, from having been the daughter of a painter or, at least, of an engraver'.[5]

Cat.35 Miss Dewsbury (early nineteenth-century English)
Great-Grandfather of Donor as a Child
Oil on canvas, 34.3 x 43.2 cm (13½ x 17 in)

Women's place in the professional art world only began to be seriously established in the late nineteenth century. Before this time, with only a few notable exceptions, the majority of women who practised art were amateurs. Miss Dewsbury probably received little art training, yet left this wonderful record of the world around her at the turn of the nineteenth century.

Cat.36 Evelyn De Morgan (neé Pickering) (1855–1919)
Aurora Triumphans, 1886
Oil on canvas heightened with gold,
117 x 172.5 cm (48 x 68 in)
Signed and dated (false signature) lower left: *EBJ 1876*

Evelyn De Morgan's *Aurora Triumphans* is a key work within her artistic career. It represents the goddess of dawn overcoming the bonds of night. The symbolism reflects De Morgan's own spiritual beliefs in the triumph of light over dark, a dichotomy explored in many of her works. Several studies for this painting exist in the collection of the De Morgan Foundation, London. These reveal both an overall symmetrical construction for the original compositional idea and several details more characteristic of her preliminary work and reflective of her time at the Slade under Edward Poynter.[1] The model for Aurora was Jane Hales.

Exhibited at the Grosvenor Gallery in 1886,

the work was originally for sale at the Liverpool Autumn Exhibition in 1891. When Herbert Russell-Cotes purchased the painting is uncertain although it was in his possession by 1922. The work appears to have been passed off as being by Edward Burne-Jones. The false signature 'EBJ 1876' is incorrect in both date and attribution. This is not to suggest that the Russell-Coteses would not have bought the picture had they known its true authorship. (Merton owned Evelyn De Morgan's *Phospherus and Hesperus* although it is no longer in the collection.)[2] Mrs Stirling, Evelyn De Morgan's sister, who knew the work well, wrote to the gallery stating:

I am in a position to deny most emphatically that Burne Jones did one single stroke of the picture AURORA TRIUMPHANS. Though ten years younger than my sister, Evelyn De Morgan, I was alive when she painted it, and saw her painting it. She was then a girl of about 21. ...

I found one of my brother's school-boy letters from Eton not long ago in which he says 'Evelyn is now painting three angels blowing tin trumpets in the sky! WHAT NEXT?'[3]

1. Mark Bills in *Drawings and Paintings of Evelyn De Morgan*, exh.cat., Russell-Cotes Art Gallery and Museum, Bournemouth, 1996, pp.4–7.
2. *Phospherus and Hesperus* (1881), oil on canvas, 23¾ x 17¼ in. Grosvenor Gallery, 1882 (No.204). Russell-Cotes sold the painting at Christie's on 27 April 1904 to Lister for £73 10s.
3. Mrs Stirling, letter to Mr Orr Paterson, c.1951. Russell-Cotes Art Gallery and Museum archive.

Early in the Victorian period, the entry of middle-class women into paid work arose as a central issue in the 'woman question'. Painting was a profession which feminists saw as accessible to those who wished to contest the dependent, domestic life that convention and prejudice envisaged for women of the middle classes. The emergence of the female artist became, indeed, one of the most conspicuous results of the campaign for women's rights in nineteenth-century Britain.[6] What kind of art women might feasibly produce became a much discussed question, the key issue being the hierarchy of genres, by which different kinds of painting (and to a lesser degree sculpture) were ranked by subject matter.

The ambitious end of Victorian women's art, then, tried for the higher rungs of this ladder of genres, with compositions based on the human figure. The most remarkable work in the collection in this light must be Augusta Freeman's marble group *The Princes Sleeping in the Tower* (1862; Cat.75), for not only does it essay the depiction of history but it does so on a scale and in a form generally assumed by prejudice to be physically as well as intellectually beyond women. It is telling that Freeman (1826–c.1870) made this piece in Rome, for it was only there that female sculptors flourished in any number in the nineteenth century. In Britain, as in France, the number of women practising professionally in sculpture would not even tax the fingers of one hand, whereas in the Italian capital many foreign women were able to learn from masters of the art and benefit from the wealth of technical assistance available as well as the ready supply of the art's basic resource, marble.

In painting, figure compositions deriving from history, literature and myth were only feasible for women after some decades of campaigning for decent art training and constructive critical attention equipped them to move up from the imitative genres of still life, landscape and portraiture; this was the case whether they trained in Britain or sought an art education on the Continent. Arguably the gem of the Russell-Cotes Art Gallery and Museum – the marvellous *Aurora Triumphans* by Evelyn De Morgan (1855–1919; Cat.36) – furnishes a good example of the effective use women made of their hard-won access to training in depicting the figure. Strange to say, this painting entered the collection as a work by a male artist. Since the artist's uncle Spencer Stanhope was also a painter, and the habit of likening female artists' work to that of their (allegedly superior) male relatives died hard, it might be expected that the misattribution was to him, but it was instead to Edward Burne-Jones, one of the modern masters of second-wave Pre-Raphaelitism and star of the Aesthetic movement in painting. Indeed, it is signed with his initials and a false date ten years short of its actual age.[7] Although this work was not documented in Burne-Jones's oeuvre, and although the collection did contain, between 1882 and 1904, an acknowledged De Morgan painting, *Phosphorus and Hesperus*, available for comparison its attribution was never called into question until the 1950s when the true artist's sister, Mrs Stirling, a vigorous promoter of Evelyn De Morgan's achievement and reputation and also her biographer, convinced the collection's curator of its real identity.[8] The dimensions of this work and its wonderfully aggrandising frame show off De Morgan's graceful allegory, typical of the ambitious and imaginative painting which, faithful to her own variation of Pre-Raphaelitism, she continued to prosecute until her death in 1919.[9]

The surest sign of the high ambition of a composition was the appearance of the nude, of which De Morgan makes discreet use here: Anna Lea Merritt's *Love Locked Out* (1899, Tate Britain) made history when it entered the national public collection

Cat.37 Amy Sawyer (*fl*.1887–1909)
Gentle Spring Brings her Garden Stuff to the Market, 1896
Oil on canvas, 198.2 x 61 cm (78 x 24 in)
Signed lower left: *Amy Sawyer*

Amy Sawyer studied at the Herkomer School of Art in Bushey. Her style of work owes much to the Arts and Crafts movement and strong decorative elements and rich colour are much in evidence in her paintings. In 1896 she contributed a four-fold screen to the Arts and Crafts Exhibition of which *The Studio* wrote: 'Its harmony of colour is exceedingly sumptuous; pitched in the key of jewels, enamels, or stained glass, it almost succeeds in deluding you into believing that oil-paint can rival crystals, or the plumage of humming birds.'[1] *Gentle Spring* displays a similar translucent colouring and fascination with the designs of nature through its depiction of flora and fauna. The unusual proportions of the canvas, which allow the artist to develop an elegant elongated form, also reflect the influence of the Arts and Crafts movement.

1. 'The Arts and Crafts Exhibition, 1896', *The Studio*, vol.IX, 1897, p.277.

through purchase by the Chantrey Fund, since no new work by a woman had been thought worthy of acquisition for the nation before.[10] The fact that the naked body is of a child, however, bespeaks the caution with which women's efforts at high art were encouraged. The Russell-Coteses' immediate commission of a copy for themselves (by Henry Ford; Cat.28) speaks volumes about the genuineness of their interest in the work of women artists. More allegory showing off an artist's ability to deploy the full-length figure is found in Amy Sawyer's *Gentle Spring* (1896; Cat.37), a Royal Academy exhibit by an artist whose oeuvre has still to be recuperated by present-day scholars. Trained at the Herkomer school, Sawyer (*fl.*1887–1909) shows little trace of her teacher's aesthetic but rather, like Lea Merritt, an affiliation with the classicising work of G.F. Watts, wherein the female figure is used to symbolise abstract concepts set off with decorative augmentations such as the cherub here, and is typically presented in a long, scroll-like format which emphasises the majesty of the protagonist.

Another successful member of the last Victorian generation, coming to prominence in 1901, was Eleanor Fortescue Brickdale who is represented in the collection by a minor but characteristic example. This watercolour *If I could have that little head …* (Cat.38) was probably bought from Brickdale's dealers, the Dowdeswell brothers, in whose galleries her series of illustrations to celebrated literary works were exhibited in synchronisation with their publication in book form.[11] Brickdale was closely related to John Byam Shaw (see Cat.33) as a practitioner of the turn-of-the-century Pre-Raphaelitism which gave literary illustration a new lease of life. Though Brickdale was a regular exhibitor of large-scale oils at the Royal Academy, such 'bits' as this would have been much cheaper – a consideration which is always on the collector's mind – and easier to house – a factor which such busy collectors as the Russell-Coteses also had to heed.

A long-established sector of 'high art' was religious painting, and *The Reception of the Prodigal Son* (1862; Cat.39) by Jane Benham Hay (1829–80) shows one Victorian female artist essaying even this almost sacrosanct genre many years before the others already mentioned ventured into epic territory. Benham Hay was in many ways a very unusual woman, however, and remains rather a romantic and provocative figure. Over a forty-year period, she appeared in London exhibitions with political subject-matter (*England and Italy*, 1859), with history painting (*The Bonfire of the Vanities*, 1867, Homerton College, Cambridge) and with Italian scenes (indicated in the background of *The Prodigal Son*), most of these sent from her self-imposed exile in Italy where she appears to have parted from her English husband, carried on her career while living with an Italian artist to whom she was unmarried, and brought up a child who himself later became an artist.[12] Though her painting shows the limitations that hampered mid-century women in their ambitions to work at the highest level of subject matter, Hay's imaginative group composition also attests to the important revival of religious painting generated by John Ruskin and the Pre-Raphaelites, a circle with which she was acquainted through her radical women friends.

Louise Jopling (1843–1933) and Alice Havers (1850–90) also made names for themselves in figure painting: though the works here are not the most significant in their makers' oeuvres, they are intensely important to the richness of the collection as an anthology of Victorian art. *Phyllis* (1883; Cat.40), a fancy head, was the sort of bread-and-butter work with which Jopling padded out her annual exhibition appearances, not a portrait but evoking a literary character, giving the work another layer of meaning; in 1883, it played second fiddle to her portrait of the famed actress Ellen

Cat.38 Eleanor Fortescue Brickdale (1871–1945)
*'If I could have that little head of hers
Painted on a background of pale gold'*
From 'A Face', Robert Browning
Watercolour, bodycolour and gold ground,
31.8 x 19 cm (12½ x 7½ in)
Signed lower left: *E F B*

Eleanor Brickdale was an artist and illustrator
influenced by the Pre-Raphaelites and early Italian
art. She studied at the Crystal Palace School of Art
and the Royal Academy Schools. In 1901 she had
an important solo exhibition for Charles and Walter
Dowdeswell at their galleries at New Bond Street,
'Such Stuff as Dreams are made of!', which
contained forty-five of her watercolours.

This painting was exhibited at another solo
exhibition at the Dowdeswell Galleries, in June
1909, this time illustrating the poems of Robert
Browning (No.28). These were published in an
anthology of Browning's verse entitled *Dramatis
Personæ and Dramatic Romances and Lyrics* in the
same year. Merton Russell-Cotes purchased several
works from the Dowdeswells and it is likely that
they were the source of this particular work. The
influence of the Pre-Raphaelites is particularly
clear in the use of a nimbus in a secular subject.

Terry as Portia. Similarly, *Sheep in an Orchard* (Cat.42) lacks Havers' usual farmworkers or villagers acting out the homely rituals of rural life, and would thus have been seen as a minor work. Quite characteristic of its author's output, though, is Sophie Anderson's *Capri Girl with Flowers* (Cat.41). Anderson (1823–1903) was a commercially successful female figure painter who came to specialise in a genre which was bound to appeal to such inveterate travellers as the Russell-Coteses. A Frenchwoman, she met the artist husband from whom she took such an English surname in the United States of America and settled in England in 1854. Her move to southern Italy in 1871 (for her health)[13] made such figures as this her stock-in-trade, and the charming young Mediterranean peasant illustrated here is sister to the artist's other staple characters such as those in *The Last of the Day*, *Guess Again* and *Music Hath Charms*. These young peasants appealed to British viewers as exotic without being strange; that they were usually female also speaks of the prevailing taste. No doubt related by its purchasers to Charles Perugini's *Capri Girl*, Edward Radford's *A Grecian Girl* and J.W. Godward's *An Italian Girl's Head*, Anderson's painting sets its heroine against a beautiful Neapolitan sky, holding a tambourine and evoking the *dolce far niente* which Italy could conjure up so easily in the English tourist's mind.

The Continental artists Therese Schwartze (1851–1918) and Henriette Browne (1829–1901) were also important figure painters, as their fine pictures in the Russell-Cotes collection show. The former, primarily a portraitist, was at the height of her fame in the decade when she painted her commanding genre figure *Dutch Peasant* (1883). It shows the Dutch tradition of realistic depiction of everyday life called upon to great effect at this period, when Realism was the established mode throughout Europe. The Frenchwoman Browne became popular in England in 1860 as the painter of devout scenes such as *The Bible Reading* (1857) and *The Nun* (1859, Sudley Art Gallery), and her work was often to be seen on exhibition in London. The Russell-Coteses' selection from her work, *Moorish Girl with Parakeet* (1875), lies not far from the Anderson canvas, conceptually speaking, and shows their interest in Orientalism, complementing as it does the Frederick Goodall paintings in the collection and more especially *Then to Her Listening Ear* by Edwin Long.[14] This line of painting, in which the countries of the eastern Mediterranean and North Africa – essentially, the Arab world – are pictured as exotic, mysterious, exciting and colourful, was even more popular in Browne's native country than in England. The painting in the Russell-Cotes collection was exhibited at the Paris Salon in 1875 while its pale-face equivalent, *The Pet Goldfinch* (1859, Victoria and Albert Museum) appeared at the Royal Academy.[15] It was offered for sale in Britain by one of the London commercial galleries, MacLean's, which made contemporary Continental painting much more familiar to British art-lovers than it had been.

If the varieties of imaginative figure painting practised in the latter half of the nineteenth century were controversial ground for female artists, the lower genres such as still life and portraiture were traditionally acceptable vehicles for women's artistic ambitions. But the portrait of the Sheppard daughters by Louisa Starr (1845–1909; Cat.43), painted in 1888, shows the creative ways in which the self-conscious and determined female painter could resist the limitations of the acceptable. Though typifying a genre in which women tended to be typecast, it breaks the usual rules quite emphatically both in its unusually large scale – 160 by 200 centimetres, which allows for full-length figures – and in its outdoor setting. The sisters depicted here, Kathleen and Mary Anne Sheppard, being shown outside, rather than in a ladylike interior, are

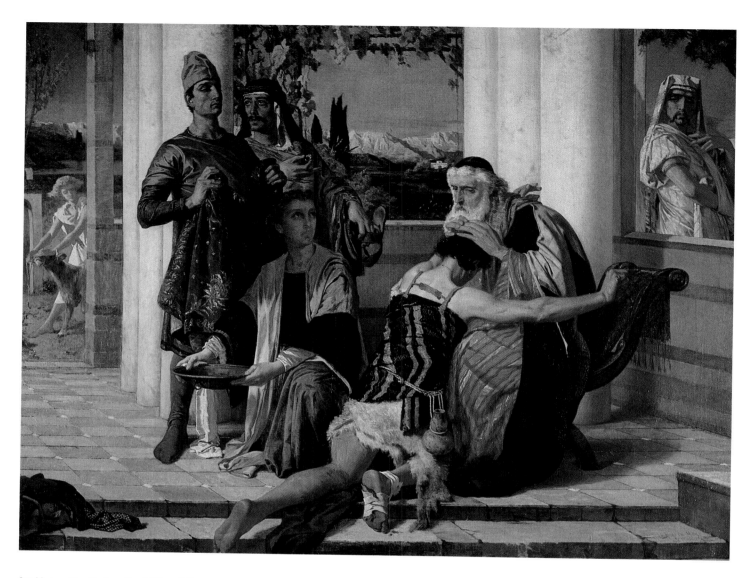

Cat.39 Jane Ellen Benham Hay (1829–c.1895)
The Reception of the Prodigal Son
Father I have sinned against heaven, etc., c.1862
Oil on canvas, 101.5 x 132 cm (40 x 52 in)
Signed: *J E Benham Hay*

Jane Benham was born in December 1829, the daughter of an ironmonger. Her first exhibition was at the Royal Academy in summer 1848 where she showed *Studies from Nature*. She travelled to Munich to study with fellow student Anna Mary Howitt (1824–84) in 1850 and married the artist William Hay in 1851. From 1853 she embarked upon a successful career as an illustrator as well as continuing to paint, producing much work for the

publisher, Heny Vizetelli. Around 1857 she travelled to Italy which made a marked impression upon her, both aesthetically and in terms of its history and her sympathy for its struggle for independence. She showed successfully at the Royal Academy from 1859, exhibiting 'compositions from historical, Biblical and literary sources which made increasing reference to Italian history culture and politics'.[1] *The Reception of the Prodigal Son* was one of these. On its exhibition in 1862, the *English Woman's Journal* wrote: 'one of the best of the rising school is a lady, Mrs Benham Hay. Her work, "The Reception of the Prodigal Son" illustrates that most beautiful of all parables … The whole is painted with great purity and

vigour, and very charming are the glimpses of Eastern landscape and bright tropical sky that form the background.'[2]

The greatest success of her career was the painting *The Florentine Procession*, known as *The Burning of the Vanities* (1867, now at Homerton College, Cambridge). Her last known exhibition was in 1888 and she is thought to have died nearly a decade later in Italy.

1. Jan Marsh and Pamela Gerrish Nunn, *Pre-Raphaelite Women Artists*, exh.cat., Manchester City Art Galleries, 1997, p.109.
2. *English Woman's Journal*, vol.x, 1862, pp.331–2.

stepping beyond the bounds of propriety just as their portrayer is in her professional ambition. An American used to a more progressive society than she found Victorian Britain to be, Starr was only too aware of the difficulties and contradictions of the female artist's position in her time and was no doubt quite deliberately parading her strengths in this commission. Though she first made her name as a star student at the Royal Academy Schools in the 1860s with a history painting – the most elevated genre – she found it was only as a portraitist that she could earn her living.[16] It is a mark of her determination that she used the modest genre to which the female artist was somewhat tied to demonstrate that her abilities deserved better openings. There are many examples of Starr's portraiture in country houses around Britain but none is as splendid as the Russell-Cotes picture.[17]

The domestic was the enduring element of the expectations placed on female artists and, though it dogged them as a group, it was acquiesced in by individuals to their personal advantage. This path is well represented in Laura Alma-Tadema's *Always Welcome* (1887; Cat.44), completely characteristic of her mode. Though this painter (1852–1909) bore a fashionable name, she did not command the prices of her more illustrious (and considerably older) husband Lawrence Alma-Tadema, one of the most popular artists to collect in the 1890s, who had been her teacher. Her Dutch domestic interiors hymning infancy, childhood, maternity and romance stand as a conspicuous expression of sexual difference beside his Neoclassical scenes of Roman life. In this narrow vein of historicised home life evoking the 'little Dutch masters', Laura Alma-Tadema made the feminine pay; she habitually worked on a small scale, with girls as her protagonists, leading her admirers to praise her works for their intimacy, exquisiteness and proper sentiment.[18]

The third artist of the family, Laura's husband's daughter Anna (1865–1943), represents the more 'arty' mode of the Grosvenor Gallery in the more recently acquired watercolour *Drawing-room 1a Holland Park* (1887). Meaning to be independent-minded when it began in 1877, the Gallery was initiated and orchestrated by Lord and Lady Coutts Lindsay, the latter of whom was a deliberate supporter of her sex's cultural activities. The interior's location in an artistic area of London and its self-consciously tasteful style is confirmed by the Rosssetti drawing on the wall, an unmistakeable testament of Aestheticism, the anti-academic trend promoted by the Grosvenor.[19] Exhibiting from 1885 in a range of venues, Anna Alma-Tadema specialised in these finely worked water-colours, which strike out independently of both her relatives' oeuvres.

Not just typical of Victorian women's art but stereotypical is the work of the Mutrie sisters, Martha (1824–85) and Annie (1826–93; Cats 45 and 46), Louise Rayner (1832–1924; Cats 47 and 48), Helen Allingham (1848–1926), Clara Montalba (1842–1929) and Henriette Ronner (1821–1909). Though the last two were Italian and Dutch respectively, all these were familiar names in Britain, known from the Royal Academy, the art press and, in the 1880s and 1890s, the commercial sector, and collected by patrons whose regard for the work of women artists was otherwise conspicuously lacking. These works, small-scale and in the lowly ranked genres of still life, topography, landscape and animal fancies,[20] and in Allingham's and Montalba's cases in the secondary medium of water-colour, exemplify what might be called mainstream taste – Ronner and Allingham were amongst the most popular artists of the 1890s – and what the general public expected from women artists. These small-scale pictures must have been tempting for patrons such as the Russell-Coteses, since their low prices

Cat.40 Louise Jopling (neé Goode) (1843–1933)
Phyllis, 1883
Oil on canvas, 53.3 x 39.8 cm (21 x 17½ in)
Signed and dated lower left: *Louise Jopling 83*

Louise Goode was born in Manchester on
16 November 1843, the daughter of a railway
contractor. She married in 1861 and had three
children before beginning her art education in
Paris in 1867 on the encouragement of the
Baroness de Rothschild. She was outraged
by the exclusion of women from the life room at
the Royal Academy and joined Leigh's School of
Art in London in 1869 instead. She separated from
her first husband in 1871 and remarried in 1874
Joseph Jopling, a less successful water-colour
artist. Louise Jopling became known for her
portraiture and figure paintings depicting fictional
and domestic scenes that pivoted on the
involvement of women. Margaret MacDonald has
written:

> Jopling's paintings included some landscapes,
> but her main area of expertise was portraiture.
> Family and friends modelled for sentimental
> portraits, which were well received. The need
> to customise her work for the market led her to
> produce 'disguised' portraits with emotive titles,
> such as her self-portrait exhibited as *Bud and
> Bloom* ... and a charming profile head in the
> classical mode popularised by Leighton, called
> *Phyllis*.[1]

The Joplings were associated with Oscar Wilde,
James Whistler and James Tissot (1836–1902)
and Louise Jopling's inclusion in the Grosvenor
Gallery exhibitions, where *Phyllis* was shown in
1883, was reflective of her association with the
Aesthetic movement. 'The Grosvenor Gallery was
such a success that, at one time, it was considered
a great compliment to be invited to exhibit in it.
The glamour of Fashion was over it, and the great
help that Lady Lindsay was able to give, by holding
Sunday receptions there, made it one of the most
fashionable resorts of the London seasons.'[2]

1. Margaret F. MacDonald in *Dictionary of Women Artists*,
edited by Delia Gaze, London and Chicago, 1997, vol.2,
p.754.
2. Louise Jopling quoted in Pamela Gerrish Nunn,
Canvassing: Recollections by Six Victorian Women Artists,
London, 1986, p.154.

and small size would never preclude them from being added to the already over-
stocked collection: and, indeed, their currency as saleable items is indicated by the fact
that some of these works were put back on the market when the Russell-Coteses
weeded their collection in 1905, 1910, 1914 and 1919.

That the Russell-Cotes Art Gallery holds as great a variety of work by women as
by men is one of its great strengths as a collection of Victorian art, for a widespread
reluctance to patronise women working on subject matter and in styles not readily
described as feminine persisted beyond the end of the century. A surprising absence,
however, is that of the French painter Rosa Bonheur (1822–99), who from the early
1850s became the very model of the female artist as exemplar of the changing lives
of women in modern society.[21] Her masterpiece *The Horse Fair* hangs in the
National Gallery, and her work was often the sole piece from a woman's hand in a
British contemporary art collection. A major turn-of-the-century addition to the
Russell-Cotes collection does, however, represent all the good that the general public
in Britain felt had been achieved by Bonheur's trailblazing.

This is Lucy Kemp-Welch's *Gypsy Horse Drovers* (1894; Cat.49). Kemp-Welch
(1869–1958) was the best-known female artist in the country when the Russell-
Coteses bought this painting in 1917 and this had been her first success.[22] The
Russell-Coteses knew the artist's family – she had been born in Bournemouth into
the same class – and there was no doubt some local patriotism at work here, for this
purchase was substantiated over the years with *Toilers* (1885?), *Foam Horses* (1896;
Cat.50) and *Autumn Gold* (1933). With these acquisitions, the Russell-Cotes collec-
tion holds its own in a roll-call of public galleries which own Kemp-Welch's work
including Tate Britain, the Imperial War Museum, Exeter City Art Gallery, Bristol
City Art Gallery, and several galleries in the former colonies. The Russell-Cotes
works are completely typical of the artist's output, and yet show the variety which
she injected into her specialisation, horse-painting, her able depictions of the beauti-
ful countryside on the south coast with which she became particularly associated,
and the ability to characterise different animals which made her such an effective
illustrator of the equine classic *Black Beauty* (1915).

One of the reasons Kemp-Welch became celebrated was that she painted on a
large scale, which many people still found almost supernaturally impressive in a
woman artist.[23] But another, which provides a framework for appreciation of the
Gallery's later works by women, was her adherence to the figurative tradition in the
era of modernism.

Modernism raised the historic challenge of abstraction, which was much debated
by British artists, even those who were most responsible for the introduction of
modern art to Britain in the first decade of the new century – Roger Fry, Duncan
Grant, Vanessa Bell – never committed themselves completely to the loss of recog-
nisable subject-matter from painting and sculpture.[24] The Russell-Coteses' own taste
was not for the avant-garde, and the female artists of the twentieth century included
in the collection are Dorothea Sharp (1874–1955), Laura Knight (1877–1970) and
Kathleen Scott (1878–1947) – represented by, respectively, *A Cornish Holiday*
(1936?), *Little Beggar!* (1947), and *George Bernard Shaw* (1933–8) – rather than, say,
Vanessa Bell, Barbara Hepworth and Eileen Agar.[25]

The richness of the Russell-Cotes collection was recognised in its own time. A
long feature in the *Art Journal* in 1895 went into some detail about its contents as
being representative of the century's art.[26] Amongst the illustrations were works by

Henriette Ronner, Laura Alma-Tadema and Therese Schwartze. Despite their presence, the author did not note the Russell-Coteses' particular embrace of the work of women artists, but this is one of the reasons it remains one of the most interesting and valuable public collections of British art nearly one hundred years after the era that gave rise to it. When the Russell-Coteses did decide to draw public attention to their collection, it was as a site of education and information as well as visual gratification; in the lesson it gives on the history of women artists, it remains a remarkable education as well as a real pleasure.

Cat.41

Cat.41 Mrs Sophie Anderson (née Gengembre)
(1823–*c*.1898)
Capri Girl with Flowers
Oil on canvas, 41.3 x 51.5 cm (16 x 20 in)

The artist was born in Paris where she studied art
and lived until 1848. With the outbreak of the
Revolution she left for America with her family.
There she met the English artist Walter Anderson
whom she married. They moved to England in
1854 and lived in Cumberland and Guildford. In
1871 she moved to Capri, returning eventually to
England where she died. This painting is set into
the overmantel of the Morning Room of East Cliff
Hall at the Russell-Cotes Art Gallery and Museum.
It depicts a Capri girl and was probably painted
during the artist's residence there.

Cat.42 Alice Mary Havers (Mrs Fred Morgan) (1850–90)
Sheep in an Orchard
Oil on canvas, 124.5 x 74 cm (49 x 29 in)

Alice Havers was born in Norfolk but lived most
of her childhood in the Falkland Islands. At the age
of twenty she returned to England and studied art
at the South Kensington Schools. She exhibited
at the Royal Academy from 1872 until 1889,
the year before her death. She painted women as
allegorical figures as well as in the workplace.
Her paintings of the countryside veered towards
the idyllic, however, and this painting is more
concerned with presenting an aesthetic response
to the picturesque beauties of nature than typical
life within the Victorian agricultural world.

Cat.42

Cat.43 Louisa Starr Canziani (1845–1909)
Kathleen and Marianne,
Daughters of Samuel G Sheppard, Esq., **1888**
Oil on canvas, 160 x 200.6 cm (63 x 79 in)

Louisa Starr was born in 1845 in Philadelphia, into an Anglo-Italian family who emigrated to England in 1858. She studied at Heatherley's School of Art in London and was one of the students to make the successful transition to the Royal Academy Schools where she studied between 1862 and 1867. Importantly, she was the first woman artist to gain medals there; the first, a gold for copying in 1865, the second, also a gold, for history painting in 1867. Throughout her career she exhibited at the Royal Academy, in Manchester and Liverpool, and at the New Gallery and the Society of Female Artists. She sympathised with causes which included the protection of animals and campaigns for dress reform. These sometimes found their expression in her painting, although she began her career as a history painter who gradually moved towards portraiture in which she excelled.

This painting was commissioned by Samuel Gurney Sheppard, a stockbroker and financier who lived at Potter's Bar, Hertfordshire. The painting depicts his two daughters (prior to their marriages), Kathleen and Mary Ann (or Marianne), set in the grounds of their family home named 'Leggatt's'. To the right is Kathleen, the oldest of the sisters (*c.*1865–1946), with Mary Ann to the left (1868–1943). It is a good example of the artist's work in portraiture. The light and positioning of the figures make it clear that the background and foreground were painted separately. In this way the painting acted as a double portrait of the sitters and the patron's estate. It was important that background was not simply set dressing but an accurate depiction.

Cat.44 Laura Alma-Tadema (née Epps) (1852–1909)
***Always Welcome**, 1887*
Oil on canvas, 37 x 54.6 cm (14½ x 21½ in)
Signed lower left: *Laura T.A.T. Op.LXVI*

Laura Epps was born in 1852, the daughter of
Dr George Napoleon Epps. Often overshadowed
by the work of her husband Sir Lawrence Alma-
Tadema, Laura produced paintings independent
of his influence. She is best known for historical
genre paintings of seventeenth-century Dutch
settings and her paintings tend to focus primarily
on children and often include the figure of the
mother. They are idealised and gentle pictures on

a domestic scale that consider the role of women
and reflect her love of children. Her own room was
filled with Delft-tiled walls as well as objects and
costumes of the period which she used as models
for her paintings. She revelled 'in the details of
domestic life, Dutch habits, Dutch dress of the
gentler and more courtly sort in the seventeenth
century'.[1] *Always Welcome* is a charming evocation
of this period. It focuses on the relationship
between mother and daughter in the rich setting
of a seventeenth-century Dutch panelled bedroom.

1. Alice Meynell, 'Laura Alma Tadema', *Art Journal*, 1883,
p.345.

Cat.45 Martha Darley Mutrie (1824—85)
Roses
Oil on panel, 35.5 x 45.5 cm (14 x 18 in)
Signed lower right: *M.D.M.*

The *Art Journal* wrote in 1869 that 'Ladies have always proved aptitude for painting flowers, and the pretty art is certainly more within their reach than these ambitious arduous walks of the profession to which women clamorous for their right now incline.'[1] Despite this typical account of the time, the flower and fruit paintings of Annie and Martha Mutrie achieved far more than a 'pretty art' and attained a level of 'truth to nature' that ellicited the admiration of the influential art critic, John Ruskin.

The Mutries were sisters who studied, lived and worked together most of their lives. They studied at the Manchester School of Design in the 1850s and exhibited their works for nearly thirty years. Their paintings achieved critical aclaim and Ruskin wrote of them, 'All these flower paintings are remarkable for very lovely, pure, and yet unobtrusive colour – perfectly tender and yet luscious, and a richness of petal texture that seems absolutely scented.'[2]

1. 'Society of Female Artists Thirteenth Exhibition', *Art Journal*, 1869, p.82.
2. 'Pre-Raphaelitism and notes on the principal pictures of the Royal Academy', John Ruskin, *Academy Notes* (1855), *c.*1907, p.57.

Cat.45

Cat.46 Annie Feray Mutrie (1826—93)
Flower Study with Butterfly, **1869**
Oil on panel, 35.5 x 43.2 cm (14 x 17 in)
Signed lower right with monogram: *AFM 1869*

Cat.46

Cat.47 Louise Rayner (1832–1924)
Walmgate Bar, York, **1864**
Water-colour and bodycolour,
19.7 x 29.8 cm (7½ x 11½ in)
Signed lower right: *Louise Rayner*

Cat.47

Cat.48 Louise Rayner (1832–1924)
Cambridge Street Scene
Water-colour and bodycolour,
35 x 24.8 cm (13½ x 9½ in)
Signed lower right: *Louise Rayner*

Louise Rayner was born in Derbyshire in 1832, the
daughter of the artist Samuel Rayner (1806–79).
The family moved to London in 1842, and as she
grew up Louise received art lessons from her
father's many and illustrious colleagues including
Andrew Geddes ARA (1783–1844), George
Cattermole (1800–68) and David Roberts RA.
In the 1860s she became increasingly known as
a topographical artist, illustrating the *Art Journal*'s
1869 feature on the historic Knole House. In 1872
she moved to Chester where she lived for over thirty
years, and spent the last years of her life in
Tunbridge Wells and St Leonards-on-Sea.

 Her work is remarkable for the records she made
of historic buildings in their contemporary settings.
They are invariably teeming with life and provide a
fascinating insight into how places looked in the
nineteenth century. Comparing Rayner's paintings
to the buildings that remain today is a tribute to
her accuracy and diligence. Every detail of
architecture is apparent and rendered accurately
in the minutest of detail. There are several works
by the artist in the Russell-Cotes collection.

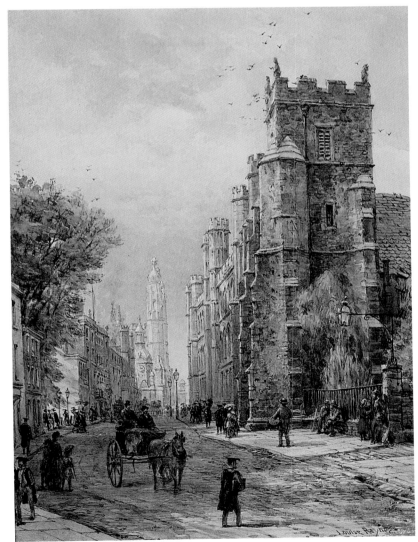
Cat.48

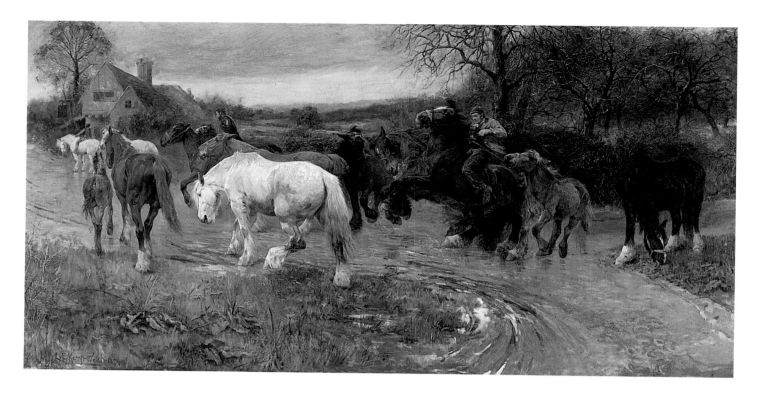

Cat.49 Lucy Elizabeth Kemp-Welch RI ROI RBA RCA
(1869–1958)

Gypsy Horse Drovers, 1894

Oil on canvas, 120.7 x 242.6 cm (47½ x 95½ in)
Signed lower left: *L.E. Kemp-Welch 1894*

Lucy Elizabeth Kemp-Welch was born in
Bournemouth in 1869. She studied at the famous
Herkomer School of Art at Bushey under its
founder, Hubert von Herkomer, and her
achievements there were reflected in the fact that
she took over the school in 1905. She found
success as an animal painter and more specifically
in her representation of horses, for which she
showed particular empathy and understanding.
Gypsy Horse Drovers was her first work to be
exhibited at the Royal Academy and was painted
whilst she was still a student at Bushey. She
recalled how the subject for the work arose:

> On one memorable day ... I saw from our front
> window a long procession of horses of all sorts
> and types going up the muddy road, no doubt to
> Barnet Fair a few miles off. They were
> shepherded and driven by wild-looking gypsy
> men on horseback, with frequent rushes to
> prevent the outliers from getting through the
> gates or turning up the side lanes. Never was
> there such an opportunity. I rushed from the
> house, gathering up my palette and a bit of
> something to paint a sketch on – this turned out
> to be part of the wooden slide out of my paint box
> – and ran after the procession which had now
> halted at a bit of green by a public house before
> going up the long, steep hill. There I made a
> lightning sketch of the scene – my long training
> of quick sketches in the street helping greatly.[1]

The work was envisaged on a large scale and the
artist ordered a canvas measuring some eight by
four feet. She had caught measles and although
she had planned to paint the picture in a large,
rented studio, she found herself confined to her
modestly sized lodgings; when she was able to
begin work on the canvas it was in the cramped
space of a tiny sitting room. It was the practice of
students at the art school to attend regular group
sessions of criticism led by Herkomer. At the next
session Kemp-Welch was able to attend she arrived
with the enormous work, as yet incomplete.

> I was, at the time one of the younger and newer
> students at the great Herkomer school. We all
> used to take any sketches and pictures that we
> did – outside school hours, to show to our Head
> Master, Professor Herkomer, and get a great
> criticism on them (sometimes a nerve-racking
> business – as he was very severe). One day
> amongst a crowd of other students – I stood
> waiting my turn to show my work, at last the
> moment came and I dragged forward my 8 ft
> canvas only half complete – with dreadful
> misgivings. There followed an unforgettable
> moment – the surprise and delight of the master
> – the stir and excitement amongst the students,
> and curiosity to see this work which had moved
> the great painter – sarcastic and severe as he
> usually was – out of his calm. From that day he
> never ceased to be the kindest and sincerest
> critic and guide, that ever a young painter had.
> This is roughly the history of the picture 'the
> Gypsy Horse Drovers' please use this little story
> if you think it of interest, but in this case I
> should like it printed as I have written it –
> without alteration or addition.[2]

Herkomer, when seeing the work completed,
suggested that the next term she should send it
to the Royal Academy. 'I accordingly sent it,'
she recalled modestly. 'It was well hung, but did
not so far as I know attract any particular attention.
That was in 1895.'[3]

Merton Russell-Cotes was a keen admirer of Kemp-Welch, whom he recalled:

> sprang up in a phenomenal way a few years ago, making her mark instantly. She is a daughter of a gentleman I have known for years, who was at one time the principal proprietor of Schweppes' Mineral Water Co. He was for many years chairman of the bench of magistrates, Christchurch. I have in the Russell-Cotes Art Gallery two of Miss Welch's finest pictures; in fact, the one that created the first recognition of her skill and obtained for her great commendation. The first picture she exhibited in the R.A. was in 1894. Her pictures have been bought both for the Chantrey Bequest and for the National Gallery of Victoria at Melbourne, Australia. She has been called the 'English Rosa Bonheur' and she certainly well deserves it, and from my own standpoint I am of the opinion that she will excel this great French artist if she has not already done so.[4]

1. Lucy Kemp-Welch quoted in Laura Wortley, *Lucy Kemp-Welch 1869–1958, The Spirit of the Horse*, Woodbridge, 1996, p.36. The study (oil on panel, 6¼ x 11½ in), was given by the artist to the Russell-Cotes collection in 1956.
2. Lucy Kemp-Welch, letter to Richard Quick (first curator of the Russell-Cotes), *c.*1922 (undated) in the Russell-Cotes Art Gallery and Museum archive; quoted in Wortley, op.cit., p.37.
3. *Ibid.*
4. Sir Merton Russell-Cotes, *Home and Abroad* (2 volumes), privately published, Bournemouth, 1921, p.724.

Cat.50 Lucy Elizabeth Kemp-Welch RI ROI RBA RCA (1869–1958)

Foam Horses, 1896

Oil on canvas, 51 x 91.5 cm (20 x 36 in)
Signed and dated lower right: *L E Kemp-Welch 1896*

The depiction of horses emerging from sea foam is a powerful image. It was used by the artist G.F. Watts in his painting *Neptune's Horses* in 1892, which may have influenced Kemp-Welch's own depiction four years later. The power and force of the charging horses is explored through the relentless movement of waves. The execution of this painting just preceeded that of the artist's masterpiece, *Colt Hunting in the New Forest* (1897) in the Tate Britain Collection, which depicts a group of horses running through the undergrowth directly towards the viewer.
Laura Wortley writes that *Foam Horses* 'gave Lucy the opportunity to experiment with structures for *Colt Hunting* before embarking upon the full-scale composition.'[1]

1. Laura Wortley, *Lucy Kemp-Welch 1869–1958, The Spirit of the Horse*, Woodbridge, 1996, p.42.

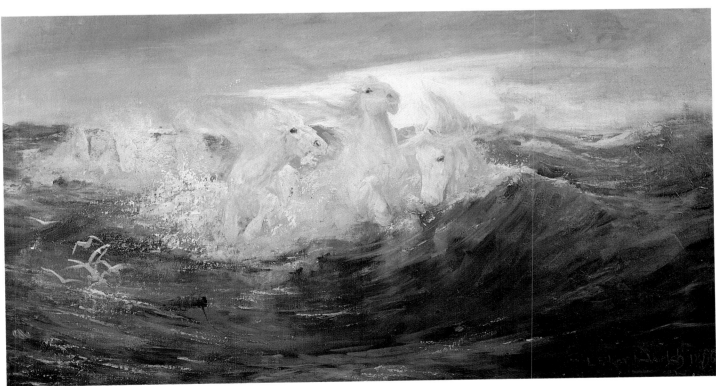

Cat.50

LANDSEER, ANIMALS
and the RUSSELL-COTES COLLECTION
MATTHEW CRASKE

When in February 1919 Princess Beatrice opened the new exten-
sion to the Russell-Cotes Art Gallery and Museum she declared to the founder a
particular interest in Edwin Landseer's *Flood in the Highlands*. The Princess recalled
that she had first seen the painting in the villa of Monsieur Flatow on the Riviera.[1]
Flatow, an entrepreneurial French dealer, had employed the painting as a star exhibit
in one of his celebrated touring art shows. Having made his money from showing
the painting, Flatow sold it to Russell-Cotes at cost price, one thousand five hun-
dred pounds.[2] It was to prove the second most expensive painting that Russell-Cotes
ever purchased.[3] He had not paid over the odds. By 1864, when Flatow acquired the
work, a copy of a much heralded *tour de force*, Landseer was probably the most
famous of all living English artists. Expecting remuneration consistent with his
fame, he seldom parted with a major work for under one thousand pounds. Such
was Landseer's renown with the British public at large that he was able to charge
three or four times the cost of a canvas for the rights to reproductive engraving.[4] His
death in 1873 was received as an occasion for national mourning.[5]

That a specialist in animal painting could attain this level of celebrity alerts us not
just to the status of this genre within the mid-Victorian art scene but to a broader
national preoccupation with hunting and pet-keeping. Since the early eighteenth
century, animal painters had thrived in Britain as nowhere else in Europe, although
for much of that century the popularity of the form had not entirely been translated
into respect for its practitioners. The author of *A Call to Connoisseurs*, a tract on the
visual arts published a century before the sale of *Flood in the Highlands*, was not
being controversial when he explained to his readers that animal painting was the
lowest branch of the profession.[6] The gap between the popularity and status of this
type of painting gradually closed between the 1760s, the decade which saw the rise
to fame of George Stubbs (1724–1806), and the 1820s, when the young Edwin
Landseer began to exhibit his works. Landseer arrived on the scene at a propitious
time. James Ward (1769–1859) had demonstrated through works such as *Fighting
Bulls with a view of St Donats Castle* (1803), now in the Victoria and Albert
Museum, that animal painting could be executed in the highest of stylistic milieu, in
this case the manner of Rubens. The enthusiasm for the selective breeding of dogs
and other forms of livestock had reached unprecedented levels, boosting the market
for images of prize specimens. A decade after Landseer first appeared on the London
art scene the Scottish Highlands became, as never before, a central locus for the
indulgence of the British aristocratic passion for hunting. Landseer was to have the
good fortune to be able to express, as no other artist could, the ideals, dreams and
aesthetics which perpetuated the national preoccupation with this wild and, despite

Fig.18 Samuel Cousins RA (1801–87),
after Sir Edwin Henry Landseer RA (1802–73),
Self Portrait, ('The Connoisseurs'). Engraving.

Fig.19 Sir Edwin Henry Landseer RA (1802–73), *The Old Shepherd's Chief Mourner*, 1837. Oil on canvas. Victoria and Albert Museum, London.

its growing accessibility, remote region. Much as the novels of Sir Walter Scott introduced the British Empire to the rugged Caledonian landscape, the paintings and prints of his friend, Edwin Landseer, became the medium through which an entire people came to envisage Scotland and its animals.

Russell-Cotes's comments on Landseer in his voluminous memoirs are revealing. An inveterate social climber and name-dropper, he seems to have recognised a fellow spirit in Landseer. His admiration of the artist's work was reinforced by the knowledge that he had been 'almost a *persona grata* with Queen Victoria and the Prince Consort'.[7] Russell-Cotes's sycophantic attraction to celebrity meant that he was generally most captivated by the works of famous artists whom he could claim as friends. Landseer was, probably, too exalted a figure to be courted in this way. A distant admirer, Russell-Cotes developed a taste for the type of sentimental canine dramas that Landseer had invented and popularised. Two paintings that he purchased, *The Dog's Home* by Walter Hunt (1860–1940; Cat.53) and *Tick-tick* by Briton Riviere (Cat.57), clearly belong to this genre. It was, indeed, for Riviere, a more reliable sentimentalist than Landseer, that Russell-Cotes reserved the title of 'the most distinguished artist in the portrayal of animals'.[8]

In his memoir Russell-Cotes praised Landseer as a purveyor of 'the highest sentiments'. He singled out *The Old Shepherd's Chief Mourner* (1837; Fig.19) as the artist's master work, describing it as 'very pathetic'.[9] It is probably no coincidence that this work, which features a sheep-dog mourning beside his master's coffin, had been highly praised by John Ruskin, the critic whose opinions upon art he most valued.[10] Russell-Cotes's reference to the pathos of this painting may well have derived from Ruskin's description of it as 'a touching poem upon canvas, which, it cannot be doubted, has caused many a stout heart to "play the woman" by moving it to tears'.[11]

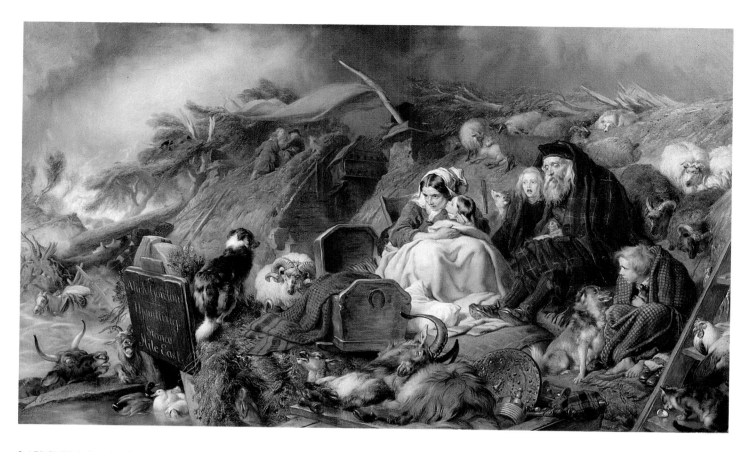

Cat.51 Sir Edwin Henry Landseer RA (1802–73)
***Flood in the Highlands**, 1864*
Original work exhibited at the 1860 RA exhibition
(Aberdeen Art Gallery).
Oil on canvas, 69.5 x 121.7 cm (27¼ x 47¾ in)

Edwin Landseer was born in London, the son of
John Landseer ARA, an eminent engraver. He was
precociously talented and first exhibited at the
Royal Academy in 1815 at the age of thirteen.
He was elected an Associate of the Royal Academy
at the age of twenty-four, Royal Academician five
years later in 1831, knighted in 1850 and elected
President of the Royal Academy in 1866, a
position which he declined to accept.

This painting is a reduced copy by Landseer of
Flood in the Highlands, painted in 1860 and now
in Aberdeen Art Gallery. It depicts the 'Muckle
Spate' of 1829 in Morayshire, floods that resulted

from unusually high rainfall on 3 and 4 August,
which had fed the rivers from the Cairngorm
Mountains and Mondahliath Hills. The flooding
caused widespread destruction, homelessness and
loss of life. The scene in Landseer's painting
represents Dandaleth, a farm below Craigellachie
where the waters of the Fiddick and Spey combined
and swept through the countryside. The main
protagonists of the drama are Alick Gordon,
proprietor of the inn for cattle drovers, his wife
and children who are sheltering on the roof.
The painting also depicts a proliferation of wildlife
sheltering alongside the family and reveals the
artist's skill in depicting convincingly the reactions
of animals.

The replica was commissioned in 1864
by Louis Victor Flatow, an art publisher whom
Merton Russell-Cotes recalled with typical
exaggeration as 'a great French dealer ... the first

man to commission the leading artists to paint
pictures for him almost regardless of the cost.
With these pictures he toured the country for the
purpose of obtaining subscribers' names ... [for
print sales] and this arrangement he carried on for
years and made a huge fortune, eventually building
a villa and settling down on the Riviera.'[1]

1. Sir Merton Russell-Cotes, *Home and Abroad*
(2 volumes), privately published, Bournemouth, 1921,
p.722. Flatow was an extraordinary character described
by Jeremy Maas as 'coarse, illiterate, without an "h" to his
name, appallingly vulgar, an excellent mimic, and an even
better ventriloquist. He was withal a much-loved character
and his early death was mourned by many artists. He was
alleged to have begun his career as a purveyor of
fraudulent Old Masters, before setting up as a chiropodist
... Thereafter he became one of the leading dealers in
London.' Jeremy Maas, *The Victorian Art World in
Photographs*, London, 1984, p.197.

The Old Shepherd's Chief Mourner is a celebration of that quality of fidelity which, since antiquity,[12] had been deemed to be the prime ennobling characteristic of the dog. The suggestion that there is within brute nature the trace of instincts beyond the base drive to survive, such as the capacity for grief and self-sacrificial loyalty, was deeply attractive to mid-nineteenth-century English sensibilities. It was no coincidence that the similar tale of Grey Friar's Bobby, the Edinburgh terrier who would not desert his master's grave, proved popular in this era. These stories tended to ease the fear, which Landseer himself explored in *Flood in the Highlands* and other pictures, that the primary forces of Nature were cruel and unsympathetic.

Russell-Cotes realised that *Flood in the Highlands* (Cat.51) was not intended to present a comforting vision of Nature. He described it as 'a most forcible and telling picture of what occurs occasionally in the Highlands of Scotland, when the water rushes down the mountain sides, carrying everything before it with appalling swiftness'.[13] The main theme of the painting, the arbitrary consequences of Nature's sudden violence, was a severe challenge to those who wanted to sustain the comforting illusion of the benign purpose behind God's creation. A contemporary twist upon the story of Noah's Ark, the narrative of the painting provided none of the reassurance of God's just retribution found in its biblical prototype. It belongs to a category of Landseer's art which exposes the bleak melancholy side to his personality that came to the fore in the mental illness of his old age.

The dark implications of *Flood in the Highlands* were noted by some contemporary observers, in particular a contributor to the *Athenaeum*. This reviewer described the scene depicted as a 'catastrophe' and noted that a major theme within it was the futility of the Highlanders' frail hope of evading the destruction of their world. He observed that the horse and cart in the background had 'already been swept past the place of safety'.[14] Thus, it was clear that the efforts of the three men perched on the thatch attempting to secure the animal with a rope were in vain. The critic found in the image of a 'breathless' and 'exhausted ox' another metaphor of vain hope. He noted how the creature 'with bloody nostrils and eyes possessed with the madness of fear, strives in vain to save itself. The dumb agony of the beast is fearful, being now spent with the violence of the flood which sweeps its flanks, the forefeet wrestle fruitlessly, and the animal will soon be borne away to destruction.'[15]

The critic rightly surmised that the animals and human beings who have found shelter upon the roof in the foreground were by no means certain to escape the same fate as the ox. In the distance two huge uprooted trees are being washed down the gorge threatening the arrival of another great wave that is likely to overwhelm the family, carry off its treasured heirlooms and drown those beasts that they have managed to rescue. It was observed that the mother with child saw 'in the struggling beast a presage of death for both'. Pessimistically, Landseer did not show the woman reacting to the threat with maternal selflessness. The critic observed that fear has caused her to exhibit a 'momentary indifference to the child'. This character's response to danger is not noble bravery but unbridled fear:

> The woman's action tells the horror and fear predominating in her soul … she glares at the approaching torrent out of large rounded eyes, that have no glance for the infant. … Her jaw is set back, paralysed with dread; her mouth is open, the lips are retracted and hard, her eyebrows are up and yet compressed, her cheek is pallid and rigid with lines of fear, her hair is dishevelled and her dress is disarrayed.[16]

Some gloomy details in the picture were not commented upon by the critic. Most

obvious was the inverted lucky horseshoe upon the cradle, luck being the only hope of the family in their peril. Beneath this was an even more disconcerting detail: a group of ducks happily frolicking in the water beside the head of the drowning ox. It is likely that Landseer intended to comment upon the manner in which the hand of fate randomly distributes misery and contentment, for the painter had devoted a major work, *A Random Shot* of 1848, to this sobering reflection.[17] The ducks' disregard for the sufferings of those beasts around them may well be considered as a metaphor for that indifference to other's pain which characterises the majority of animal life. This theme is sustained by the image of the cat upon a ladder in the right-hand corner who takes the opportunity of the disaster to steal a meal. The cockerel and hen who sit powerless as the cat consumes the substance of their future family were probably intended as a portent of how the flood will in the next few moments devour the baby.

Near to this cat Landseer placed the image of a hare attempting to escape the water, clearly an animal metaphor for the notion of desperation. The critic of the *Athenaeum* explained the meaning of this detail admirably: 'Close under the eaves of the house, and just emerging from the water, is a poor hare, endeavouring to burrow away into the thatch, with struggling feet and ears laid back; the flood has brought this timorous beast into the neighbourhood of man and it is pitiful to see its frantic efforts to make a place of refuge in the very habitation of its enemies.'[18]

In summary, Landseer depicted the consequences of natural disaster to be fear, vain hope, indifference, cruelty and despair. There was virtually no trace of the sentimental consolation – found, for instance, in the final drowning scene of Dickens's *Great Expectations* (published 1853) – that tragedy would prove a providential opportunity to reveal compassion and bravery.

That this painting offered none of these consolations is all the more remarkable because Landseer's career had been built upon works that offered such solace. The most notable example of such sentiments can be found in *Attachment* (1829), a painting on the familiar theme of a dog's fidelity. This work was based upon a poem by Walter Scott entitled 'Helvellyn' which tells the story of man who fell to his death upon that mountain. His body lay undiscovered for three months, for which time his faithful dog stood guard over it. As the contrast between the wild unforgiving rocky landscape and the affectionate tenderness of the dog intimates, Landseer's theme was the manner in which a dog can form the exception to the pitiless manifestations of Nature. This theme was present in Scott's poem:

Dark green was the spot mid the brown heather,
Where the Pilgrim of Nature lay stretch'd in decay,
Like the corpse of an outcast abandoned to the weather,
Till the mountain-winds wasted the tenantless clay.
Nor yet quite deserted, though lonely extended,
For faithful in death his mute favourite attended,
The much loved remains of his master defended,
And chased the hill-fox and the raven away.

Whilst this painting is not one of those works in which Landseer celebrates the culture of hunting, it can be seen to reflect some of the conventional philosophical attitudes to the chase, in particular the belief that in the raw and dispassionate realm of Nature man could only rely upon his companions and domesticated animals to be his friends. This idea increased in importance as, in the mid-nineteenth century,

Cat.52 Louis Bosworth Hurt (1856–1929)
Caledonia, Stern and Wild, **1907**
Oil on canvas, 127 x 101.6 cm (50 x 40 in)
Signed and dated lower left: *Louis B. Hurt, 1907*

Louis Bosworth Hurt was born in Ashbourne, Derbyshire in 1856. He studied art in London and under the Derbyshire landscape artist George Turner (1843–1910) and was influenced by the animal paintings of Sir Edwin Landseer and the Scottish landscapes of Peter Graham RA (1836–1921), to whom he is often compared. He was fascinated by the mountainous glens of Scotland and by Highland cattle which he regularly depicted in their atmospheric settings, but most of his paintings were actually executed in his studio, 'Ivonbrook', in Darley Dale, Derbyshire.

The title of this painting, *Caledonia, Stern and Wild*, is a quote from Sir Walter Scott and is indicative of the artist's subjects in general. His paintings were extremely popular, particularly this one, of which he painted three versions; this is the original, one was painted for the Sydney Gallery in Australia in 1907, and the third version is in a private collection in the United States.

Sir Merton and Lady Annie Russell-Cotes were friends of Louis Hurt and stayed at 'Ivonbrook', purchasing many works for the collection. 'Among all my artistic friends,' wrote Sir Merton, 'I esteem none more than my old friend, Louis B. Hurt, for whom and his charming wife I have the deepest affection. The feeling is participated in by my beloved wife …. His principal style is similar to that of Peter Graham and McWhirter, but in my opinion he is more varied in the subjects chosen and treats them in a more powerful manner, than either of these artists.'[1]

1. Sir Merton Russell-Cotes, *Home and Abroad* (2 volumes), privately published, Bournemouth, 1921, pp.707–8.

hunting society focused upon very wild and remote landscapes such as the Highlands of Scotland or the Lake District: in this world the kindly gilly became a hero as did the loyal dog and patient Highland pony.

Like the majority of English artists who specialised in animal painting from the early eighteenth century onwards, Landseer was not just a recorder of hunting but a participant. As such he was probably entirely familiar with the notion that the hardy huntsman was meant to discover through the chase a knowledge of the cruelty of Nature and recognise the manly imperative to participate within that cruelty. This idea was enshrined in sporting initiation rituals such as 'blooding' and celebrated in numerous eighteenth-century paintings which equate a young gentleman's coming of age, and accepting the responsibilities of his manhood, with the act of shooting a bird.[19] This convention had its most beautiful expression in Allan Ramsay's *Portrait of Thomas 2nd Baron Mansel of Margam with his half brothers and sister* (1742) now in the Tate Britain Collection. In this painting a young male heir is seen to return to his siblings with a recently shot partridge. His calm indifference to the death of the bird is contrasted with the sentimental response of his sister whose sex is deemed to render her timid in the face of the cruelties of Nature.

Whilst it is reasonable to interpret Landseer's interest in that cruelty as a sign of his melancholy tendencies, it is also best to remember that this harsh view was part of the wider prerogative of sporting manhood. Before Landseer, Stubbs had also acted from the huntsman's assumption that Nature was a cruel element, this idea being most dramatically expressed in his series of paintings on the theme of the horse being attacked by a lion (1762–70). The horror of Stubbs's imagery was exceeded by Landseer upon at least one occasion, most notably in his *The Otter*

Cat.53 Walter Hunt (1860–1940)
The Dog's Home, 1883
Oil on canvas, 101.6 x 169 cm (40 x 66½ in)
Signed lower left: *W. Hunt*

Walter Hunt was a painter of animals like his father Charles and his brother Edgar. Walter specialised in the painting of dogs and his most famous work, *Dog in the Manger*, was bought by the Chantrey Bequest and is now in Tate Britain.

This painting was simply but accurately described by the *Art Journal* as 'A clever group of dogs of various sorts'.[1] The artist was very skilled in his depiction of such a wide variety of dogs and clearly spent a long time observing them. The young puppy, the sleeping and tethered dog, show a variety of empathetic expressions that directly appeal to the sentiment of the viewer.

1. *Art Journal*, 1883, p.219.

Speared, a celebration of the otter hunt of the Earl of Aberdeen. This image disgusted numerous tender-hearted commentators upon its exhibition at the Royal Academy in 1844. One voiced his feeling of regret:

> that the genius of the painter should have been employed on a subject so revolting, and from which one so gladly turns away. What can be much more painful to look upon than the wretched animal held aloft and writhing upon the point of a man's spear, with a pyramid of hounds about him, some in the stream of water at the man's feet, others on the high bank above him and other climbing and leaping around him, but all vociferating and struggling to get at the victim.[20]

This review alerts us to the fact that Landseer both harmonised with and transgressed mid-nineteenth-century tendencies to sentimentalise the animal kingdom. The more closely he became associated with sweet anthropomorphic works such as *Dignity and Impudence* (1839), the more his huntsman's transgressions had the power to shock.

The *Otter Speared* is, like the majority of Landseer's hunting paintings, an image of death. In the tradition of Stubbs's series of paintings, the work exploits the potential of animal imagery to form a thought-provoking spin on the notion of the *memento mori*. The expectation that observing the death of animals would invite thoughts on human mortality went back much before Stubbs. The great hunting still lives of Frans Snyders (1579–1657), an artist with whose work Landseer was highly familiar, frequently employ the image of dead game as a focus for such meditations. Landseer's contributions to this genre are numerous. A fine set of engravings published in 1846 under the title of *Landseer's Deer Stalking in the Highlands* makes this point most clearly. The book begins with a monumental image of an antler trophy which forms an introductory *memento mori*. Each print of dead deer thereafter carries an inscription reflecting upon mortality. This theme was developed in Landseer's fine images of a combat between and subsequent death of two Highland stags entitled *Night* and *Morning* (1853). The latter bears the following inscription:

> Locked in the close embrace of death they lay,
> Those mighty heroes of the mountain side,
> Contending champions for the Kingly sway,
> In strength and spirit matched, they fought and died.

Landseer's biographer, Cosmo Monkhouse, assumed that these paintings, and another major work devoted to stags' competition for mates entitled *None but the Brave Deserve the Fair* (1838), were the artist's commentaries upon 'natural selection'.[21] If so, it is unlikely that Landseer derived the idea from Charles Darwin, who published his *Origin of the Species* (1859) some years after the artist had completed these works. Nevertheless, the concept of 'natural selection' had been current amongst breeders of animals since the 1830s and Landseer could have heard of it. It is possible that this concept contributed to Landseer's appreciation of the cruelty at the heart of Nature's system.

Despite such dark reflections upon the mechanism of Nature, Landseer was known to his contemporaries as a pious man.[22] He was, apparently, capable of preventing his vision of the brutality of God's creation from eroding entirely his belief in the goodness of his creator.[23] Indeed, in later life he was prone to making spontaneous expostulations upon that goodness.[24] It is not unreasonable, however, to reflect that the vehemence of these outbursts may well have been fuelled by the intensity of his doubts and fears.[25] Had Russell-Cotes known of these tortures it is

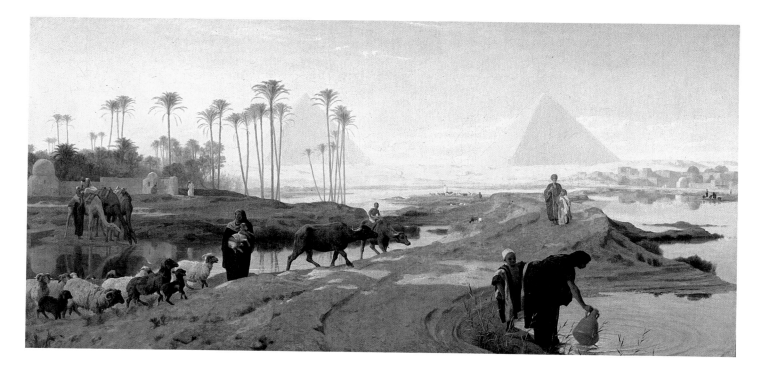

unlikely that it would have increased his admiration of the artist, for the collector had little patience with troubles of faith. In the introduction to his biographical memoirs, he explained his view that the duty of man was to learn to appreciate 'with childlike simplicity ... the beauty of the world and the benefice of God'.[26] He launched into an extensive diatribe on the evils of modern secularism, putting forward the argument that the horrors of the First World War were the consequences of a century of European diversion from the virtues of a simple unquestioning faith. Whilst the decay of German culture was most stridently blamed for the war, his fellow Englishmen did not escape censure:

> We cannot quite go forward with clean hands ourselves when England has produced such men as Darwin, Huxley and Bradlaugh, Keir Hardie and many others who seem to have come into the world to undo all the happy, restful and contented faith of the Christian era. It seems incredible that in the Victorian age such men as the former should have their names perpetuated by being buried in Westminster Abbey.[27]

Landseer was no obvious champion of Darwin. He was, however, the child of an intellectual culture that found itself drawn towards the notion of Nature as an amoral system which was difficult to match with a 'simple' belief in the Creator's 'benefice'. In so far as *Flood in the Highlands* expressed a harsh and pessimistic view of nature, it could not have been expected to generate a 'happy, restful, and contented' response. These three words do, however, perfectly describe the animal imagery of another painting purchased by Russell-Cotes, Frederick Goodall's *The Subsiding of the Nile* (1873; Cat.54). This work was painted in Goodall's studio in St John's Wood close by that of Landseer, and held by the painter as an opportunity to use as models a flock of Egyptian sheep that he had introduced to his suburban garden.[28] Goodall placed these sheep in a landscape familiar from the Old Testament and bathed them in a pale yellow light of biblical nostalgia. In this comforting image of water subsiding and animals peacefully walking to pasture Russell-Cotes acquired the complete antithesis to Landseer's reworking of the theme of Noah's Ark.

Cat.54 Frederick Goodall RA (1822–1904)
***The Subsiding of the Nile*, 1873**
Oil on canvas, 75 x 151.1 cm (29 x 59 in)
Signed with monogram and dated lower left: *FG, 1873*

Frederick Goodall came from an artistic family. His father, Edward, was an engraver and his brother, Edward Alfred, was a painter and illustrator. His own first paintings were rustic genre scenes in the manner of Sir David Wilkie. From 1860, however, his reputation was established with his paintings of Egypt and biblical genre scenes. Goodall visited Egypt on several occasions and collected around him models for the details of his pictures including date palms and even a small flock of Egyptian sheep which were quite tame and lived in his garden.[1]

The Subsiding of the Nile is a copy painted by Goodall of his 1873 Royal Academy picture (No.292), which sold at Christie's in 1888 for £1522.[2] He wrote of the original that it was painted in his London studio and was the first picture to use his flock of Egyptian sheep as models,[3] combined with 'studies I have made for it in the immediate locality, especially the ancient causeway supposed to have been built for transporting the stones of which the Pyramids are built ... The most beautiful time of the whole year is when the Nile overflows almost to the foot of the Pyramids. As it subsides, there almost immediately springs up on the higher portions of the land the

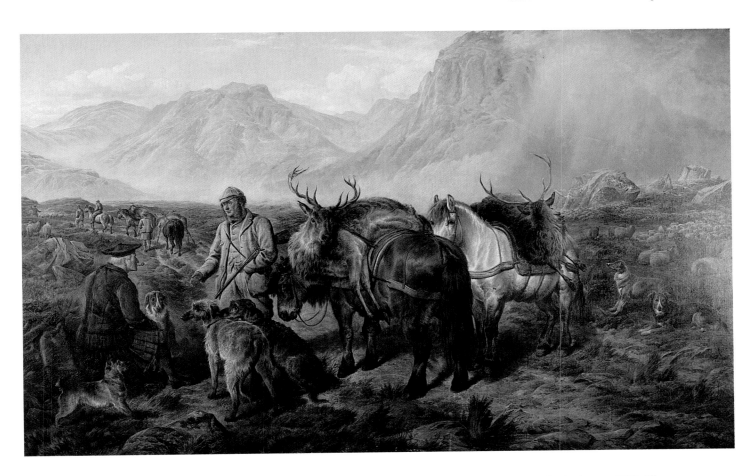

vegetation which affords without any cultivation an immense quantity of food for the Bedouin flocks.'⁴ Goodall painted many very similar scenes of matching proportions, including *The Water of the Nile*, *The Flooding of the Nile* and, in particular, *The Ancient Causeway* (RA 1898), which takes almost exactly the same viewpoint and includes a flock of sheep.

Merton Russell-Cotes was a great admirer of Goodall, whom he described as his 'old friend'. He owned many works by him, several of which are no longer in the collection, such as *The Palm Offering* (RA 1863) and *The Sackiyeh*, as well as a palette owned by the artist.⁵ He wrote, as he did of many other artists, that 'amongst all our artistic friends, there is none for whom we had a more sincere regard than Mr. Frederick Goodall R.A. He ought to have been President of the Royal Academy; a remarkably handsome man and unusually courteous and genial, with a quiet personal dignity of manner. As a kindly host, he was to the manner born, on our visits, no one could have afforded us more cordial hospitality than did he and his wife.'⁶

1. Russell-Cotes recalled his studio as 'decorated with all kinds of Eastern trophies, mostly those he collected in Egypt and used by him as models in painting his beautiful Eastern subjects ;' *Home and Abroad* (2 volumes), privately published, Bournemouth, 1921, pp.722–3.
2. The original was purchased by Mr Gambart for 1200 guineas, sold to Sir William Agnew and then to Mr Orr of Glasgow in 1902.
3. 'Norman Shaw had made me a grand painting-room, where I painted some of my most important pictures … "Subsiding the Nile", a picture twelve feet long, in which I introduce my Egyptian sheep.' *The Reminiscences of Frederick Goodall R.A.*, London and Newcastle, 1902, p.283.
4. *Ibid.*, p.384.
5. 'The collection of Merton Russell-Cotes, Esq, JP, the Mayor of Bournemouth', *Art Journal*, 1895, pp.216–17. *The Sackiyeh* is illustrated on p.216. *The Palm Offering*, one of Goodall's most important works, is illustrated in Russell-Cotes, op.cit., facing p.722. It went up for auction in 1905, was bought back by him at a later date and was sold by the Museum in 1961.
6. Russell-Cotes, op.cit., p.722.

Cat.55 Charles Jones RCA (1837–92)
Bringing Home the Deer, 1867
Oil on canvas, 147.3 x 236.2 cm (58 x 93 in)
Signed and dated lower right: *C Jones, 1867*

Charles Jones was born in 1837 at Mile End, Middlesex, the son of the artist S.J.E. Jones. At twenty-one he went to live in a farmhouse at Maidenhead, where he painted farm animals. He became known as 'Sheep' Jones and indeed there is a Jones painting in the Russell-Cotes collection depicting sheep. Around 1890 he won a medal at the Crystal Palace for his painting.

For the last twenty years of his life Jones painted in Scotland, particularly Argyllshire and along the west coast. It was here that he painted this work. This was a period when stag-hunting in the Highlands reached the height of its popularity, particularly amongst the *nouveaux riche*. The weekends of mass slaughter by rich British and Americans are idealised in works such as these, which were eagerly collected by hunters and aspiring middle-class patrons alike.

Cat.56 Joseph Farquharson RA (1846–1935)
The Silent Evening Hour, 1911
Oil on canvas, 129.5 x 101.6 cm (51 x 40 in)
Signed lower right: *J Farquharson*

The Scottish painter, Joseph Farquharson, was born at Finzean in Aberdeenshire in 1846. He moved to Edinburgh and was initially taught by the artist Peter Graham RA, a friend of the family. He then studied at the Board of Manufacture School in the city under the superintendent, Mr Hodder, where he learnt the skills of life-drawing and figure-painting. He began exhibiting at the Royal Scottish Academy in 1859 and the Royal Academy from 1873. In 1880 he began two years study under the French artist Carolus Duran in Paris.

His first painterly ambition was to establish himself as a figure painter and in the 1880s he came under the influence of the social realism movement, led in Britain by artists such as Hubert von Herkomer, Thomas Faed (1826–1900) and Luke Fildes. This influence is evident in Farquharson's important works, which include *Joyless Winter Day* and *Where Next?* Phipps Jackson wrote in an 1893 *Art Journal* article that Farquharson found a more optimistic approach in the mid-1880s with works like *The English Vintage*, although this painting clearly depicted the hardships of hop-picking. Farquharson underwent a radical change in subject in the late 1880s and moved towards the depiction of landscapes and more particularly of the animals in it, and Jackson was right when he wrote that 'Mr Farquharson is fond of sheep pictures'.[1] It is within this area of painting that he is now primarily known, developing his own distinctive style in atmospheric Scottish scenes. In this he has many similarities to Peter Graham and Louis Bosworth Hurt, although he remains the most well-known.

In 1929, when this work was purchased by the Russell-Cotes Art Gallery and Museum, the then curator, Richard Quick, wrote to the artist at his home and studio at Finzean. (This had originally been owned by Farquharson's brother, who gave it up when he succeeded to an estate.) The letter included a photograph for identification. 'Thank you for the photo,' he replied, 'which is an excellent one. I remember the picture... It was painted not far from my home here.'[2]

1. Mr Phipps Jackson, 'Mr Joseph Farquharson and his works', *Art Journal*, 1893, p.155.
2. Joseph Farquharson, letter to Richard Quick, 6 November 1929. Russell-Cotes Art Gallery and Museum archive.

Cat.57 Briton Riviere RA RE (1840–1920)
***Tick-tick*, 1881**
Oil on canvas, 36.9 x 48.2 cm (14½ x 19 in)
Signed and dated lower left: *B Riviere 1881*

Briton Riviere studied at Cheltenham College where his father, William Riviere, was a drawing master. He was precociously talented and sent two works for exhibition at the British Institution at the age of eleven, *Kitten and Tomtit* and *Love at First Sight*. As early as these works were, they gave a good indication of the direction that his painting was to take, the latter depicting a kitten being introduced to its first mouse. He débuted at the Royal Academy in 1858. In the early 1860s he came under the influence of the Pre-Raphaelites, particularly through Millais, and produced several paintings according to the principles of the Brotherhood including *Elaine on the Barge* and *Hamlet and Ophelia*. Neither of these works, however, found favour with the exhibition committee of the Royal Academy and they were

turned away. He began exhibiting again at the Royal Academy in 1864 when the influence of the Pre-Raphaelites was less discernible in his painting and was elected as an Associate in 1878 and a full Academician in 1881.

As an animal painter, Riviere was seen as the heir to Landseer: in reviewing Russell-Cotes's collection the *Art Journal* wrote that Riviere was 'the one who comes closest to Landseer, and it is only just to say that several of his important pictures are equal to many of the best Landseers.'[1] In many of his ambitious works depictions of animals are used in dealing with grand subjects such as *Persepolis*, *In Manus Tuas, Domine* and *Daniel*, but the historically accurate settings are equally if not more important and Sir Walter Armstrong wrote in 1891 that the artist took greatest pride in works such as *Ganymede*, where animals took the least part.[2] Despite this Riviere painted mainly animal scenes and was known by the majority of the public as an animal painter. Most typical are works in which animals show

discernible emotions and human characteristics, as in *Treasure Trove*, *Sympathy* and *An Anxious Moment*. Russell-Cotes was a great admirer of Riviere, writing that he

is the most distinguished English artist in the portrayal of animals … I have possessed several of his works, but perhaps the one that he appreciated most as his own work, although on a very small scale, is the one 'Tick Tack', which hangs in the Russell-Cotes Art Gallery and Museum. It vividly portrays its own story, which is that of a pug puppy gazing with surprise and wonderment, and perhaps a little fear, at an old-fashioned 'turnip' watch. He cannot understand where the sound comes from. It is altogether a most admirable little work in his best style.[3]

1. 'The collection of Merton Russell-Cotes, Esq, JP, the Mayor of Bournemouth', *Art Journal*, 1895, p.295.
2. Sir Walter Armstrong, 'Briton Riviere', *Art Journal, Art Annual*, 1891.
3. Sir Merton Russell-Cotes, *Home and Abroad* (2 volumes), privately published, Bournemouth, 1921, p.727.

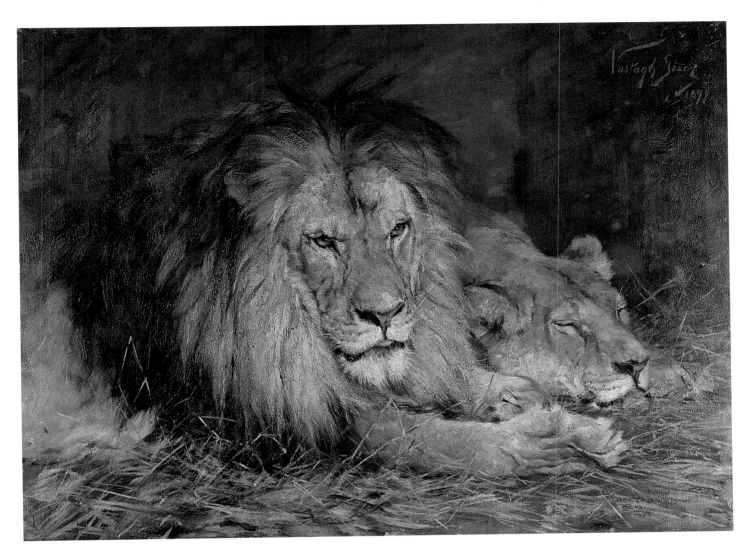

Cat.58 Géza Vastagh (1866–1919)
The British Lion or *Repose*, 1899
Oil on canvas, 94 x 127 cm (37 x 50 in)
Signed and dated top right: *Géza Vastagh 1899*

The Hungarian artist Géza Vastagh was born in 1866 and died in Budapest in 1919. He studied under his father, Györy Vastagh (1834–1922), a successful portraitist, and under Professor Hackl who taught at the Munich Academy. He also travelled to Budapest, Paris and London and his works are held in major collections around Europe. He was primarily a painter of animals, particularly lions and tigers.

This painting was acquired by Pears Soap Limited to be used as one of their annual prints. Pears released three prints a year, the most famous

being J.E. Millais' *Bubbles*, produced in 1897. Such prints were overtly sentimental and produced for a popular market. Vastagh's painting appealed to the viewer's patriotism although, despite its title, it is quite typical of his animal paintings. Measuring 19½ by 28 inches, the print was produced in 1900 as *The British Lion* and cost two shillings and sixpence including postage and packing. The painting does bear another title, *Repose*, and it is probable that it was renamed by Pears to enhance its saleability.

The texture of the lion's mane, its pose and facial expression are carefully studied and rendered. This image is one of Vastagh's most popular and has been widely copied in many paintings and even in textiles produced in Japan.

Cat.59

Cat.60

Cat.59 Henry Stacy Marks RA RWS HRCA HRPE (1829–98)
***Cockatoos, Toucan, Macaw and Parrots*, 1889**
Oil on canvas, 121.9 x 82.5 cm (48 x 32½ in)
Signed lower right: *H.S.M.*

The year 1871 was an important one for Marks in
providing him with another great success through
his painting, *St Francis Preaching to the Birds*,
exhibited at the Royal Academy. It secured his
election as an Associate of the Academy and
established him as a leading animal painter,
particularly of birds. Austin Chester later wrote
that 'Stacy Marks found in birds the link which
united his special talents to the decorative.
No one before or since his time has touched with
an exactly right amount of emphasis on the human
qualities which his observation saw in birds.
He pointed out similitudes which one feels should,
to the meanest intelligence, have been obvious.'[1]

This carefully observed work was painted in
1889. Between May and October that year the
artist spent much of his time studying birds at
Regent's Park Zoo.[2] His time spent sketching in
the parrot house resulted in this work which

was first exhibited at the Fine Art Society from
21 October to 2 December 1889.

1. Austin Chester, 'The Art of Henry Stacy Marks R.A.',
The Windsor Magazine, No.206, February 1912, article I,
p.344.
2. Henry Stacy Marks, *Pen and Pencil Sketches*
(two volumes), London, 1894, vol.II, p.147.

Cat.60 Richard Beavis RWS (1824–96)
***Horses*, c.1870**
Oil on canvas, 47 x 72.4 cm (18½ x 28½ in)

Richard Beavis was born in Exmouth in 1824, but
spent most of his childhood in Sidmouth. In these
formative years, the artist learnt to draw and built
up a strong affinity with the sea which appears in
many of his works. He joined the Royal Academy as
a student of painting in 1846 although he found it
difficult to support himself financially. Between
1850 and 1863 he worked for the upholsterers
and decorators Messrs Trollope and produced many
successful designs for them. Beavis's paintings
gained recognition and he became an independent

artist, moving to live in Boulogne between 1867
and 1868. His works of the late 1860s and early
1870s were similar to this painting of horses and
included *Drawing Timber in Picardy* (1866) and
Autumn Ploughing – Showery Weather (c.1868).
He was influenced by Jean-François Millet
(1814–75) and the Barbizon painters to some
extent although he remained independent of any
artistic allegiances. In 1875 he travelled to Venice,
Alexandria, Cairo, Jaffa and Jerusalem which
provided new material for his work. He was
extremely prolific and drawn by his own
observations rather than by any particular genre
of painting, as the *Art Journal* noted: 'We cannot
call Mr. Beavis a disciple of any particular school
nor a follower of any special artist: he is a close
and diligent student of nature alone, and works
out his subjects – and they are varied – with taste,
judgement and skilful execution.'[1]

1. James Dafforne, 'The Works of Richard Beavis',
Art Journal, 1877, p.68.

ART AND TASTE IN BLACK AND WHITE
Prints in the Victorian period

MARK BILLS

A key characteristic of the Victorian period was the vast increase in population and urbanisation. By the end of the nineteenth century the number of inhabitants of the urban centres of England and Wales was about eight times what it had been at the beginning of the century. Widening education meant that these new populations were more literate and eager for forms of art that reached a broader audience. Industrial and technical development made it possible to meet this demand through the production of journals and periodicals, of which there were over 50,000 individual titles. Their impact on Victorian cultural life was greater than at any other period of history and 'was perhaps the first demonstration of the potential of the mass media …'[1] The most popular journals carried examples of art and literature and consequently the awareness of art and artists by a wider public grew throughout the Victorian period, being greatly enhanced by the ability of publishers to mass-produce images for popular consumption. The printed image reached the height of its popularity and was the medium through which the majority of the public consumed art and formed their opinions about it. Such exposure not only drew crowds to exhibitions of art but also influenced the art that was produced, for within the sale of copyright fortunes by artists and publishers were to be made. In 1897 *The Studio* reviewed the development of art in the reign of Queen Victoria:

> The desire to be in touch with art was no longer confined to the few, to the rare experts
> whose isolation in a Philistine world had been a pathetic feature of the previous period;
> on the contrary, every one began in greater or less degree to show that the new ideas and
> the more active aspirations had power to persuade them.[2]

The individual print served both as an original piece of art that could be owned by many and as a memento of a particular painting that was admired. A variety of different types of print were produced, their prices determined by rarity and quality. In 1888, a plain print of Edwin Long's *Diana or Christ?* (1881) produced by Agnew's cost two guineas, while proofs of the same on India paper cost three guineas, and proofs before mass production cost more still. The artist's proof, which included his signature (not that of the engraver), cost the most at eight guineas. The periodicals responded to the demand for prints by issuing free prints with certain editions: *The Graphic* and the *World* offered presentation prints to boost their sales (Cat.61) and the *Art Journal* provided high-quality reproductions of art for its readers (Fig.22). The development and renaissance of wood-engraving in particular encouraged the production of illustrations by the leading artists of the day. Artists flourished and perhaps at no other time has art been so much the product of public appetite. Yet during Victoria's reign the development of print technology and the

Fig.20 *The People's Gallery of Engravings*, Volume 3, Fisher, Son & Co., London and Paris. Edited by C.H. Timperlay, 1846.
'History, portrait, landscape, and scripture, in succession, adorn the pages of these volumes; and the selection being made from an exclusive gallery of admirable works, each is entitled to the merit of being a gem of its own class.'
Editor's preface, 31 March 1846

need to produce large numbers of the same image transformed the face of printmaking. The significant impact of photography in the process was key in determining change and eventually eradicating certain forms of mass printing. By the end of the nineteenth century illustrated periodicals and records of art in other media were predominantly produced using photography, and the hand and eye of the artist were removed almost entirely from the process.

The print has always had an important role for the collector. In the eighteenth century, portfolios of prints were an essential element in a connoisseur's collection. They were produced in relatively modest numbers and, although clearly seen as secondary to painting, maintained the status of an original work of art. Collected

Cat.61 Harry Furniss (1854–1925)
The Private View, 1882
Tinted wood-engraving, presentation plate for the *World*, Christmas 1882, 30.5 x 49.5 cm (12 x 19½ in)
Drawn by Harry Furniss (signed lower left: *H.F.*), engraved by Edmund Evans,

'Presented Gratis with the Christmas Number of the "World", 1882'. Presentation prints were common amongst Victorian illustrated periodicals. The 1880 Christmas edition of *The Graphic* sold out all its copies due to a presentation print of J.E. Millais' *Cherry Ripe* and had to be reprinted. This is actually alluded to in this print, where a painting on the wall depicts Millais drawing his model for *Cherry Ripe* with a placard with 'Xmas number' written on it in her lap.

This image refers to the private viewing of the 1882 Royal Academy Summer Exhibition and caricatures the leading figures of the day who attended the event: the Prince of Wales, Oscar Wilde, Whistler, William Gladstone, Millais, Frith and Henry Irving to name just a few. On the wall can be seen caricatures of works by the artists who regularly exhibited at the Royal Academy at this time. They are not intended to show specific works that were exhibited in 1882 but rather to mimic their general style. These include Sir Lawrence Alma-Tadema's 'Marble Works'; Lord Leighton 'P.R.A.' represented as a classical marble bust with the Three Graces in the background; and seascapes by Henry Moore RA (1831–95), which often consisted of little more than an horizon line to those who caricatured him.

on the Grand Tour or bought from exclusive print vendors, they provided examples of the Old Masters and Neoclassical art. Wealthy nineteenth-century collectors such as Sir Merton Russell-Cotes saw prints in a very different way from their predecessors. In printmaking as in painting, it was the work of his contemporaries that he most eagerly sought to collect. Prints by Continental schools and depictions of the great achievements of Italian art may have been the basis of an eighteenth-century connoisseur's collection, but they are not to be found within the Russell-Cotes Art Gallery and Museum, where art books and periodicals are seen alongside individual prints. They are predominantly British and reflective of the Russell-Cotes painting collection.

The concept of the print as an original work of art was still retained yet the sheer number of prints available on the market meant that to a certain extent its status had been diminished. It would be wrong, however, to regard the Victorian attitude to prints as consistently one of a poor relation. As a general rule, techniques improved and in certain areas, such as wood-engraving, the medium achieved its zenith. The appeal of owning an 'original work of art' was certainly exploited by print publishers who offered varying grades of prints, including those signed and proofed by the artist at a greater cost to the customer. The smaller the edition of a print the closer it was to being seen as a work of art in itself. The subject matter, approach taken and the use of photography were also

elements which influenced a print's artistic merits. It is also important, particularly when discussing reproductive prints, to distinguish the differing roles of the artist and engraver.

A print after a painting by a leading artist may have been signed by the artist who had produced the painting, yet it was the engraver who, with greater or lesser skill, had translated the oil on canvas into black and white lines. Prints that were directly produced by the artist were of much higher status. Indeed, in most cases the status of even the most skilled engraver was deemed secondary to that of the painter. Certainly their skill was acknowledged, and particular engravers were sought out by painters, yet because their art consisted in copying another two-dimensional image it was seen of secondary importance. This attitude was upheld by the Royal Academy whose treatment of engravers was reflected in its laws and Council statement of 1812 where it declared that engraving was devoid of 'those intellectual qualities of Invention and Composition, which painting, sculpture and Architecture so eminently possess; its greatest praise consisting in translating with as little loss as possible the beauties of these original Arts of Design.'[3] In 1769 it was possible to be elected as an Associate Member of the Royal Academy as an engraver, of whom only six were allowed at any one time, yet with no prospect of becoming a full Royal Academician. In 1853, after much lobbying and with the support of Queen Victoria and Prince Albert, the Royal Academy relented and a new group of Academician Engravers were created. In 1855 Samuel Cousins (1801–87) heralded the change and became the first of these although it was not until 1928 that engravers achieved equal membership.

Primarily it was the artist who instigated sales of prints and not the engraver. The print-buying public wanted copies of prints after their favourite artists, who achieved great acclaim and fame. When illustrations appeared in books and periodicals it was the artist who had drawn the image who was the principal attraction, not the engraver (who often remained anonymous). Yet it was often through the skill of the engraver that the reproduction succeeded or failed. Certain engravers and illustrators achieved acclaim, particularly Samuel Cousins RA, William James Linton (1812–98) and Lumb Stocks RA (1812–92), but they were a handful.

It was the popularity of art in the Victorian period that influenced much of its development and the ability to produce large numbers of copies was a factor in

Cat.62 Lumb Stocks RA (1812–92), after Daniel Maclise RA (1806–70), 1857–66
Wellington and Blucher Meeting after the Battle of Waterloo
Line engraving, *c.*1867, 30.5 x 114.2 cm (12 x 45 in)
Published by the *Art-Union*, London, this edition 1875

Lumb Stocks was born in Lightcliffe in Yorkshire in 1812. In 1827 he moved to London to apprentice himself to an engraver. In the 1830s he made a reputation for himself with miniature crayon portraits. His exceptional skill in drawing and engraving was evident and he was elected Associate Engraver of the Royal Academy, becoming a full Royal Academician in 1871. He is known particularly for line-engraving and his distinguished copies of important paintings of the period.

Engravings of important events within British history were extremely popular.

determining the medium that was adopted. Line engraving, for example, underwent a renaissance for the reason that steel plates could produce over a thousand crisp images rather than the two hundred that copper plates produced before wearing down. It was in this medium that the reproduction of paintings found its greatest expression. Wood-engraving, where wax mouldings were taken from a wood block, could produce several metal plates. These plates could be sent abroad for illustration in foreign magazines and their usage was probably limitless, making wood-engraving the favoured medium for books and periodicals.

In the age of Victoria, when a painting was sold by an artist of note, both the painting and the copyright were sold. Indeed the two were often sold independently and could command similar prices. The publisher or art dealer (often interchangeable roles at this time) who purchased the copyright could potentially earn large sums from it. When William Powell Frith's *Ramsgate Sands* or *'Life at the Sea-Side'* (1854) failed to find a private buyer, the artist sold it to the picture dealers

Cat.63 Sir Hubert von Herkomer RA (1849–1914)
***Alfred Lord Tennyson*, 1879**
Etching, 47 x 34.3 cm (18½ x 13½ in)
Inscribed (etched): *H.H.79*

Hubert von Herkomer was born in Germany but spent most of his working life in Britain. It was within printmaking that Herkomer first established himself, with drawings which became wood-engravings for *The Graphic*. These illustrations showed a concern for social issues and their sensitive observation of line marked a change in the depiction of the poor in Victorian art.

Herkomer also painted many of the leading lights of his age and made etchings after these portraits. This etching of the poet, Alfred, Lord Tennyson was made by Herkomer from one of his own paintings, begun on the Isle of Wight in December 1878 when Herkomer went to stay with Tennyson there. He went for long walks with the poet and nicknamed him 'Alfred the Great'. The painting was completed on Herkomer's return to his studio in 1879, the year he made this etching. Such portraits were popular both as works of art and as depictions of admired figures and the reproduction rights to this image were retained by the Fine Art Society. Herkomer produced two other etchings in this series after his own paintings of John Ruskin and Richard Wagner. The Russell-Coteses purchased copies of all three and they remain in the collection.

Messrs Lloyd.[4] When the painting was exhibited at the Royal Academy Queen Victoria bought it from Messrs Lloyd for the price they had paid for it. Frith points out that they had not done badly by the deal, 'their profit accruing from the loan of it for three years for the purpose of engraving … the Art Union of London paid £3,000 for the plate.'[5]

Agnew, Ernest Gambart and Francis Moon were just a few of the many dealers and publishers that set up in business in London.[6] A good example of fine art publishers were Fairless and Beeforth, partners in a firm that in 1868 set up the Doré Gallery at 35 New Bond Street (now Sotheby's) to exhibit exclusively the works of Gustave Doré. The French artist's large religious canvases were displayed in the gallery and prints sold after them. Doré's sudden death in Paris on 6 January 1883 was a setback and, as the *Magazine of Art* put it: 'When Gustave Doré died, the caterers for that devout and sentimental portion of the public who took unctuous delight in the wonders of the Doré Gallery could find in England no worthier heir to his mantle than Mr. Long who exerted himself considerably in their behalf.'[7] Edwin Long was commissioned to paint several large-scale images of religious and ancient subjects to furnish Fairless and Beeforth's new gallery at 168 New Bond Street (Cat.66, 67). Here the public were charged a shilling to experience its delights and bought many thousands of prints. Merton Russell-Cotes, who later bought many of the original works, recalled the financial arrangement made by the dealer:

> Mr. Beeforth, whom I knew intimately, was a very wealthy art collector and connoisseur … induced Long to paint a series of pictures … the commission to be paid half in cash and half out of receipts … A gentleman named Cadham was engaged to tour the country to obtain subscriptions for the engraved reproductions of these works, the receipts from which soon became a gold mine. These subscriptions ranged from two guineas for an ordinary print to ten guineas for an artist's signed proof on India paper.[8]

This makes quite explicit the profits that were to be made.

The development of photography in producing photogravures and other prints meant that the process was in one sense more efficient and accurate. In another it meant that the artist's hand in the process was removed further and when good quality photography developed, the sale of prints rapidly diminished due to a changing market place. Photography had been used in reproducing works of art through engraving for many years before this, however. Lumb Stocks's 1867 line-engraving of Daniel Maclise's *Wellington and Blucher Meeting after the Battle of Waterloo* (1857–66; Cat.62), for example, used photographs in its translation into print from the walls of the Houses of Parliament. 'This grand picture,' the *Art Journal* wrote, 'is in the process of engraving, by Mr. Lumb Stocks, for the Art-Union of London; the engraver is working, not from a copy, but the original in the House of Lords. It was found impossible to obtain an accurate copy, except by a large expenditure of time. Mr. Stocks has the aid of photographs.'[9]

Another important area in which the printed image flourished in the Victorian age was in the illustration of books, small magazines and journals. The predominant medium for this was the wood-engraving which was developed to new heights, a phenomenon that was explored in two important books which highlighted the importance of wood-engraving illustration in Britain between 1855 and 1880.[10] This golden age of engraving included art produced by the Pre-Raphaelites, the so-called Idyllic School artists such as John Pettie (1839–93) and Robert Barnes

ROYAL ACADEMY PICTURES.
1891.

MRS. JOSEPH PRIOR, JUN.
A. S. Cope.

Fig.21 *Royal Academy Pictures illustrating the hundred and twenty third exhibition of the Royal Academy, being the supplement of 'The Magazine of Art', 1891*. Cassell & Company Limited, London, Paris and Melbourne, 1891.

With the increasing use of photography in printmaking towards the end of the nineteenth century, the production of illustrations for art periodicals and weeklies became much easier. *The Daily Graphic*, the first illustrated daily paper, could be produced alongside the original weekly, *The Graphic*, and *Royal Academy Pictures* could illustrate key works from the Summer Exhibition with speed and accuracy, if without the charm of wood-engraving.

Cat.64 Sir Hubert von Herkomer RA (1849–1914)
Self-Portrait with his Two Children (Elsa and Siegfried), **1879**
Etching, 35.5 x 20.3 cm (14 x 8 in)
Inscribed in pencil by the artist: *Hubert Herkomer 1884 (finished art proof) picturing myself To Rowland McFadden for whom I owe my very first test in etching January, 1878, This is my best etching so far. H.H.*

This etching by Hubert von Herkomer was the print with which he was most pleased among his many works in this medium. It was produced on a visit to Wales in 1879 and drawn in a windswept tent. He travelled there with his friend Mansel Lewis with whom he shared chemicals to etch the metal plates that they carried with them. He had made his first etching in January 1878 with Rowland MacFadden, a fellow student and lifelong friend. His trip to Wales was informed by this early experiment, and by a print manual by Philip Gilbert Hamerton, *Etching and Etchers* (London, 1868). Hamerton later called the work Herkomer's finest etching. In his etching Herkomer strove to achieve a Rembrandt-like effect using line to create delicate tones.

(1840–95) and High Victorians, including Lord Leighton, which flowered in many books and small magazines such as the *Cornhill Magazine, Good Words, The Quiver* and *Once a Week,* to name just a small number. In them artists saw the possibilities of expressing their art in black and white for wide circulation.

Of a different order, yet of great importance in spreading images of art to a wide audience, were the art periodicals who approached their task with a missionary zeal, using the new possibilities of reproduction to spread the word to an eager public

with varying amounts of consistency. Samuel Carter Hall, the editor of the *Art Journal* (originally entitled the *Art-Union*), announced in the first edition: 'We shall endeavour, by rendering "good Art cheap", to place its meritorious examples in the hands of "the many" – so to become sources of pleasure and instruction.'[11] In many ways the *Journal* retained a consistent educational position, presented art in national terms and made available good-quality prints. Other periodicals such as the *Magazine of Art* were by contrast quite random miscellanies that attempted to be 'poor man's' versions of the *Art Journal* but were broader in scope and less consistent in their coverage.

At the other end of the spectrum was a periodical that had an enormous impact on the art world and the quality of printmaking in the period. This was *The Graphic*, which started in 1869 as a rival to the *Illustrated London News*. Its editor was William Luson Thomas, whose own artistic background influenced his unique philosophy: 'The originality of the scheme,' he wrote, 'consisted in establishing a weekly illustrated journal open to all artists, whatever their method, instead of confining my staff to draughtsmen on wood as had been hitherto the general custom.'[12] As a result *The Graphic* championed artists beginning their careers, such as Hubert von Herkomer (Cats 63–5) and Luke Fildes. Each of them had the freedom to produce black-and-white images that were truthful to their art and social conscience. *The Graphic*'s importance was also in its employment of artists whose truth to nature showed a bleaker side of the human condition in Victorian Britain. Social realism in late-nineteenth-century Britain found its expression in large-scale oils although its impact in black and white was in many ways more expressive and wider reaching, even influencing the art of Vincent Van Gogh.[13]

The paper's aim, according to Thomas, was 'telling a story that really interests … the man of less educated tastes'.[14] For all its high purpose of promoting artists with a strong social conscience on its inception, *The Graphic* later veered towards what was most sentimentally popular, giving away free prints in its summer and Christmas editions. Its 1880 Christmas edition containing a presentation print of J.E. Millais' sweet and sickly *Cherry Ripe* sold out and had to be reprinted. The quality of the artists featured in *The Graphic* waned as the century progressed and each achieved his own ambitions, mainly through paint or prints directly drawn onto the plate and not through the interpretation of an engraver. Herkomer went on to distinguish himself as an artist in etching and experimental print methods such as his patented 'herkomagravure' and remained sceptical about the translation from drawing to wood engraving:

> Unfortunately in those days photography was not yet a practicable thing for the
> transfer to the block of a drawing made on paper. In that case the engravers would
> always have had the drawing to refer to: as it was, the original drawing was cut away,
> and the only satisfaction left to the artist was to growl at the engraver. In only too
> many cases the creed of the latter was – 'cut through the shower of lines, never mind
> what the artist drew,' with the result that we could barely recognise our own work.[15]

No longer pre-eminent in reporting images or presenting accurate copies of art, the role of prints fundamentally changed with the advent of photographic reproduction and the copyright value of pictures subsequently diminished. Artists reclaimed the print as their own in the twentieth century. It was the hand of the artist that sold prints, not the copy, nor the translation of an engraver. As a consequence, etching emerged as the most direct of the intaglio processes, and mono-

Fig.22 *Art Journal*, new series, J.S. Virtue & Co. Limited, London, 1886.

Opposite page 227 (August 1886), a wood-engraving of Sir Edward John Poynter's *Faithful Unto Death*, engraved by F. Joubert.

Art periodicals were important in this period in providing reviews and opinions about current and historical art; commentaries on artists' lifestyles with articles about their homes and studios; and articles on subjects for art, which included topography and archaeology. These journals needed illustrations which were, until the late nineteenth century, almost exclusively wood-engravings. They included images of new paintings, portraits of artists, and artefacts that were of general interest and useful as a sourcebook for artists.

Art Journal (or *Art-Union* as it was originally called) was founded in 1839 by Samuel C. Hall who declared that his aim was to 'express opinion fully, freely and without reserve'.[1]

1. *Art-Union*, May 1839, p.65.

Cat.65 Sir Hubert von Herkomer RA (1849—1914)
Words of Comfort, 1879
Etching, 25.4 x 17.8 cm (10 x 7 in)
Published by E. Delarue, Paris

This etching by Herkomer depicts a scene in Bavaria, the area where he had been born and to which he often returned, producing a series of drawings for *The Graphic* throughout the 1870s.

types, lithography and screenprinting, which recorded the artists' marks with greater immediacy, became increasingly predominant. Photography had so revolutionised the process of reproducing images in ever-increasing numbers that the value of a limited edition emerged as an important factor once more. It is perhaps ironic that the Victorian images produced for mass consumption are now becoming collectors' items as more value is placed on their rarity.

Cat.66 John Cother Webb (1855–1927),
after Edwin Longsden Long RA (1829–91), 1885
The Search for Beauty, c.1885
Line-engraving, editions from 1885,
48.3 x 76.2 cm (19 x 30 in)
Published by Fairless and Beeforth, London,
this edition 1888
Inscribed: *London, August 7ᵗʰ 1888, published by*
Fairless and Beeforth, 128 New Bond Street, W.,
Copyright Registered. Entered according to the acts of
Congress in the year 1888 by Frank Hunter Potter in the
Office of the Librarian of Congress of Washington, U.S.A.

John Cother Webb was a distinguished line-
engraver born in Torquay in 1855. To succeed as
an artist meant moving to London, the centre of
the British art world in Victorian Britain. There he
lived and worked until his death in 1927. He
studied under Thomas Landseer ARA (1795–1880),
the brother of Edwin and Charles Landseer, and
became known for his engravings, particularly
those reproducing the landscapes of Claude Lorrain
and J.M.W. Turner. This print depicts a painting by
the artist Edwin Longsden Long who produced

several works for the fine art publishers, Fairless
and Beeforth. These works, of which Sir Merton
Russell-Cotes later bought five,[1] were on display for
several years on Bond Street to visitors who paid a
shilling entry fee. They could then purchase
engraved copies of the painting that were produced
by Fairless and Beeforth. These were available at
different costs, depending on whether they were
the first impressions taking from the plate, signed
by the artist of the painting (not the engraver), and
what quality of paper they were printed on. It was
an extremely lucrative market; on this print can be
found its registration for sales in the United States.

Long's painting is one of two which tell the same
story and were known as companion paintings. This
is the first of the two, showing the artist Zeuxis who
had been commissioned by the people of Crotona
to produce an image of Helen of Troy for their
temple (see Cat.67).

1. *Jephthah's Vow* (three separate paintings, 1885–6);
Anno Domini or The Flight into Egypt (1883); and *The*
Chosen Five (1885), on semi-permanent display in Gallery I
of the Russell-Cotes Art Gallery and Museum.

Cat.67

Cat.68

Cat.67 Probably John Cother Webb (1855–1927), after Edwin Longsden Long RA (1829–91), 1885
***The Chosen Five, c.*1885**
Line-engraving (artist's proof),
48.3 x 76.2 cm (19 x 30 in)
Published by Fairless and Beeforth, London, this edition 1890

Cat.68 Edwin Longsden Long RA (1829–91)
***Henry Irving as Hamlet, c.*1880**
Photogravure, 47 x 34.3 cm (18½ x 13½ in)
Published by Goupil and Co.
Inscribed in pencil: *To Merton Russell-Cotes from Henry Irving with kindest greeting and Best wishes 1899*

This photogravure is made after Edwin Long's portrait of Henry Irving originally commissioned by Baroness Angela Burdett-Coutts, the wealthy philanthropist and friend of the great tragic actor. Long had spent a Mediterranean cruise with the Baroness and Irving and the portrait was painted on his return to London. The Russell-Coteses were great admirers of Irving as they were of Long and there are several copies of this print in the collection. This copy is particularly important in having a note inscribed by Irving.

Cat.69

Cat.69 Myles Birket Foster RWS (1825—99)
Geese, c.1890
Etching (stamped proof), 24 x 34.3 cm (9½ x 13½ in)
Inscribed in pencil lower right: *Birket Foster*
Drawn on plate by Foster, etching process by 'FW'

Myles Birket Foster is known primarily for his
picturesque scenes of rustic life. He was born in
North Shields but moved to London at the age of
five. He was apprenticed to Ebenezer Landells,
an important wood-engraver who had learnt his art
directly from Thomas Bewick (1753—1828).
He engraved wood blocks for the leading illustrated
periodicals of the day and progressed to drawing
for them. In 1846 he set up on his own producing
illustrations for the *Illustrated London News*.
Around 1859 he began painting, mainly in water-
colour, his success allowing him to build a house
at Witley, Surrey where he painted countryside
scenes. They are often sentimental, adopt a soft
technique and were extremely popular.

Cat.70

Cat.70 P. Brannon
***Bath Hotel, Bournemouth,* 1865**
Wood-engraving, 7.6 x 12.7 cm (3 x 5 in)
Published by Sydenham, Poole, 1 July 1855
Inscribed in pencil by Merton Russell-Cotes: *Purchased by Merton Russell-Cotes, Xmas Day 1876*

Wood-engraving was used for series of topographical prints as well as for periodical publication. These were very much influenced by the way in which Thomas Bewick had developed the medium. This view is from a set of prints of Bournemouth of the 1850s. It is particularly important because of the inscription in Sir Merton Russell-Cotes's own hand and the fact that it shows building before it became the Royal Bath and before its extensive expansion by the Russell-Coteses.

Cat.71: William Lionel Wyllie RA RI RE (1851–1931)
***Seagulls,* 1924**
Etching and aquatint, 30.5 x 21.7 cm (12 x 8½ in)
Inscribed in pencil lower left: *W L Wyllie*

A maritime artist, Wyllie studied at Heatherley's School of Art in London and at the Royal Academy, where he won the Turner Gold Medal in 1869. He painted many harbour and dock scenes and the Russell-Coteses collected many paintings by him and his younger brother, Charles William Wyllie ROI (1853–1923). W.L. Wyllie was also a distinguished etcher and produced many drawings and prints of ships and the sea. This etching shows his mastery in using line and tone, through etching and aquatint, to evoke gulls and the sea.

Cat.72: Anonymous
***Adele,* undated**
Coloured lithograph, 35.6 x 25.4 cm (14 x 10 in)
Inscribed: *Adele, a waltz by Dan Godfrey, band master grenadier guards, composer of 'Mabel, 'Hilda, 'Guards' &c.*

Lithography was often used for posters, folio covers and other areas of publicity and this cover for sheet music is a typical example. In this case it shows a woman's portrait for a waltz called *Adele*.

The print is typical of mass-produced images of beauty that evoked a sentimental reaction. The artist or draughtsman is unknown as the image was primarily intended for commercial purposes to encourage sales.

Cat.71

Cat.72

VICTORIAN SCULPTURE *at the* RUSSELL-COTES ART GALLERY AND MUSEUM

BENEDICT READ

The use of the term 'provincial' with reference to English art collections outside London inevitably carries with it hints of pejorative condescension, and such a term can preclude any allowance for the nature and significance of non-metropolitan culture. In the Victorian period, however, increased access to political control at national and municipal level following the Reform Act of 1832 and Municipal Corporations Act of 1835 meant that a sense of individual local pride became paramount. For much of the nineteenth-century Liverpool was allegedly the third largest port in the world and Manchester, the centre of the world's cotton industry, was the stronghold of Radicalism and Free Trade. In the early twentieth century Leeds became the centre of such a radical cultural avant-garde that such alleged London leaders as Bloomsbury or the Vorticists seem wimps in comparison: it was only the outbreak of the First World War in 1914 that prevented Wassily Kandinsky from arriving at Leeds University to be its first Professor of Fine Art.[1] The assertion of this new economic and political power had its artistic consequences. Cultural associations and institutions developed at the same time as the increase in industry, business and wealth: the Liverpool Academy was founded in 1810, the Liverpool Royal Institution in 1814, the Royal Manchester Institution in 1823. Then came the new municipalities' town halls: St

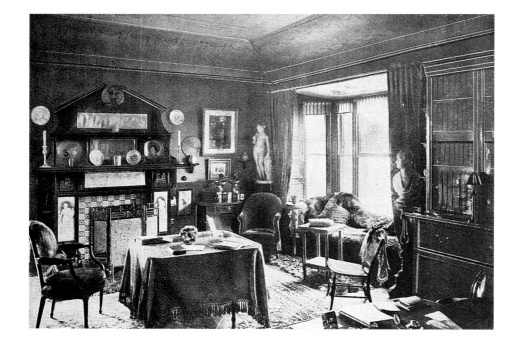

Fig.23 Sir Merton and Lady Russell-Cotes, sitting room of their old bungalow, Bournemouth, late nineteenth century.

George's Hall, Liverpool (1840–56) was described at the time as a Temple for the Merchant Princes of Liverpool,[2] while Manchester Town Hall (1866–77) was considered a worthy contemporary equivalent to the medieval cloth halls of Flanders.[3] With the town halls came public statues, particularly of Sir Robert Peel – the mercantile middle classes' great political hero; after his death in 1850 some twenty-six statues were erected to him alone in the newly enfranchised industrial towns of the North and Midlands.

Municipal art galleries came a generation later: the Walker Art Gallery in Liverpool did not open until 1877, the City Art Gallery, Manchester in 1882 and Leeds City Art Gallery in 1887. It was local 'brass' as well as local pride that brought

Fig.24 The Long Room in the gallery extension of the Russell-Cotes Art Gallery and Museum, *c.*1919.

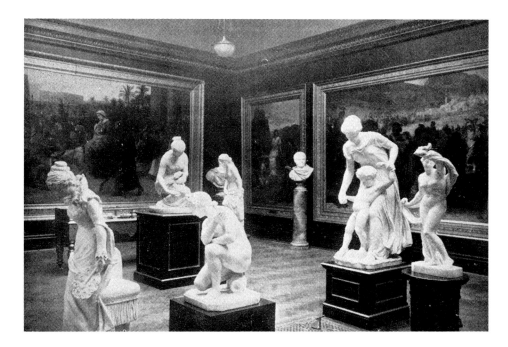

these public galleries into being. Sir Andrew Barclay Walker, for example, was a brewer (whose business subsequently merged with Tetley's, of Leeds) and it has been said that 'Shipping and alcoholic beverages played as important a part in the story of the [Walker Art] Gallery as did municipal idealism and Ruskinian notions of the moral value of art to society'.[4] The contents of these galleries were acquired by what one can only describe as a process of semi-random accretion. Purchases of contemporary art, sometimes from major exhibitions held in the cities, certainly occurred, and there were donations and bequests from the same type of local industrialists who had started the galleries in the first place. The subsequent fate of the initial collections has also been uneven – as with other Victorian values they have undergone eclipse followed by a revival, with the sculpture collections largely lagging behind in terms of both reinvestigation and redisplay. The Walker Art Gallery is an outstanding exception to this, having pioneered the reinvention of Victorian sculpture, but it only highlights the more typical opposite extreme found at Salford Art Gallery, for example, where (to the regret of the current curators) of some twenty pieces of ideal or subject sculpture acquired in the nineteenth century, only nine remain, not all in a satisfactory condition for display. Of the rest, three were sold, one was moved to a park where it disintegrated and seven have disappeared without trace.[5]

Against this background, the collection of sculpture at the Russell-Cotes Art Gallery and Museum is in certain respects unique.[6] While its major originator, the hotelier Merton Russell-Cotes, may be compared with shipping magnates and brewers in ministering to the local municipality, the quantity of sculpture he collected, its significant presence in the collection as a whole, its survival and current availability are exceptional. In addition, his collection is uniquely wide-ranging, in terms of artists' nationalities, the different styles and implicit aesthetics represented, and the variety of types of work. Surprisingly, however, there seems to be no documentation whatsoever of where or how he acquired his sculpture and there is virtually no record of what he thought about it: in the chapter 'Art and Artists' in his autobiography *Home and Abroad* there is no mention of sculpture or sculptors. One can only deduce that sculpture did mean something to him from its sizeable presence in the surviving collection. One might also note that a photograph of the sitting-room of his original bungalow residence does feature a statue and a bust among the furnishings (Fig.23).

At the heart of the collection is a series of classic 'ideal' works, that is subject pieces, that are almost archetypal for the years 1830–80. Though Lawrence Macdonald (1799–1878) was to some extent an adherent of the British Neoclassical school – he lived and worked in Rome for most of his life – he occasionally veered from classical portrayals of Venus, Ulysses or Penelope to a more sentimental genre type, as in his *Girl and Carrier Pigeon* (Cat.73), dated 1833 and shown at the Royal Academy of 1835. Benjamin Edward Spence (1822–66) was, like Macdonald, a member of the Neoclassical school, studying in Rome with both Richard James Wyatt (1795–1850) and John Gibson (see Cat.1) and working there most of his life. But his subject pieces were rarely classical: more often they had a base in literature or the Bible (*Highland Mary*, *Rebecca at the Well*) or were more simply allegorical (*Innocence*, *Spring*); his *Female Figure* of 1866 in the collection would almost certainly have had a specific title.

The Bathers (Cat.74) by Edward Bowring Stephens (1815–82) is mainstream Victorian genre sculpture. Subtitled 'One More Step and In We Go', nothing could be more realistically straightforward and emotionally direct. *Samuel* of 1859 by Giovanni Maria Benzoni (1809–73), known as *Morning Prayer* in a photograph

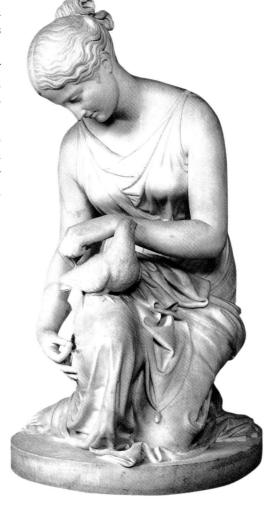

Cat.73: Lawrence Macdonald (1799–1878)
Girl and Carrier Pigeon, or The Messenger, c.1833
Marble, 100 cm (39½ in) high
Inscribed: *Lawrence Macdonald Roma 1833*

This is a classical expression of Victorian sentiment. Notice the care that has been bestowed upon the chiselling of the pigeon.

Lawrence Macdonald was born at Gask in Perthshire and began to carve in stone at an early age while serving his apprenticeship to a local mason named Thomas Gibson. Macdonald's first recorded work, a statue of a boy supporting a vase on his head, dates from this period and is now in a garden at Moncrieffe, in Perthshire. In 1822 he went to Edinburgh, where he entered the Trustees' Academy and later in that same year went to study in Rome, becoming one of the founders of the British Academy of Arts in that city. Four years later he returned to Edinburgh where he showed classical groups, a figure of 'The Youthful Slinger' and a number of busts including one of the actor Charles Kemble. He was one of the most popular portrait sculptors of his day.

Macdonald exhibited at the Royal Academy from 1828 to 1857, at the British Institution in 1832, at the Scottish Academy from 1827 to 1865 and at the Great Exhibition of 1851.

album of the sculptor's works,[7] can also be read as a sentimental 'kiddy' work, but it has additional biblical references and its particular Italian blend of religion and sentiment features in other sculpture collections made in nineteenth-century England. Brodsworth Hall in Yorkshire has Giuseppe Lazzerini's *Education*, also known as *The Lord's Prayer*, in which a mother is teaching a child, while *Ruth the Gleaner*, attributed to Benzoni, has come to rest in Todmorden Town Hall. *The Princes Sleeping in the Tower* (Cat.75) by Augusta Freeman (active in Rome *c*.1845–*c*.1866) is another sentimental child portrayal which derives an added *frisson* from the viewer's knowledge that the Princes' slumber is a prelude to their murder. This was Mrs Freeman's *forte*; one of her earliest works was *The Death of Little Nell*. Otherwise she occupied herself with child subjects, 'as if to supply the want of that which has been denied to her, she throws all the tenderness of her woman nature into the pretty marble statuettes and heads which she creates'.[8] The more sensational mood is also present in *Die Schöne Melusine* (Cat.76) by Ludwig Michael Schwanthaler (1802–48);[9] she may look just like a water nymph (in any case a good excuse for portraying the naked female form), but she was in legend a supernatural half-serpent. Knowledge of this impending metamorphosis may have added to the voyeuristic pleasure of the knowledgeable (assumed male) viewer. Two of the works in the collection by Orazio Andreoni[10] are similarly sensational. One of the two women in *Pereat* is giving the thumbs down to the defeated gladiator, with her companion seemingly in accord. *Jael* (Cat.77) represents the biblical heroine who killed a Canaanite enemy of the Israelites with a nail; one has to go round behind the sculpture to view the semi-concealed weapon.

A distinct section of the collection is formed by a series of bronze replicas of French nineteenth-century sculptures; *The First Funeral* (Cat.78) by Louis-Ernest Barrias (1841–1905); supposedly *Una and the Lion* by Jean-Baptiste Clésinger (1814–83); *A Lucky Find at Pompeii* of 1863 by Hippolyte-Alexandre-Julien Moulin (1832–84); *Diana* of 1882 by Jean-Alexandre-Joseph Falguière (1831–1900); and others. These were all normally authorised copies of famous works. There was a substantial market for these as for plaster replicas of works such as Andreoni's *Pereat*, let alone for 'original' marbles – there were thirty-seven versions of Benzoni's *Rebecca*[11] and around 150 of Hiram Powers's *Proserpine* (see below).[12] This meant a plurality of collectors could share in the ownership of a great work and an artist could profit in this field. Russell-Cotes had no qualms; a marble or plaster version of *The First Funeral* is

Cat.74 Edward Bowring Stephens ARA (1815–82)
The Bathers ('One More Step and in We Go'), 1878
Marble, 153 cm (60 in) high

This sculpture was exhibited at the Royal Academy in 1878. The disturbance of the rhythmic flowing lines between the uplifted arm of the boy and his instructress was perhaps a deliberate action to denote the emotion of fear at his first steps into the sea.

Edward Bowring Stephens was originally from Exeter and was a pupil of Edward Hodges Bailey. He contributed to a collection of full-length statues of scientists at the University Museum of Oxford. He also executed the statue of *Joseph Priestley: Discoverer of Oxygen* and *Albert* in the Albert Memorial Museum, Exeter. Other works include figures from English literature such as *Chaucer* in the Egyptian Hall at the Mansion House and the Burlington House Complex, on the front of the Royal Academy building facing Piccadilly, London.

illustrated in *Home and Abroad* (page 561) and his own bronze replica of this work gets the longest entry for a sculpture in Richard Quick's 1923 catalogue, where it is referred to as 'this most beautiful group ... the figures are moulded with most admirable truth and beauty, and the composition [is] a striking success, both from an anatomical and artistic point of view'.[13]

Another series of marble statues, with no disrespect to their (largely unknown) artists, fulfil a more emphatically decorative role around the building. Two marble statues greet one at the entrance and in the main staircase area one is met with a flurry of scantily clad if not naked female figures. The main figure of *The Bathers* on the landing wears a clinging costume of fully fretted marble. On the two risers to the gallery *Nymph and Cupid, or Morning* and *Nymph and Cupid, or Night* (Cat.79) energetically disport themselves in positions that enhance their three-dimensionality. Along the gallery *The Shiva Slave* by Girolamo Oldofredi is nude, the smoothness of her flesh enhanced by the rougher finish of her long hair. By contrast, *Griselda* by David Watson Stevenson (1842–1904) of 1874 is a modest clothed figure, though an alternative allure may be implied in her legendary patient submission to her husband.

The treatment of the costume in *The Bathers* is a characteristic of late-nineteenth-century sculpture, particularly Italian, in which the natural solidity and intractability of marble challenged artists to produce an effect of excitement and frills. *The Reception* demonstrates this to the full, every lacy detail of the female figure's fashionable clothes scrupulously rendered in stone. There are three ladies with mantillas (one each by Pallatti and Ruga) in the collection, in which this item of costume posed no problem to the technical dexterity of the artists.

Russell-Cotes's collection of marble and bronze subject pieces was complemented by a substantial collection of busts, some subject pieces but the majority of the others portraits. Among the former are some perhaps standard works by the Italian Pietro Calvi (1833–84) of *Summer*, *Winter*, *An Arab Chief*, *Othello* (Cat.80) and *A Black Queen*. The last three can be designated 'effectist' by their blending of marble and bronze to produce work in different colours, as the subjects allowed. There is a *Clytie* by Guirlandi and a *Cleopatra* by Eugenio Lombardi, which was exhibited at the Royal Academy in 1888, and there are six Roman Emperors by Ercole Rosa (1846–93). Outstanding of this type is *Pharaoh's Daughter* by John Adams-Acton (1831–1910), a sculptor of some significance in nineteenth-century England, though better known for his portraiture. He was responsible for the most remarkable of Russell-Cotes's portrait busts, that of John Landseer, the father of the painter Edwin Landseer (Cat.81). This was in fact executed thirty years after the subject's death from a similar-sized painted portrait by his son. There was a close family friendship between Adams-Acton, his wife and the Landseers, as well as between Mrs Adams-Acton and Frederick Goodall; perhaps it was this sort of association that led Russell-Cotes to acquire these works.[14] Such considerations were certainly involved in some of the other portrait busts he collected. First came royalty, with whom Russell-Cotes liked to be associated: notable are *Queen Victoria* by John Gibson, *The Princess Royal* by the

Cat.75 Augusta Freeman (*c*.1845–*c*.1866)
The Princes Sleeping in the Tower, 1862
Marble, 40.5 x 117 cm (16 x 46 in)
Inscribed: *Mrs Augusta Freeman Roma 1862*

The Princes Sleeping in the Tower illustrates the sentimental tendency common in much Victorian and Edwardian sculpture. The 'princes' (in fact, the thirteen-year-old Edward V and his brother Richard, Duke of York) were held captive in the Tower of London by Richard, Duke of Gloucester, during his attempts to secure the English throne for himself. According to popular belief whilst there they were murdered, either by Richard himself or his henchmen.

Although little is known about her, it seems Augusta Freeman was well known for her depictions of children, especially if they allowed for a maudlin element. Another work by her, *Sleeping Nelly*, shows the heroine of Dickens's *Old Curiosity Shop* abandoned to her fate, lying on a rough mattress but watched over by guardian angels. Similarly, in *The Princes Sleeping in the Tower*, two rather cherubic boys sleep blissfully, unaware that they will shortly be killed. Compositionally, the Russell-Cotes piece bears a strong resemblance to Lichfield Cathedral's *The Sleeping Children* (1817) by Sir Francis Chantrey (1781–1841).

Cat.76 Ludwig Michael Schwanthaler (1802–48)
Melusine (Die Schöne Melusine), c.1841–5
Marble, 117 cm (46 in) high
Inscribed on base with monogram

The story of Melusine is part of a cycle of French legends. There are a number of versions but all seem to agree on the basic story. Melusine was a water nymph who took on human form to marry the man with whom she had fallen in love. Before agreeing to the marriage she made one condition, which was that she should be allowed to bathe alone and unseen every Saturday. Her husband-to-be readily agreed to this and, once married, the couple lived happily for many years and had several children. After some time, however, curiosity got the better of the husband and he spied on Melusine as she took her weekly bath. He then saw her in her supernatural form: a beautiful woman from the waist up but a writhing serpent below. Knowing that he had betrayed her, Melusine ultimately abandoned both him and her children and returned to her watery home.

The original version of this figure was sited in the marble bath of Hohenschwangau Castle, near the present German–Austrian border. The naked yet fully human figure, stepping apprehensively forward, undoubtedly represents Melusine about to transform herself before entering the bath.

The Munich-based Schwanthaler was the master of Neoclassical sculpture in southern Germany during the early nineteenth century. On a number of occasions he was commissioned by King Ludwig I to decorate Bavarian palaces, museums and other public buildings. He had numerous other patrons and won many awards, ultimately being ennobled by the King.

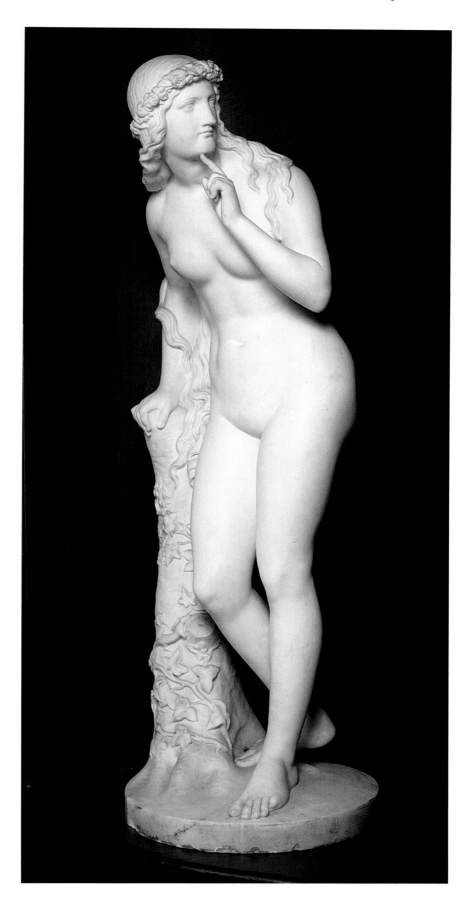

German sculptor Ferdinand Junck (Cat.82) and particularly *Edward VII* by Ernesto Gazzeri (b.1866), to whom Russell-Cotes and his wife also sat for their portraits. There are theatrical portaits: *Shakespeare* by an anonymous sculptor, *Irving* by Pollock (1877–1943) and the *Death-mask of Beerbohm-Tree* by Sir George Frampton (1860–1928). There were maybe political heroisations involved: *Cromwell* after Louis-François Roubiliac (1705–62), *Napoleon* and *Josephine* (the latter after Canova) balanced by *Nelson* after John Flaxman (1755–1826). *Lord George Bentinck* was a prominent Tory politician who supported horse-racing and helped to oust Peel from the party after the repeal of the Corn Laws; his portrait is by Edward Hodges Baily (1788–1867). There are also two busts of *Benjamin Disraeli* by William Behnes (1795–1864) and Count Victor Gleichen (1833–91), a sculptor who married into the British royal family.

What is virtually unique about Russell-Cotes's sculpture collection is that it passed into public hands. There were collections of sculpture in Britain throughout the nineteenth century but they have largely disappeared, their existence detectable only from occasional fossil-like traces in contemporary publications. The only real parallel to what Russell-Cotes effected can be found in the collection Lord Leverhulme gave to Port Sunlight. Here, too, sculpture held a prominent position in the total collection, though what Leverhulme collected was very different.[15]

At a rough count Russell-Cotes's collection had eighteen British, twenty-six Italian, eight French and four German sculptures. It included work by major British – Macdonald, Spence, Stephens – and European artists – Schwanthaler, Benzoni, Andreoni, Barrias and others. It would be intriguing to know where and how Russell-Cotes acquired the works. He went to Italy several times, including some 'considerable time' in Rome where he sat to Gazzeri for the portrait busts.[16] Did he see work there, visit artists' studios? There was a substantial market in French and Italian sculpture in London (Calvi, Lombardi and Oldofredi all exhibited at the Royal Academy) and perhaps Russell-Cotes relied on galleries or dealers or even on sales to find or have found for him what he wanted.

Two works best encapsulate the real mystery behind the sculpture collection. First, why Schwanthaler? He was a major German sculptor, certainly the leading sculptor of Bavaria, but he had died in 1848 and so far as one can tell his work was little known in England. One piece, *Undine*, used to feature in the collection at Wentworth Woodhouse, Yorkshire,[17] another exists at Chatsworth, Derbyshire, and yet another, *Schwanhilda*, survives to this day at Salford (ironically in the circumstances described earlier).[18] Even more intriguing is the *Centaur and Mermaid*

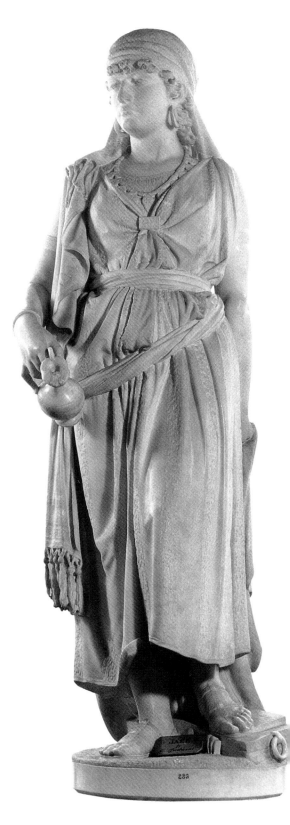

Cat.77 Attributed to Orazio Andreoni
Jael, late nineteenth century
Marble, 167.5 cm (66 in) high

The story of Jael is taken from the Bible (Judges 4: 12–28). Wife of Heber the Kenite, she gave shelter to Sisera, captain of the Canaanite army, after he had been defeated in battle by the Israelites. The Canaanite demanded that she stand in the entrance to his tent and, should anybody enquire after him, deny she had seen him. Jael agreed, gave him milk to drink before he settled down to sleep and then left him. A short time later she took a hammer and a nail, crept softly back in and drove the nail through his head, fastening it to the ground.

Holding the jug of milk she gave to Sisera in front of her, Jael is here depicted as a very calm figure, apparently without malice. Behind her back, though, she firmly holds the nail with which she will kill Sisera.

Andreoni is another little-known nineteenth-century sculptor. What is known is that he frequently used the Bible as source material. It seems likely that he was reasonably successful and employed assistants in his studio.

(Cat.84) by Jozef Müllner (1879–?). Müllner is known in Austria, but almost as a late Symbolist artist. Why Müllner?

The sculpture acquisitions of the collection after Russell-Cotes's death corresponded more to the pattern of random accretion outlined earlier, though one should not think the less of them for that. The collection of ideal and portrait busts was considerably enhanced: *Proserpine* is by Hiram Powers (1805–73), one of America's leading nineteenth-century sculptors, *Mrs St Barbe Sladen* is by Carlo Marochetti (1805–67), a major figure in Italian, French and British sculpture between the 1830s and the 1860s. Giovanni Dupré (1817–82) was a senior figure in Italian nineteenth-century sculpture and the significance of his bust of *Baroness von Hügel* (Cat.83) is increased by the identity of the sitter: wife of the Austrian minister at Florence (where Dupré worked) and mother of Friedrich, the major

Cat.78 Louis-Ernest Barrias (1841–1905)
The First Funeral (Les Premières Funérailles, Adam et Eve portant Abel), 1878
Bronze, 83.8 cm (33 in) high

This bronze group represents Adam and Eve mourning their second son Abel after his murder by Cain, their first. Barrias has used the subject to contrast male and female responses to grief, although in a rather conventional way.
Adam is represented as being both physically and emotionally strong. With an impassive face, he strains backwards and upwards, apparently taking the main weight of the corpse. Compositionally, the sculpture hangs from this figure. By way of contrast, Eve crouches over the body, seeming about to kiss it, in an open display of grief.

The Parisian Barrias was brought up in an artistic household, his father being a miniaturist and ceramic decorator, and his brother a painter. After studying at the Ecole des Beaux-Arts he began to exhibit regularly at the Paris Salon in 1861. He won many awards including, in 1884, Officer of the Legion of Honour and Member of the Academy. In his day, Barrias was considered the greatest French sculptor in the classical style, though this piece has more a feel of the New Sculpture in its form. If Neoclassicism had tended to idealise the figure, the New Sculpture aimed to be eminently realistic and treat the figures in a more vigorous, active manner.

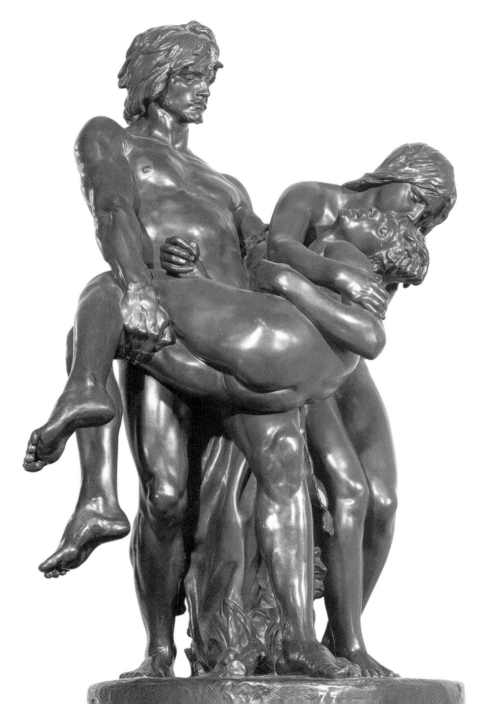

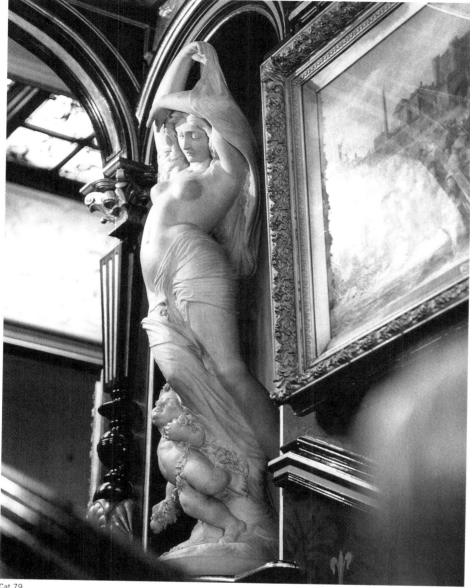

Cat.79

Cat.79 Anonymous
***Nymph and Cupid, or Night,* late nineteenth century**
Marble, 177.7 cm (70 in) high

In Greek mythology nymphs were usually associated with fertile, growing things, such as trees or water. They were not immortal but extremely long-lived and were on the whole kindly disposed toward men. They were distinguished according to the sphere of nature with which they were connected.

Cat.80 Pietro Calvi (1833–84)
***Othello (Il Moro di Venezia),* c.1881**
Marble and bronze, 72.5 cm (28½ in) high
Inscribed on reverse: *Calvi Milano*

Othello is the subject of one of Shakespeare's late tragedies. Due to the designs of his scheming ensign, Iago, Othello becomes convinced that his wife Desdemona is being unfaithful to him. At the climax of the play, in a rage of despair and jealousy, Othello strangles her only to realise in the aftermath not only that he has killed the person he loved but that she was innocent. Overcome with grief he commits suicide. None of this is apparent in Calvi's bust which portrays a self-assured, dignified figure much in keeping with the character of Othello at the beginning of the play.
The features are probably those of Ira Aldridge, a well-known actor of the time. The plinth bears the Lion of St Mark, an allusion to the Venetian setting of the play.

Calvi exhibited widely in America and Europe, including at the Royal Academy, London. Milan, though, was his birthplace, where he studied and lived until his death. His work is particularly interesting, for not only was he popular with Merton Russell-Cotes (whose collection holds five busts attributed to him) but he was also an exponent of polychrome (multi-coloured) sculpture. The practice of colouring sculpture was not common in nineteenth-century Europe, conventional thought – basing its ideas on weather- and age-worn examples of Greek and Roman sculpture – regarding it as eccentric and aberrational. There were sporadic outbreaks, however, particularly towards the end of the century.

Although he seems never to have gone so far as some sculptors and actually painted his work, Calvi nevertheless makes effective use of the contrast between bronze and marble. Of the five busts in the collection, three are constructed by this method. They all depict Africans and this suggests

Catholic controversialist of *c.*1900. Maybe *W.H. Smith* by Joseph Durham (1814–77) does not quite rank with this, though Smith is a much more famous figure today, and the bust came from his eponymous firm. There are two busts of Florence Nightingale, one by Patrick Macdowell (1799–1870), a leading Royal Academician between 1831 and 1870. The other is by Joseph Towne (1808–79) who managed to combine a successful career in sculpture with being for fifty-three years official anatomical modeller at Guy's Hospital in London, where he might have met the sitter. She certainly had connections with Bournemouth, being involved in the design of the Herbert Hospital in 1865. There are also two 'ideal' sculptures of importance. *Daedalus and Icarus* by Francis Derwent Wood (1871–1926) is the artist's original plaster model of the work that won him the Royal Academy gold medal in 1895, and was presented by his widow. Wood was a prominent younger member of the New Sculpture movement in England at the end of the nineteenth century. Although the choice of subject for this work was pre-

ordained by the Royal Academy authorities, it had particular reverberations at the time: it was a subject that had been treated in painting in 1869 by the artist who was now President of the Royal Academy, Frederic Leighton, and was one of the prime encouragers of the new movement; in addition, the subject of Icarus had also been treated in sculpture the previous decade by the great hero of the movement, Alfred Gilbert (1854–1934).[19]

The range and richness of the Russell-Cotes sculpture acquisitions has continued into recent years, with adventurous gifts and even direct commissions from sculptors of an emphatically contemporary flavour, for instance *Nine Pines*, *c*.1990, by Nicholas Pope (b.1949), the gift of Southern Arts. A museum and gallery cannot continue to fulfil a lively public function unless it embraces the art of today as well as that of the past and in this the gallery can be seen to be maintaining the agenda of its founder.

the influence of Charles-Henri-Joseph Cordier (1827–1905) who was commissioned in 1850 to create a series of ethnic types in polychromy for the Muséum d'Histoire naturelle, Paris. On the other hand, he may simply have been responding to current fashions, for at the time there was a vogue in Italy for sculpture which mixed bronze, marble and other materials.

A close inspection of Calvi's bronze and marble busts reveals that the marble is in at least two and sometimes three separate sections. These would have been worked upon to achieve a general outline of the forms as well as an overall fit. The face, having been modelled in clay or wax, would be cast in bronze and then fitted into the marble. Once the pieces were secured, Calvi could then tidy up the carving to achieve an apparently seamless finish.

This bust was originally shown at the Paris Salon in 1881. A different treatment of *Othello* was exhibited at the Royal Academy in 1872 and there is another version, dated to 1879, currently in a private collection. The composition of the 1879 bust differs from that in the Russell-Cotes collection by showing Othello holding in his left hand the handkerchief used to incriminate Desdemona.

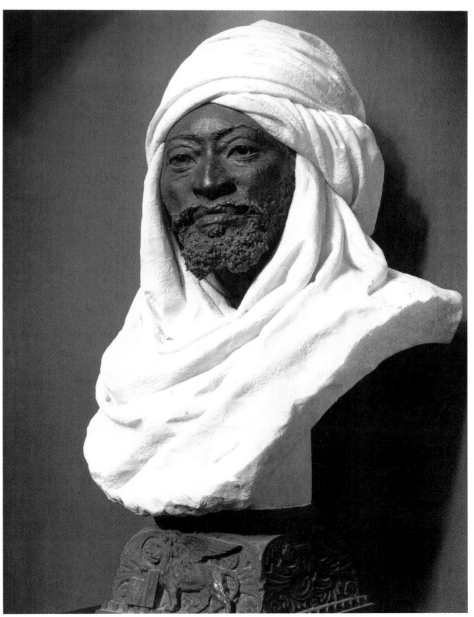

Cat.80

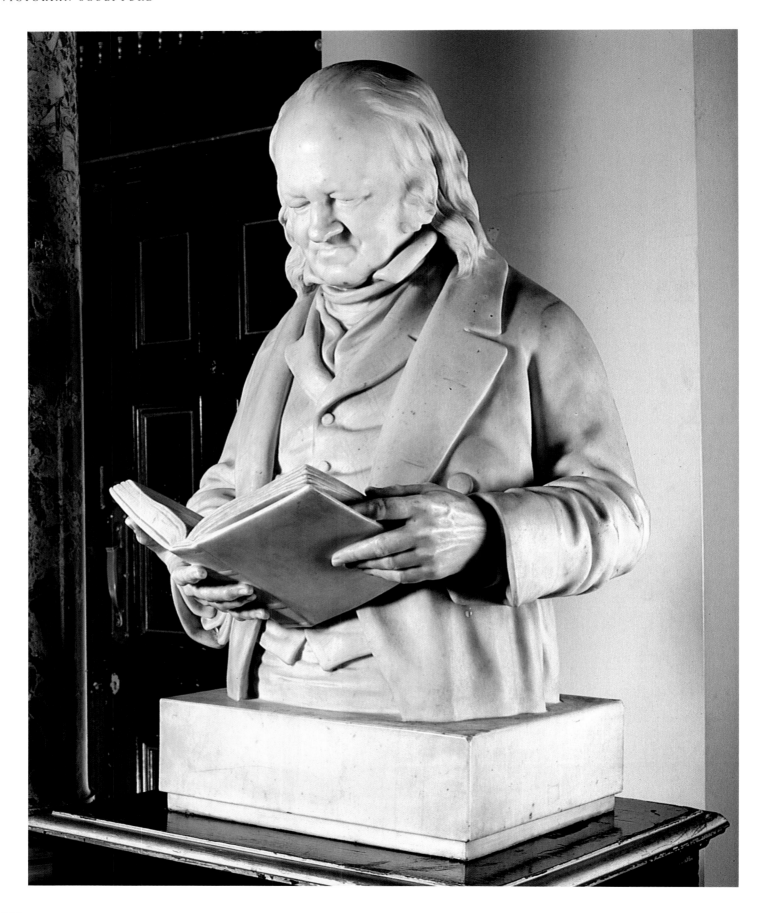

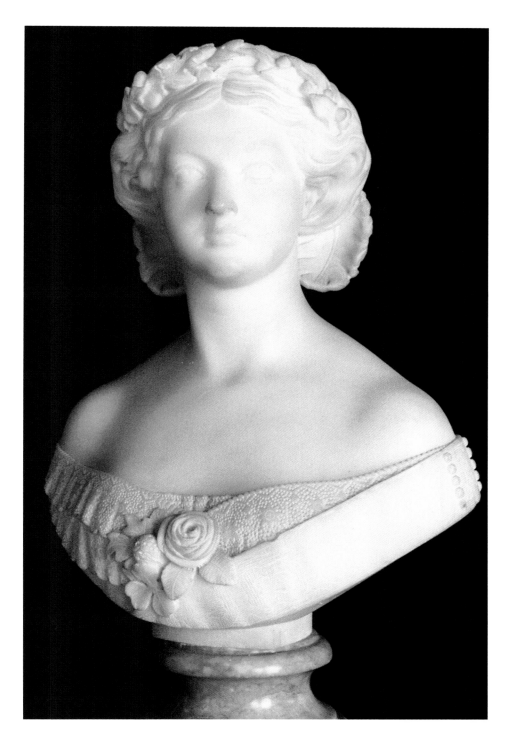

Cat.81 John Adams-Acton (1831–1910)
John Landseer, **1882**
Marble, 83.8 cm (33 in) high

John Landseer is remembered now mainly as the
father of Edwin Landseer, the great Victorian
animal artist, sculptor of the lions at the base of
Nelson's Column, painter of *The Monarch of the
Glen* and *Flood in the Highlands*. He was himself
an artist, however, being a respected engraver and
printmaker. By all accounts an eccentric and highly
argumentative individual he became involved in a
protracted dispute with the Royal Academy over its
failure to honour engravers. This continued even
after the Academy (presumably fed up with
Landseer) made him its Associate Engraver in
1802. Besides engraving he also wrote and had
two books published on rather obscure antiquarian
subjects, *Observations on the Engraved Gems from
Babylon* and *Sabaean Researches*.

 Born John Adams in Acton, London in 1831,
the sculptor of this bust studied under Timothy
Butler (1806–*c*.80) before moving to the Royal
Academy Schools. For an original group he was
awarded a gold medal and a travelling scholarship
to Rome, where he lived for ten years. From 1851
he exhibited regularly at the Royal Academy and
did so until 1892. In 1868 he took the name John
Adams-Acton to avoid confusion with a painter,
also called John Adams.

 Adams-Acton's work consists chiefly of portraits
of celebrities of the day including royal figures
such as Queen Victoria, Prince Albert and Edward
VII. Though artistically conventional, he was one of
the leading sculptors of the period. His work now
tends to be forgotten in favour of more radical
artists such as Sir Alfred Gilbert.

Cat.82 Ferdinand Junck
Queen Victoria, **1858**
Marble, 37.5 cm (14¾ in) high
Inscribed: *F.Junck 1858*

This white marble bust depicting a woman of about
thirty-five years identifies Queen Victoria, who would
have been around thirty-eight years old during this
period of time. A sash runs from her left shoulder
downwards as if to fit under her right arm, and at
her breast she wears a rose, a thistle and a shamrock,
signifying the kingdoms of the United Kingdom.
Finally, she wears a wreath of oak leaves, acorns
and olive or laurel leaves in her hair and draped at
the back to the left and right are ostrich feathers.
Her hair is thick and centrally parted, coiled and
plaited behind, and she wears an off-the-shoulder
dress bordered with double lace fringes.

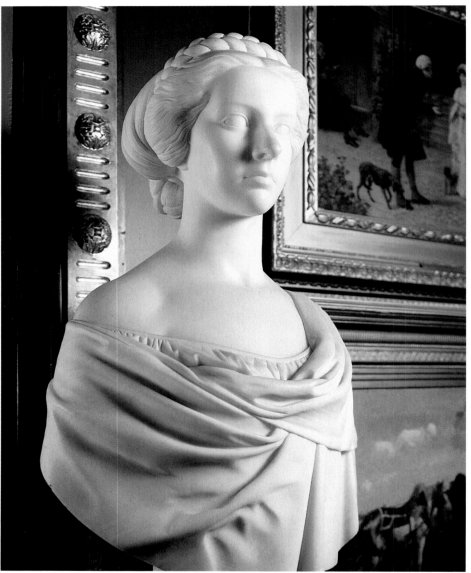

Cat.83

Cat.83 Giovanni Dupré (1817–82)
Baroness von Hügel, **1853**
Marble, 73.7 cm (29 in) high
Inscribed on reverse: *G. Dupré FA 1853*

Giovanni Dupré studied at the academy in Florence
and was taught by Lorenzo Bartolini (1777–1850).
His career began in 1842 with the life-size *Dead
Abel* of which many replicas were made in bronze
and marble. Its physical detail and realism were
praised by contemporaries and it is now in the
Musée du Louvre in Paris.

 Dupré was a pioneer of *verismo* or realism but
had abandoned it by the middle of the century.
He was regarded as the greatest Italian sculptor of
his day – although his popularity waned after he
produced his sculpture of *Camillo Benso di Cavour*
commissioned for Turin to celebrate the
reunification of Italy. This showed Cavour in a toga
with a semi-nude Italia clinging to him. Dupré also
executed various religious subjects, especially for
funerary monuments.

Cat.84 Josef Müllner (1879–?)
Centaur and Mermaid, **1919**
Bronze, 93 cm (36½ in) high
Inscribed on base: *J. Müllner, 1919*

Müllner taught sculpture at the Vienna Academy
from 1910 and was to become Director of the
Sculpture Masterclass there in 1922.

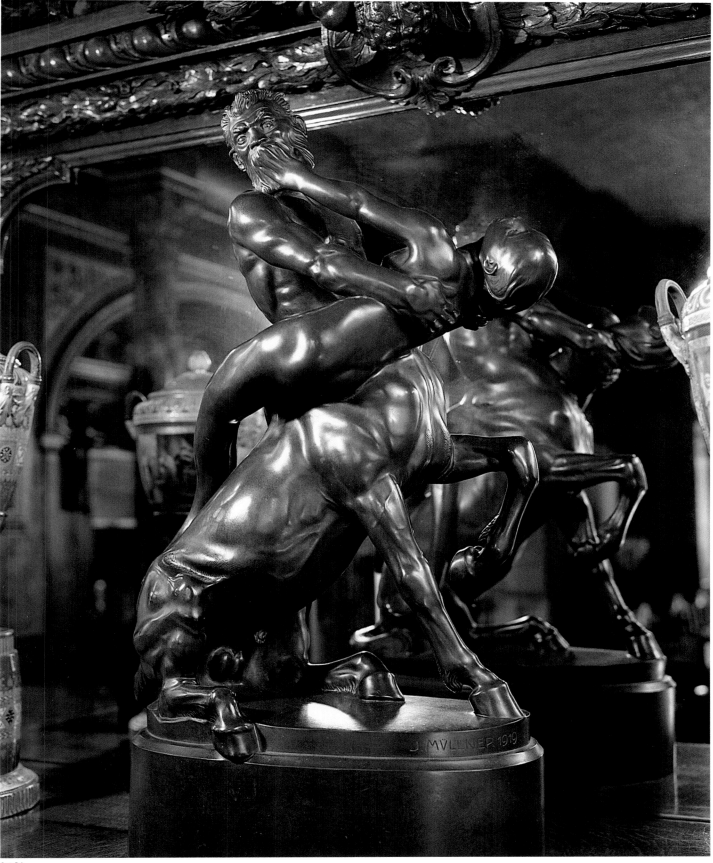

Cat.84

AFTERWORD

Characterising the art of an age is not easy, particularly one that lasted for more than sixty years. In the years of Victoria's reign 1837–1901 many developments occurred that had a radical effect upon the production and status of art. Yet there are common characteristics that bind the period together. The forging of an empire, increasing urbanisation and the growing importance of mass industry, and the social change that resulted all had their impact on the development of art in this period. Art was moulded by a national identity that served the needs of a new society characterised by a changing hierarchy, and a strengthening belief in education and philanthropy. The collectors, too, were a new breed. In this series of essays, which give fascinating insights into diverse aspects of Victorian art, we see how a single collection can act as a microcosm for the entire art world.

One of the best summings-up of the period came in 1897, Queen Victoria's Diamond Jubilee year, when schemes were put forward to celebrate the art of her reign and it was proposed that a gallery devoted exclusively to the British art of the last sixty years be established. This art was characterised thus by *The Studio* magazine:

> Before the Queen's reign had lasted many years the signs of improvement and the
> promise of better things became too evident for the possibility of doubt. A great art
> revival was soon seen to be commencing, and its progress with each successive year grew
> to be more rapid and remarkable. Not only did artists of real capacity and admirable
> skill appear in all directions, but the popular view, as well, expanded. The desire to be in
> touch with art was no longer confined to the few, to the rare experts whose isolation in a
> Philistine world had been a pathetic feature of the previous period; on the contrary,
> every one began in greater or less degree to show that the new ideas and the more active
> aspirations had power to persuade them. Before long the reality of the change was
> beyond the possibility of doubt; the movement became irresistible, and has continued
> since with hardly a pause or hint of hesitation to sweep forward in the direction of
> universal conviction.[1]

This spirit of the age can be found within the Russell-Cotes collection, which leaves a remarkable chronicle of Victorian art that can still be enjoyed by visitors today.

NOTES
1. *A Victorian Gallery*, 'A suggestion for commemorating the longest reign on record', *The Studio*, 1897, p.260.

130

Notes

CHAPTER ONE

1. *Art Union*, August 1840, p.127; *Art Union*, January 1842, p.3.

2. Clive Bell, *Landmarks in Nineteenth-Century Painting*, London, 1927, p.111.

3. Wyndham Lewis, 'The Brotherhood', *Listener*, 22 April 1948, p.672.

4. M. Arnold, 'Barbarians, Philistines, Populace' in *Culture & Anarchy*, London, 1869.

5. Sir Merton Russell-Cotes, *Home and Abroad*, privately published, Bournemouth, 1921, pp.686–7.

6. *Art Union,* January 1842, p.3; March 1843, p.58.

7. *Art Union*, August 1843, p.207.

8. *New Monthly Magazine*, August 1844; quoted in J.C. Olmsted, *Victorian Painting: Essays & Reviews*, vol.1, New York, 1980, pp.552, 559.

9. J. Dafforne, 'J. Cross', *Art Journal*, 1862, p.119.

10. *Illustrated London News*, 18 May 1867, p.487; *Athenaeum*, 4 May 1867, p.594.

11. Solomon Hart, 'Lecture VI', *Athenaeum,* 29 March 1856, p.397.

12. Quoted in *Great Victorian Pictures*, exh.cat., Arts Council of Great Britain, London,1978, p.38.

13. 'Mr. E. Frost', *Art Journal*, 1849, p.184.

14. William Holman Hunt, *Pre-Raphaelitism*, vol.1, London, 1905, p.142; D.G. Rossetti, *Works*, edited by W.M. Rossetti, London, 1911, pp.572, 574.

15. Quoted in *Great Victorian Pictures*, op.cit., p.38; *Illustrated London News*, 18 May 1867, p.487.

16. Hippolyte Taine, *Notes on England*, London,1957, pp.258–9.

17. [J.B. Atkinson], 'London Art Season', *Blackwoods Magazine*, August 1869, p.223.

18. Ian Jenkins, *Archaeologists and Aesthetes*, London, 1992, p.33.

19. S. Colvin, 'English Painters in 1867', *Fortnightly Review*, October 1867, p.468; [J.B. Atkinson], op.cit., p.223.

20. Quoted in M.S. Watts, *G.F. Watts*, vol.1, London, 1912, p.93.

21. Quoted in H.H. Statham, 'Leighton & Watts', *Fortnightly Review*, February 1897, p.309.

22. R. Ormond, *Lord Leighton*, exh.cat., Royal Academy, London, November 1996, p.24.

23. H. Quilter, 'R.A. Ex.', *Contemporary Review*, June 1882, p.946.

24. Walter Pater, 'The School of Giorgione' (1877) in *The Renaissance, Works*, London, 1910, pp.132–3.

25. W. Graham Robertson, *Time Was*, London, 1955 (1931), pp.58–60.

26. Mark Bills, *Edwin Long*, London, 1998, p.141.

27. *Burne-Jones Talking*, edited by M. Lago, London, 1981.

28. 'History in Landscape', *Saturday Review*, 12 July 1856, p.247.

29. Frederick Goodall, *Reminiscences*, London, 1902, p.266.

30. G.P. Gooch, *History and Historians in the Nineteenth Century*, London, 1920, p.78.

31. Dianne Sachko McLeod, 'Art Collecting and Victorian Middle-Class Taste', *Art History*, vol.10, no.3, September 1987, p.328.

32. *Victorian Paintings*, exh.cat., Mappin Art Gallery Sheffield, 1986, p.35; *Victorian Paintings*, exh.cat., Arts Council of Great Britain, London, 1962, Introduction.

33. *Athenaeum*, 13 May 1865, p.657.

34. Quoted in Wilfred Meynell, *Modern School of Art*, London, n.d., vol.III, p.111.

35. *Illustrated London News*, 9 May 1874, p.446.

36. Quoted in Meynell, op.cit., p.111, pp.107–8.

37. [J.B. Atkinson], op.cit., p.230.

38. W.M. Thackeray, 'On the French School of Painting' in *Paris Sketchbook, Works*, vol.XVI, London, 1879, p.43.

39. W.M. Thackeray, 'May Gambols' (June 1844) in *Miscellaneous Essays, Works*, vol.XV, London, 1886, p.194.

40. Tom Taylor, 'English Painting in 1862', *Fine Art Quarterly Review*, May 1863, p.15.

41. Frank Davis, 'The Victorian Scene', *Illustrated London News*, 6 March 1965, p.30.

42. William Powell Frith, *Further Reminiscences*, London, 1888, p.9.

43. W.M. Rossetti, 'London Exhibitions of 1861', *Fraser's Magazine*, November 1861, p.588; F. Wedmore, 'Genre in the Summer Exhibitions', *Fortnightly Review*, June 1883, p.865.

44. William Powell Frith, *My Autobiography & Reminiscences*, London, 1887, vol.1, p.246.

45. *Art Journal*, 1863, p.110.

46. F. Wedmore, op.cit., p.866.

47. Wilfred Meynell, op.cit., vol.II, p.185.

48. Quoted in Edward Morris, *Victorian & Edwardian Paintings in the Lady Lever Art Gallery*, 1994, p.43.

49. Walter Pater, 'Prosper Merimee' (1890) in *Miscellaneous Studies, Works*, London, 1910, p.12.

50. P.T. Forsyth, *Religion in Recent Art*, London, 1905 (1889), p.16.

51. *Art Journal*, 1878, p.155.

52. R. de Sizeranne, 'The Late Sir Edward Burne-Jones', supplement to *The Artist*, July 1898, p.6.

53. A. Symons, *Studies in Seven Arts* (1906) in *Works*, London, 1924, vol.9, p.62.

54. Lois Jane Drawmer, *The Impact of Science and Spiritualism in the Works of Evelyn De Morgan*, unpublished Ph.D. thesis, Buckinghamshire Chilterns University College, 2001, p.58. See also Judy Oberhausen, 'E. De Morgan & Spiritualism' in *Evelyn De Morgan: Oil Paintings*, edited by C. Gordon, 1996, pp.33–52.

55. Quentin Bell, *Victorian Painters*, London, 1975 (1967), p.1.

56. William Powell Frith, 'Crazes in Art', *Magazine of Art*, XX (1888), p.191.

57. *Art Journal*, 1878, p.166.

58. Simon Olding, 'A Victorian Salon: An introduction' in *A Victorian Salon*, edited by Mark Bills, Russell-Cotes Art Gallery & Museum, Bournemouth, 1999, p.11.

CHAPTER TWO

1. *New Monthly Magazine*, XXXVII, 1833, p.247.

2. Helene E. Roberts, 'Exhibition and Review: the periodical press and the Victorian art exhibition system' in *The Victorian Periodical Press: Samplings and Soundings*, edited by Joanne Shattock and Michael Wolff, Leicester University Press and University of Toronto Press, 1982, p.80.

3. Harry Quilter, *Sententiæ Artis, First Principles of Art for Painters and Picture Lovers*, London, 1886, pp.27–8.

4. Sir Merton Russell-Cotes, *Home and Abroad* (2 volumes), privately published, Bournemouth, 1921, pp.722–3.

5. *Ibid.*, p.709.

6. *National Review*, vol.V, 1885, p.458.

7. 'The opening of the Exhibition of the Royal Academy is one of our annual metropolitan galas, belonging to the same category as Christmas Day, Easter Monday, and the opening of Parliament.' *Pictorial Times*, vol.IX, 1847, p.289.

8. *Art Journal*, 1848, p.180.

9. Sir Merton Russell-Cotes, op.cit., p.686.

10. Stephen Fronk in *Palaces of Art*, edited by Giles Waterfield, Dulwich Picture Gallery, 1991, p.167.

11. 'During his residence at Bournemouth,' Merton recalled, 'he was a frequent guest with us at East Cliff Hall, and never seemed to tire of looking through our collection … we have many works of art purchased through him.' Sir Merton Russell-Cotes, op.cit., pp.694–5.

12. *Ibid.*, p.710.

13. Lewis Day, 'How to Hang Pictures', *Magazine of Art*, 1882, pp.58–60.

14. Percy Fitzgerald, 'Picture Frames', *Art Journal*, 1886, p.325.

CHAPTER THREE

1. Sir Merton Russell-Cotes, *Home and Abroad* (2 volumes), privately published, Bournemouth, 1921, pp.719–20. In promoting the English nude Russell-Cotes also collected studies of particular models (such as Godward's *Ethel Warwick*) as well as representations of 'virtuous' women. Goodall's drawing for *Susannah* was, for example, described by the *Athenaeum* as 'a portly matron of an English type, stark naked' (12 June 1886, with reference to the painting exhibited at the Royal Academy in that year).

2. Malcolm C. Salaman, 'Etty's pictures in Lord Leverhulme's collection', *The Studio*, vol.85, January 1923, p.3.

3. 'Vanities', *Vanity Fair*, 4 February 1882, p.65. The painting referred to was Etty's *Musidora*, bequeathed to the National Gallery by Jacob Bell in 1859.

4. The phrase is reiterated in Russell-Cotes, op.cit., pp.713, 733.

5. Henry Justice Ford, letter to the curator, Norman Silvester, 30 October 1935. Russell-Cotes Art Gallery and Museum archive.

6. See Rathbone's lecture 'The Mission of the Undraped Figure in Art', delivered to the Cheltenham Social Science Congress in 1878 and reproduced in the *Builder*, 9 November 1878, p.1170.

7. P.G. Hamerton, *Man in Art*, London, 1892, pp.33–4.

8. The Russell-Coteses owned Solomon's *Bathers Alarmed*, Faléro's *The Butterfly* and a painting attributed to Poynter, *Cleopatra and the Asp*.

9. C. Lansing, 'Preface' in *The Nude in Art*, London, 1896, p.1.

10. The correspondence between Leighton and Horsfall is reproduced in Mrs Russell Barrington, *The Life, Letters and Work of Frederic Leighton*, London, 1906, vol.2, pp.274, 278.

11. The term was first coined by Justice Stephen in his *A Digest of Criminal Law (Crimes and Punishments)*, London, 1877, p.104.

12. Russell-Cotes, op.cit., p.36.

13. Letter dated 30 June 1899, reproduced in Russell-Cotes, op.cit., p.733. The custom of debating the nude in daily papers with participants adopting pseudonyms had precedents in earlier controversies. See Alison Smith, *The Victorian Nude: Sexuality, Morality and Art*, Manchester, 1996, pp.204, 227–9.

14. Those who supported 'East Ender' included 'Another East Ender' writing on 10 and 13 July, and 'Social Purity' on 17 July. The writers adopting a pragmatic approach were 'Candid Critic', 4 July, 'Dawned Love', 12 July and 'Anti-Humbug', 4 July. The letters are all reproduced in Russell-Cotes, op.cit., pp.733–6.

15. *Art Journal*, 1894, pp.191, 222.

16. Robyn Asleson, *Albert Moore*, Oxford, 2000, pp.188–9.

17. Giles Waterfield, 'A Home of Luxury and a Temple of Art' in *A Victorian Salon*, edited by Mark Bills, Russell-Cotes Art Gallery and Museum, Bournemouth, 1999, p.11.

18. The reasons for supposing the collector was probably responsible for these additions are explained in *A Victorian Salon*, op.cit., p.84.

19. *Bournemouth Times*, 13 November, 9 November 1956. Russell-Cotes Museum archive.

CHAPTER FOUR

1. Census returns show there were 278 professional women artists in 1841, 1069 in 1871.

2. Dianne Sachko MacLeod, *Art and the Victorian Middle Class*, New York, 1996.

3. See Charlotte Yeldham, *Women Artists in nineteenth-century France and England*, New York, 1984; Pamela Gerrish Nunn, *Victorian Women Artists*, London, 1987.

4. The only names on whom information survives in any detail are Mary Thornycroft (1809–95), Susan Durant (*fl.*1847–73) and Margaret Foley (d.1877). On the sculptor community in nineteenth-century Rome, see Margaret F. Thorp, *The Literary Sculptors*, 1965.

5. Sarah Tytler, *Modern Painters and their Paintings*, London, 1874, p.300.

6. See Nunn, op.cit.; Deborah Cherry, *Painting Women: Victorian women artists*, London and New York, 1993.

7. It is not known quite when this painting entered the collection: it was not there by 1895, or it would have been featured in the 1895 *Art Journal* article profiling the collection, but it was acquired before 1922.

8. Mrs Stirling, letter to Orr Paterson, c.1951. Russell-Cotes Art Gallery and Museum archive.

9. See Catherine Gordon (ed.), *Evelyn DeMorgan: oil paintings*, London, 1996.

10. See *Great Victorian Pictures: their paths to fame*, Arts Council of Great Britain, London, 1978, p.59; *Love Locked Out: the memoirs of Anna Lea Merritt*, edited by Galina Gorokhoff, Boston, 1982.

11. See, for instance, *Poems by Alfred Lord Tennyson*, London, 1905; *Pippa Passes & Men and Women*, London, 1908; *The Idylls of the King*, London, 1911.

12. See Annabel Robinson, John Purkis and Ann Massing, *A Florentine Procession*, Cambridge, 1997; Jan Marsh and Pamela Gerrish Nunn, *Pre-Raphaelite Women Artists*, exh.cat., Manchester City Art Galleries, 1997.

13. She returned to England in 1894 to live in the mild climate of Cornwall.

14. An earlier example of her line in 'exotic foreigners', *The Rhodean Girl* (1861), shows how close Orientalism was in some artists' hands to the Mediterranean peasant painting of Anderson.

15. The idea that these two function as a pair, assisted by the appearance of the figure in the former work, suggests that the young person in the Russell-Cotes picture is not a girl but a boy, the dark, male opposite of the white, female figure in the Victoria and Albert Museum's painting.

16. See the artist's daughter Estella Canziani's autobiography, *Round About Three Palace Green*, London, 1939.

17. For instance, a portrait of Frances, Mrs Justice Drewe in Castle Drogo, Devon.

18. Very few collectors of Lawrence Alma-Tadema also bought from Laura, which makes the Russell-Coteses' action unusual. The collection no longer contains the works by the husband, which were put up for sale in 1905, as was that by Laura, but bought back in 1910.

19. See Caroline Dakers, *The Holland Park Circle*, London and New Haven, 1999.

20. On the role of genre in the typecasting of women's art, see Pamela Gerrish Nunn, *Problem Pictures: women and men in Victorian painting*, Aldershot, 1996.

21. For instance, Florence Claxton's *Women's Work: a medley* (1861) included 'An artist (Rosa B-) [who] has attained the top of the wall (upon which the rank weeds of Misrepresentation and prickly thorns of Ridicule flourish) – others are following'. This description is from the artist's gloss as included in the catalogue for the Liverpool Autumn Exhibition at which the work was shown in 1862. Bonheur's non-representation in the Russell-Cotes collection is the more surprising because the animal painting for which she became known was evidently within the bounds of the collectors' taste, as proven by their acquisition of Maud Earl's *Red Deer, Early Morning*, Thomas Cooper's *Cows* and Henry Banks Davis's *Approaching Thunderstorm*.

22. See Laura Wortley, *Lucy Kemp-Welch 1869–1958, The Spirit of the Horse*, Woodbridge, 1996.

23. *Timber Hauling in the New Forest*, for instance, measures 148.5 by 302.2 centimetres. It seems likely that the plans to extend the Russell-Cotes Gallery, begun in 1916, spurred the acquisition of *The Gypsy Horse Drovers*, though the first part of the new space was not opened for use until 1919.

24. See Christopher Green, *Art made Modern: Roger Fry's Vision of Art*, London, 1999.

25. See Teresa Grimes, Judith Collins and Ariana Baddeley, *Five Women Painters*, 1989. On Scott, see Louisa Young, *A great Task of Happiness: the life of Kathleen Scott*, Oxford, 1995; and Mark Stocker, 'My masculine Models: the sculpture of Kathleen Scott', *Apollo*, vol.150, no.451, 1999, pp.47–54.

26. Anonymous, 'The Collection of Merton Russell-Cotes, esq, JP', *Art Journal*, 1895, pp.81–4, 216–20, 281–4, 294–5, 341–2.

CHAPTER FIVE

1. Sir Merton Russell-Cotes, *Home and Abroad* (2 volumes), privately published, Bournemouth, 1921, p.711.

2. *Ibid.*, p.722.

3. The most expensive was Frederick Goodall's *Palm Offering* for which £2000 was paid. This work was later sold by the custodians of the Russell-Cotes collection.

4. F.G. Stephens, *Memoirs of Sir Edwin Landseer*, London, 1874, list of prices pp.143–5.

5. R. Ormond, *Sir Edwin Landseer*, exh.cat., Philadelphia Museum of Art, 1981, p.22.

6. T.B., *A Call to Connoisseurs, a decision of sense with respect to the present state of painting and sculpture and their several professors*, London, 1756, p.8.

7. Russell-Cotes, op.cit., p.726.

8. *Ibid.*, p.727.

9. Loc.cit.

10. For his admiration of Ruskin, see Russell-Cotes, op.cit., pp.745–8.

11. Quoted from Ruskin's *Greatness in Art* in J. Dafforne, *Pictures by Sir Edwin Landseer*, London, 1874, p.17.

12. See, for instance, the myth of the shepherd Endymion and his dog.

13. Russell-Cotes, op.cit., p.727.

14. Stephens, op.cit., p.131.

15. *Ibid.*

16. Loc.cit.

17. For a description of the melancholy subject matter of *A Random Shot*, see Dafforne, op.cit., p.33.

18. *Ibid.*

19. Arthur Devis, *The Orde Family with William Orde presenting a shot bird to his parents*, Yale Collection, c.1740.

20. Quoted in Dafforne, op.cit., p.26.

21. C. Monkhouse, *The Works of Sir Edwin Landseer*, London, 1877, p.86.

22. This piety was most forcibly expressed in his *A Shepherd's Prayer* of 1845 and *The Baptismal Font* of 1872.

23. In this regard it is interesting to note that Landseer had an enduring fascination with the biblical notion of the lion laying down with the lamb. He made a picture on this subject in 1871. This fascination is, perhaps, an indication of his enduring belief that with the coming of God's kingdom the tension between the cruelty of Nature and a good God's will might be resolved.

24. Ormond, op.cit., pp.20–3.

25. The best evidence of Landseer's difficulties in believing in a consoling vision of Nature is his great late drawing *My Last Night's Nightmare*, which shows a lion eating a man. The image seems to tell of the tensions between his daylight piety and the troubles of his night-time imagination.

26. Russell-Cotes, op.cit., p.8.

27. *Ibid.*, p.7.

28. F. Goodall, *The Reminiscences of Frederick Goodall R.A.*, London and Newcastle, 1902, p.283.

CHAPTER SIX

1. Michael Wolff and Celina Fox, 'Pictures from the Magazines' in *The Victorian City*, edited by Michael Wolff and H.J. Dyos, London, 1973 (2 vols), p.559.

2. 'A Victorian Gallery. A suggestion for commemorating the longest reign on record', *The Studio*, 1897, p.260.

3. Statement of the Council of the Royal Academy of Arts, 1812, quoted in Jeremy Maas, *The Victorian Art World in Photographs*, London, 1984, p.213.

4. William Powell Frith, *My Autobiography and Reminiscences*, London, 1887, vol.I, pp.252–3.

5. *Ibid.*

6. In 1855, the *London Post Office Directory* listed 85 print-sellers and 92 picture dealers.

7. Obituary of Edwin Long, *Magazine of Art*, July 1891, p.xl.

8. Sir Merton Russell-Cotes, *Home and Abroad* (2 volumes) privately published, Bournemouth, 1921, pp.709–10.

9. *Art Journal*, 1867, p.62.

10. These influential books are Gleeson White, *English Illustration, The Sixties: 1855–70*, London, 1897; reprinted Trowbridge and London, 1970; and Forrest Reid, *Illustrators of the Sixties*, London, 1928; reprinted New York, 1975. A more recent but important study is Paul Goldman, *Victorian Illustration; The Pre-Raphaelites, the Idyllic School and the High Victorians*, Aldershot, 1996.

11. *Art-Union*, February 1839, p.1.

12. William Luson Thomas, 'The Making of "The Graphic"', *Universal Review*, 1888, p.80.

13. See Ronald Pickvance, *English Influences on Vincent Van Gogh*, exh.cat., University of Nottingham, 1974.

14. *The Graphic*, 8 January 1870, p.123.

15. Hubert von Herkomer, *The Herkomers*, London, 1910, vol.I, pp.150.

CHAPTER SEVEN

1. See T. Steele, *Alfred Orage and The Leeds Arts Club 1893–1923*, Aldershot, 1990.

2. R. Rawlinson, *Correspondence relative to St. George's Hall, Liverpool*, London, 1871, p.26.

3. G. Messinger, *Manchester in the Victorian Age*, Manchester, 1985, p.159.

4. See E. Morris, *Victorian & Edwardian Paintings in the Walker Art Gallery & at Sudley House*, London, 1996, esp. pp.vii, 1ff.; M. Greenwood, 'Victorian Ideal Sculpture 1830–1870: Merseyside Sculptors and Collectors' in *Patronage and Practice: Sculpture on Merseyside*, edited by P. Curtis, Liverpool, 1989, esp. p.50; J. Archer (ed.), *Art and Architecture in Victorian Manchester*, Manchester, 1985, esp. pp.28, 43 and 77; *Leeds City Art Gallery: A Selection of the Paintings Sculpture Drawings Watercolours and Prints*, n.d., unpaginated.

5. See P. Wells, *The Salford Peel Park Sculpture Collection*, unpublished B.A. dissertation, Fine Art Department, University of Leeds, 1999.

6. For information on Merton Russell-Cotes, his collection and Bournemouth see *A Victorian Salon: Paintings from the Russell-Cotes Art Gallery and Museum*, edited by Mark Bills, Bournemouth, 1999; E. Edwards, *Bournemouth Past*, Chichester, 1998.

7. Private collection; copy photographs in Conway Library, Courtauld Institute of Art, London.

8. *Art Journal*, 1866, p.177; see also U. Thieme and F. Becker, *Allgemeine Lexicon der bildenden Künstler*, Leipzig, 1907–50, XII, p.406.

9. See F. Otten, *Ludwig Michael Schwanthaler 1802–1848*, Munich, 1970, p.151; ill.294.

10. Andreoni's precise birth and death dates are as yet irretrievable. He was exhibiting from 1884 in Italy and Germany; see Thieme-Becker, op.cit., I, p.479.

11. A. Panzetta, *Dizionario degli Scultori Italiani dell' Ottocento*, Turin, 1989, p.27.

12. R. Wunder, *Hiram Powers Vermont Sculptor 1805–1873*, Newark and London, 1991, II, p.202.

13. R. Quick, *Catalogue of the Pictures and Sculpture in the Russell-Cotes Art Gallery and Museum*, Bournemouth, 1923, p.63.

14. See A. Stirling, *Victorian Sidelights*, London, 1954, p.88 for the Landseer bust and *passim* for the family connections.

15. See E. Morris and M. Evans, *Catalogue of Foreign Paintings, Drawings, Miniatures, Tapestries, Post-Classical Sculpture and Prints in the Lady Lever Art Gallery*, Liverpool, 1983; A. Clay and others, *British Sculpture in the Lady Lever Art Gallery*, Liverpool, 1999.

16. Sir Merton Russell-Cotes, *Home and Abroad* (2 volumes), privately published, Bournemouth, 1921, pp.657, 665.

17. N. Pevsner and E. Radcliffe, *The Buildings of England: Yorkshire West Riding*, London, 1989, p.542.

18. See Wells, op.cit.

19. See *The Last Romantics*, exh.cat., Barbican Art Gallery, London, 1989; 1993, pp.145–6.

INDEX

Adams-Acton, John 120, 127
Adele (anon) 115
Albert, Prince 9, 27, 89, 106, 127
Alfred Lord Tennyson (Herkomer) *107*
Allingham, Helen 77
Alma-Tadema, Anna 77
Alma-Tadema, Laura 25–6, 77, 80, 83
Alma-Tadema, Lawrence 15, 18, 19, 77, 105
Always Welcome (Laura Alma-Tadema) 25–6, 77, *83*
Anderson, Sophie 75, 81
Andreoni, Orazio 119, 122
Anno Domini or the Flight into Egypt (Long) 10, 18, 47, *52*, 62, *62*, 112
Arab Chief, An (Calvi) 120
Arnold, Reginald Edward 22
Attachment (Landseer) 92
Aurora Triumphans (De Morgan) 10, 34, 36, 46, *71*, 72
Awakening: Studying Galileo, The (Arnold) 22, *22*

Baroness von Hügel (Dupré) 123, *128*
Barrias, Louis-Ernest 119, 122, 123
Bates, David 47
Bath Hotel, Bournemouth (Brannon) *114*, 115
Bathers Alarmed, The (Solomon) *64*
Bathers, The (Stephens) 118, *119*, 120
Bayard, Emile 31
Beavis, Richard 103
Beggar, The (Glindoni) 25, *28*
Behnes, William 122
Benham Hay, Jane Ellen 73, 76
Benjamin Disraeli (Behnes) 122
Benjamin Disraeli (Gleichen) 122
Benzoni, Giovanni Maria 118–19, 122
Bigg, William Redmore 26, 29
Billet Doux, The (Oliver) 30, 34, *35*
Blaas, Eugène de 31
Black Queen, A (Calvi) 120
Blossoms (anon *after* Moore) 16, 17–18
Bone, Herbert A. 22, 23, 24
Bonfire of the Vanities, The (Hay) 73
Bonheur, Rosa 79
Boulter's Lock (Gregory) 30, *32*
Brannon, P. 115
Breakspeare, William A. 59, 65
Brickdale, Eleanor Fortescue 33, 34, 73, 75
Bringing Home the Deer (Jones) *97*
British Lion or Repose, The (Vastagh) *101*
Brock, Charles 24

Brock, H.M. 24
Browne, Henriette 20, 75
Burgess, John Bagnold 25
Burne-Jones, Edward Coley 16, 18, 28, 34, 46, 71, 72
Butterfly, The (Faléro) *54*

Caldecott, Randolph 24
Calderon, Philip Hermogenes 24, 26
Caledonia, Stern and Wild (Hurt) 92, *93*
Calvi, Pietro 120, 122, 124–5
Cambridge Street Scene (Rayner) *85*
Canova, Antonio 9, 122
Canziani, Louisa Starr 75, 77, 82
Capri Girl with Flowers (Anderson) 75, 80, 81
Capri Girl (Perugini) 75
Captive Andromeda (Hill) 17, 61, 65
Centaur and Mermaid (Müllner) 122–3, 128, *129*
Chosen Five, The (Long) 18, 59, 61, *113*
Cleopatra (Lombardi) 120
Clésinger, Jean-Baptiste 119
Clytie (Guirlandi) 120
'Clique, The' 22
Cockatoos, Toucan, Macaw and Parrots *102*, 103
Coming of Age in the Olden Time (Frith) 22
Cornish Holiday, A (Sharp) 79
Cousins, Samuel *88*, 106
Cromwell (*after* Roubiliac) 122

Daedalus and Icarus (Wood) 124
Dawn of Love, The (Etty) 56–7, 59
De Morgan, Evelyn 10, 34, 46, 71, 72
Death-mask of Beerbohm-Tree (Frampton) 122
Dewsbury, Miss 69–70
Diana (Falguière) 119
Die Schöne Melusine (Schwanthaler) 119
Disraeli, Benjamin *122*
Distraining for Rent (Wilkie) 26
Dog's Home, The (Hunt) 89, *94*
Drawing-room 1a Holland Park (Anna Alma-Tadema) 77
Dupré, Giovanni 123, 128
Duran, Carolus 98
Durham, Joseph 124
Dutch Peasant (Schwartze) 75

Edward VII (Gazzeri) 122
Edward VIII 127
Egyptian Water-Carrier, An (Hill) 20, 62, *65*
Elsley, Arthur 26
England and Italy (Hay) 73
English Girl, An (Fildes) 48, 50, *51*
Etching and Etchers (Hamerton) 109
Etty, William 15, 53, 55, 56, 56–7, 59

Faed, Thomas 98
Faithful Unto Death (Poynter) *110*
Faléro, Luis Riccardo 53, 54, 56
Falguière, Jean-Alexandre-Joseph 119
Farquharson, Joseph 98
Female Figure (Spence) 118
Fildes, Sir Samuel Luke 25, 44, 48, 50, 98, 110
First Funeral, The (Barrias) 119–20, *123*
Flaxman, John 122
Flood in the Highlands (Landseer) 26, 88, *90*, 91–2, 94, 96, 127
Florence Nightingale (Macdowell) 124
Florence Nightingale (Towne) 124
Flower Study with Butterfly (A.F. Mutrie) *84*
Foam Horses (Kemp-Welch) 79, *87*
Fogerty, John Frederick 58
Ford, Henry Justice 55, 63, 73
Foster, Myles Birket 114
Four Generations, The (Orchardson) *11*
Frampton, Sir George 122
Freeman, Augusta 72, 119, 120
Frith, William Powell 22, 26, 30, 37, 107–8
Frost, William Edward 15, 16, 47, 53, 59
Furniss, Harry 105

Ganymede (Riviere) 100
Gazzeri, Ernesto 122
Geese (Foster) *114*
Gentle Spring Brings her Garden Stuff to the Market (Sawyer) 72, 73, *73*
George Bernard Shaw (Scott) 79
Gibson, John 9, 118, 120
Gilbert, Alfred 125
Girl and Carrier Pigeon (Macdonald) 118
Gleichen, Count Victor 122
Glindoni, Henry Gillard 25, 28
Godward, John William 20, 75
Good and Bad News (Burgess) 25

Goodall, Frederick 20, 44, 60, 75, 96, 120
Graham, Peter 92, 98
Great-Grandfather of Donor as a Child (Dewsbury) *70*
Grecian Girl, A (Radford) 75
Gregory, Edward John 28, 30, 32
Griselda (Stevenson) 120
Guess Again (Anderson) 75
Gypsy Horse Drovers (Kemp-Welch) 79, *86*

Habit Does not Make the Monk, The (Watts) *14*, 15, 17
Hale, Edward Matthew 19, 61, 62, 66
Hamerton, Philip Gilbert 56, 109
Hark, hark! the dogs do bark... (Marks) 24, 26, *27*
Hart, Solomon Alexander 13, 15, 16
Havers, Alice Mary 73, 81
Heavenly Stair, The (Hughes) 27–8, *39*
Henry Irving as Hamlet (Long) *113*
Her First Love (Knowles) 30–1, *41*
Herkomer, Hubert von 33, 98, 107, 109, 110, 111
Highland Mary (Spence) 118
Hill, Arthur 17, 20, 61, 62, 65
Hireling Shepherd (Hunt) 26
Home Again (Knowles) 41
Home from Work (Hughes) 27, *38*
Horses (Beavis) *103*
How the Danes came up the Channel a Thousand Years Ago (Bone) 22, *23*, 24
Hügel, Friedrich von 123–4
Hughes, Arthur 27–8, 38, 39
Hunt, Walter 89, 94
Hunt, William Holman 16, 18, 22, 26
Hurt, Louis Bosworth 92, 98

If I could have that little head of hers Painted on a background of pale gold (Brickdale) 73, *74*, 75
Impressionists 28, 36
In Full Swing (Wilson) *50*
Incantation (Collier) 62
Innocence (Spence) 118
Irving (Pollock) 122
Italian Girl, The (Godward) 20, 75

Jael (Andreoni) 119, *122*
Jephthah's Vow (Webb) 112
Jezebel (Shaw) 18–19, 48, 53, 61, 62, *67*

John Landseer (Adams-Acton) *126*
Jolly Strollers (Wilkinson) 28, *30*, *31*
Jones, Charles 97
Jopling, Louise 73, 79
Josephine (*after* Canova) 122
Judith (Landelle) 20, *21*
Junck, Ferdinand 122, 127

Kathleen and Marianne, Daughters of Samuel G. Sheppard, Esq (Canziani) *82*
Kemp-Welch, Lucy Elizabeth 79, 86–7
King Ahab's Coveting (Rooke) 18
Kitten and Tomtit (Riviere) 100
Knowles, George Sheridan 30, 41

Lady Hamilton as Venus (Romney) *55*
Landelle, Charles 20, 53
Landseer, Edwin Henry 26, 88–9, 90, 91–2, 94–6, 112, 120, 127
Landseer, John 120, *126*
Landseer's Deer Stalking in the Highlands (engravings) 95
Last of the Day, The (Anderson) 75
Leighton, Frederic 15, 16, 17, 19, 20, 43, 56, 57, 58, 105, 109, 125
Leslie, George Dunlop 24, 30
Leverhulme, William Hesketh, Lord 13, 36, 53, 55, 122
Lewis, Mansel 109
Linton, William James 106
Little Beggar! (Knight) 79
Lombardi, Eugenio 120, 122
Long, Edwin Longsden 10, 18, 20, 25, 26, 43, 44, 47, 52, 59, 60, 61, 62, 75, 104, 112, 113
Lord George Bentinck (Baily) 122
Lorenz Herkomer, Siegfried and Elsa (Herkomer) *33*
Love at First Sight (Riviere) 100
Love Letter, The (Knowles) 41
Love Locked Out (Ford *after* Merritt) 55, *63*
Love Locked Out (Merritt) 15, 55, 72–3
Lucky Find at Pompeii, A (Moulin) 119

Macdonald, Lawrence 118, 122
Macdowell, Patrick 124
Maclise, Daniel 15, 106, 108
Man in Art (Hamerton) 56
Marks, Henry Stacy 22, 24, 26, 103
Marochetti, Carlo 123
Melusine (Schwanthaler) *121*
Merritt, Anna Lea 15, 55, 63, 72
Midsummer (Moore) 18
Millais, John Everett 22, *23*, 100, 101, 105, 110
Monarch of the Glen, The (Landseer) 127
Montalba, Clara 77
Moore, Albert Joseph 16, 17–18, 19, 31, 44, 46, 53, 58, 59
Moorish Girl with Parakeet (Browne) 20, 75
Moorish Proselytes of Archbishop Ximenes, The (Long) 18, *19*
Morton, Sir William Scott 59
Moulin, Hippolyte-Alexandre-Julien 119

Mrs St Barbe Sladen (Marochetti) 123
Müllner, Jozef 123, 128
Music Hath Charms (Anderson) 75
Mutrie, Annie Feray 77, 84
Mutrie, Martha Darley 77, 84
Mystery of Edwin Drood, The (Dickens) 50

Napoleon (sculpture) 122
Nelson (*after* Flaxman) 122
New Model, The (Skuteczky) 25
Nicol, John Watson 47
Night and Morning (Landseer) 95
Nightingale, Florence 124
Nine Pines (Pope) 125
Nisbett, Noel Laura 68, 69
None but the Brave Deserve the Fair (Landseer) 95
Nude in Art 56
Nude (Breakspeare) 59, *65*
Nymph and Cupid or Morning (sculpture) 120
Nymph and Cupid or Night (sculpture) 120, *124*

Old Shepherd's Chief Mourner, The (Landseer) 89, *89*, 91
Oldofredi, Girolamo 120, 122
Oliver, William 30, 34
Orchardson, William Quiller 11, 22, 24, 28
Origin of the Species (Darwin) 95
Othello (Calvi) 120, 124–5
Otter Speared, The (Landseer) 94–5

Pallatti, (sculptor) 120
Parting of Marie Antoinette and Her Son (Ward) 22
People's Gallery of Engravings, The 104
Pereat (Andreoni) 119
Perugini, Charles 20, 75
Pet Goldfinch, The (Browne) 75
Pharaoh's Daughter (Adams-Acton) 120
Phosphorus and Hesperus (De Morgan) 71, 72
Phyllis (Jopling) 73, *78*, 79
Pickersgill, Frederick 15–16, 16, 53
Piggies' Feeding Time, The (Bayard) 31
Pollock, (sculptor) 122
Pope, Nicholas 125
Portrait of a Girl (Leslie) 24
Powers, Hiram 119, 123
Poynter, Edward John 18, 19, 56, 57, 58, 71, 110
Pre-Raphaelites 12, 15, 16, 22, 26, 27, 31, 38, 46, 67, 72, 73, 75, 100, 108
Princes Sleeping in the Tower, The (Freeman) 72, 119, *120*
Princess Royal, The (Junck) 120, 122
Private View, The (Furniss) *105*
Proserpine (Powers) 119, 123
Psyche at the Throne of Venus (Hale) 19, 61, 62, *66*
Psyche's Toil in Venus' Garden (Hale) 66

Queen Elizabeth Discovers that she is No Longer Young (Egg) 22
Queen!, The (Wilson) *45*
Queen Victoria (Gibson) *9*, 120

Queen Victoria (Junck) *127*
Quilter, Harry 42–3

Radford, Edward 20, 75
Ramsgate Sands or 'Life at the Sea-Side' (Frith) 26, *37*, 107–8
Random Shot, A (Landseer) 92
Rayner, Louise 70, 77, 85
Rebecca at the Well (Spence) 118
Rebecca (Benzoni) 119
Reception of the Prodigal Son, The (Benham Hay) 73, *76*
Reception, The (sculpture) 120
Reminiscences (Goodall) 20
Riviere, Briton 26, 89, 100
Roberts, David 18, 22, 85
Romney, George 53, 55
Ronner, Henriette 77, 80
Rooke, Thomas Matthews 18
Rosa, Ercole 120
Roses (M.D. Mutrie) *84*
Rossetti, Dante Gabriel 16, 31–3, 34, 38, 40, 48, 53, 62
Roubiliac, Louis-François 122
Royal Academy Pictures 108
Ruga, (sculptor) 120
Ruskin, John 15, 16, 56, 73, *84*, 107
Russell-Cotes Art Gallery and Museum 8, 9, 36–7, 47, *48*, 49, *49*, 50, *59*, 88, 105, *117*, 118
Russell-Cotes, Herbert 10
Russell-Cotes, Lady Annie 8, 36, 53, 56, 68, 69, 73, 77, 79, 80, 92, 122
Russell-Cotes, Sir Merton 8, 10, 12, 13, 18, 26, 36, 43, 44, 45, 47, 53, 55, 56, 58, 61–2, 68, 69, 73, 77, 79, 80, 87, 89, 92, 95–6, 105, 118, 119, 120, 122

Sailor Boy's Return from a Prosperous Voyage, The (Bigg) 26, *29*
Sale at Christie's, A (Wilson) *46*
Salmon Leap on the Lleds (Bates) 47
Samuel (Benzoni) 118–19
Sawyer, Amy 72, 73
Schwanthaler, Ludwig Michael 119, 121, 122
Schwartze, Therese 75, 80
Scott, Kathleen 79
Sea Cave, The (Frost) 16, 47, 59
Seagulls (Wyllie) *115*
Search for Beauty, The (Long) 60, *112*
Self-Portrait (Cousins) *88*
Self-Portrait with his Two Children (Elsa and Siegfried) (Herkomer) *109*
Self-Portrait (Nisbet) *69*
Shakespeare (sculpture) 122
Sharp, Dorothea 79
Shaw, John Liston Byam 18–19, 33, 34, 48, 53, 61, 62, 67, 73
Sheep in an Orchard (Havers) 75, *81*
Sheppard, Kathleen 75, 77
Sheppard, Mary Anne 75, 77
Shiva Slave, The (Oldofredi) 120
Silent Evening Hour, The (Farquharson) 98, *99*
Skuteczky, Dome 25
Snyders, Frans 95
Solomon, Solomon J. 56, 64
Spence, Benjamin Edward 118, 122

Spring (Spence) 118
Stanhope, Spencer 34, 72
Starr, Louisa *see* Canziani, Louisa Starr
Stephens, Edward Bowring 118, 119, 122
Stevenson, David Watson 120
Stocks, Lumb 106, 108
Stubbs, George 88, 94, 95
Submission of the Emperor Barbarossa to Pope Alexander the Third, The (Hart) *13*, 15
Subsiding of the Nile, The (Goodall) 20, 22, 96, *96*
Summer (Calvi) 120
Summer's Night, A (Moore) 58, *58*
Susannah (Goodall) *60*

Taking In (anon) *45*
Tate, Sir Henry 13, 36, 55
Tennyson, Alfred, Lord *107*
Then to her Listening Ear... (Long) 20, 75
Thomas, John 59
Thomas, Oliver 59
Tick-tick (Riviere) 89, *100*
Toothache in the Middle-Ages (Marks) 22
Towne, Joseph 124

Una and the Lion (Clésinger) 119
Undine (Schwanthaler) 122

Vastagh, Géza 101
Venetian Water-Carrier (Blaas) 31
Venus Rising (J. and O. Thomas) 59
Venus Verticordia (D.G. Rossetti) 31, 32–3, *40*, 53, 62
Victoria, Queen 9, 13, 16, 22, 27, 45, 89, 106, 120, *127*, 130

Walmgate Bar (Rayner) *85*
Wardrobe, A (Moore) 59
Watts, George Frederick 15, 16–17, 26, 34, 87
Webb, John Cother 112, 113
Wellington and Blucher Meeting after the Battle of Waterloo (Maclise) *106*, 108
W.H. Smith (Durham) 124
When a Man's Single (Nicol) 47
Whistler, James Mcneil 16, 31, 7946
Wilkie, David 24, 26, 27, 96
Wilkinson, R. Ellis 28, 30, 31
Wilson, T. Walter 45, 46, 50
Winter (Calvi) 120
Wood, Francis Derwent 124
Words of Comfort (Herkomer) *111*
Wounded Knight, The (Knowles) 41
Wyllie, William Lionel 115

Zinkheisen, Anna 69